Casa Batlló Barcelona
Gaudí

TRIANGLE ▼ POSTALS

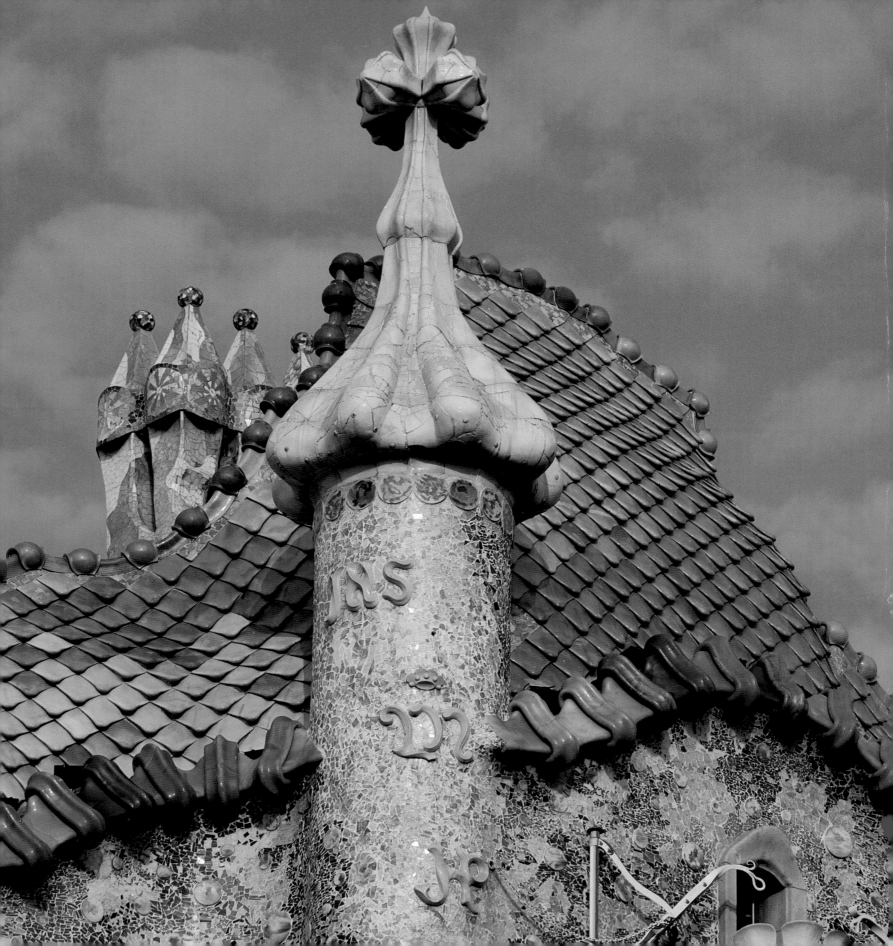

CASA BATLLÓ

GAUDÍ

TEXT
Juan José Lahuerta

PHOTOGRAPHY
Pere Vivas / Ricard Pla

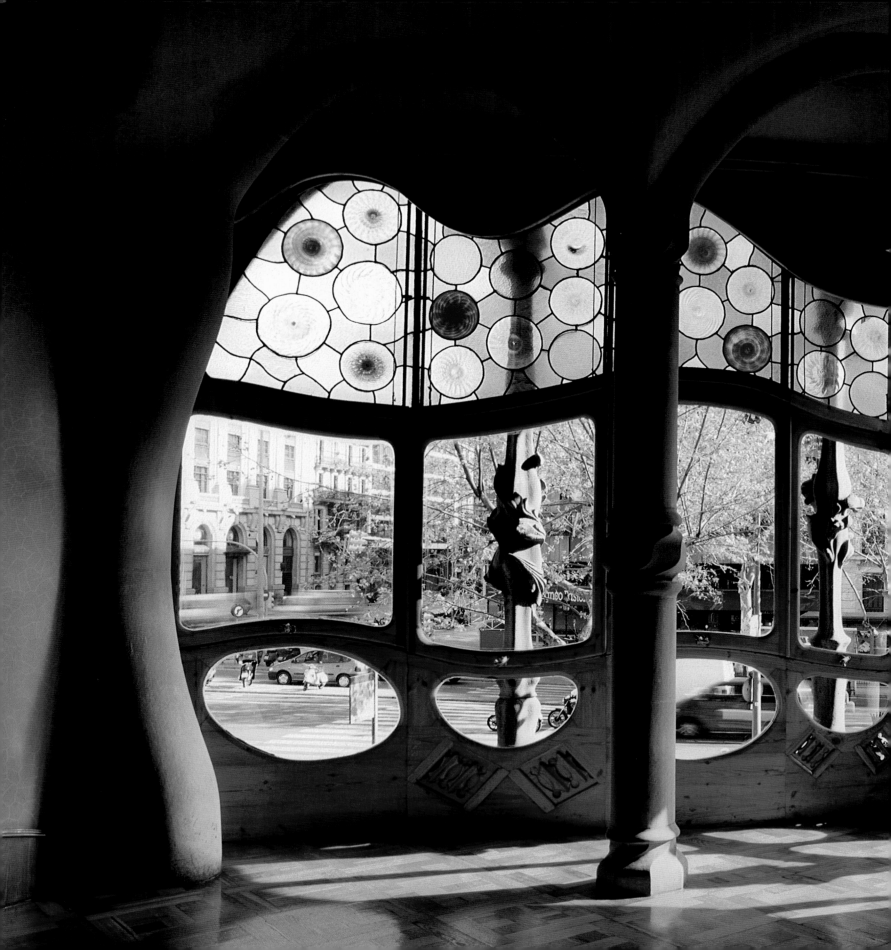

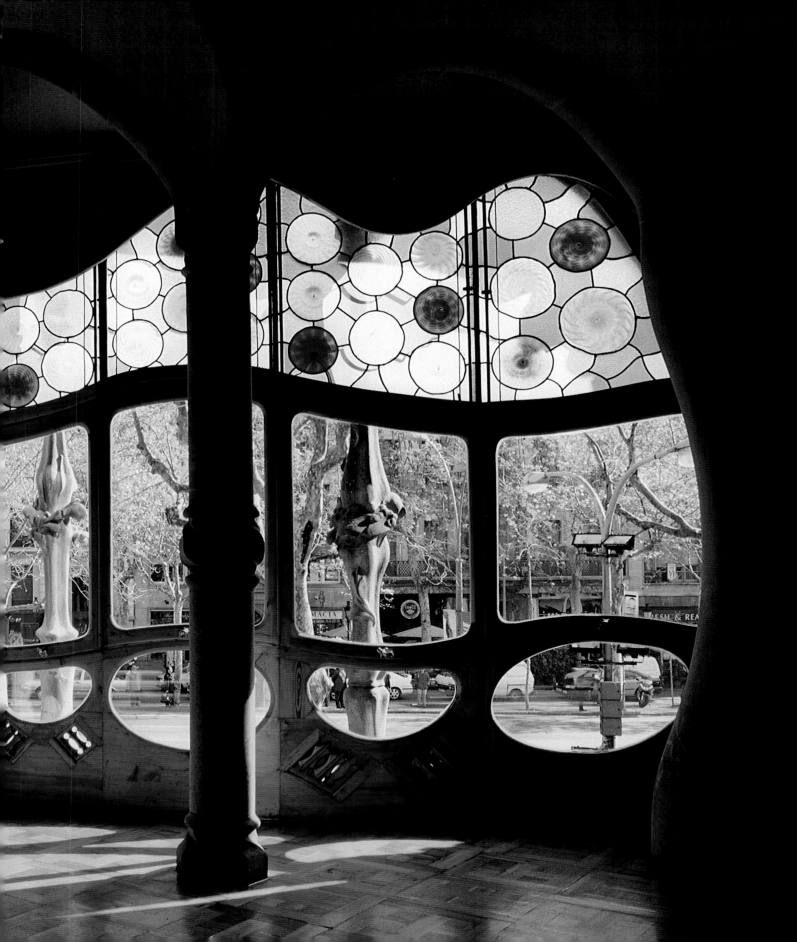

CASA BATLLÓ

Contents

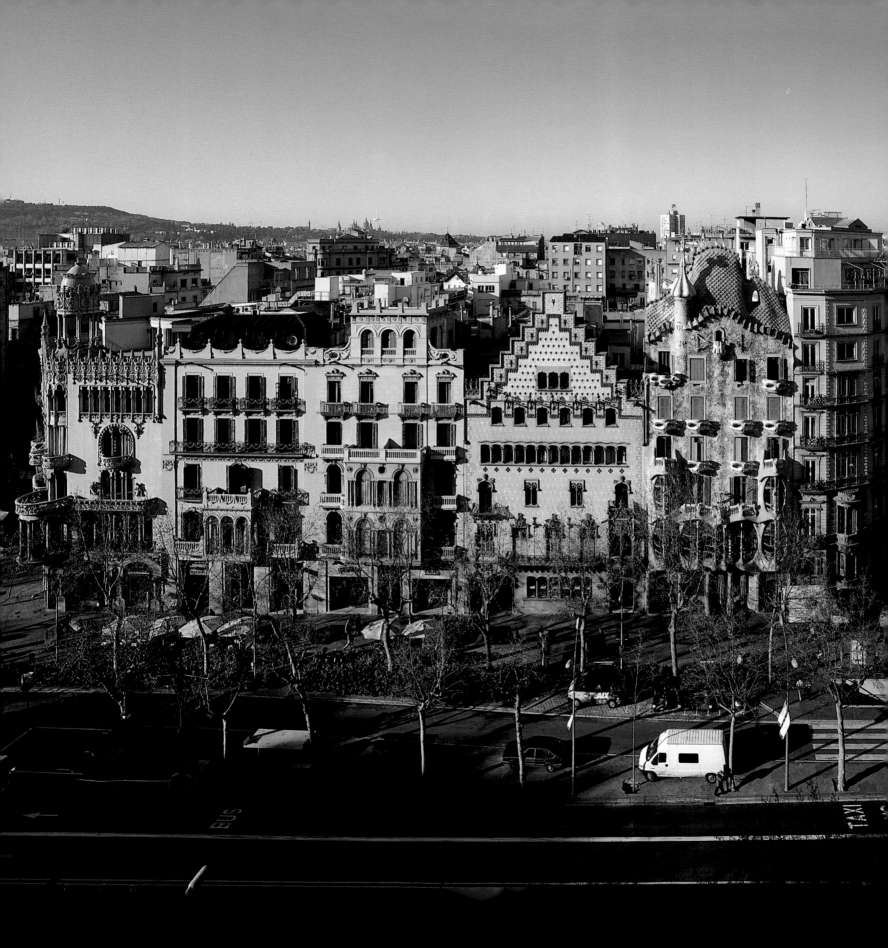

Modern Constructions:
«La pâtisserie Barcelone»

Juan José Lahuerta

"*¿Qui us la fa la casa, en Domènech, en Gaudí ó en Puig y Cadafalch?*" [Who will build the house for you, Domènech, Gaudí or Puig i Cadafalch?] ask some shabbily-dressed characters to another elegantly attired man, perhaps overdressed, too much in fashion, a little dandified – the contrast is essential – in a caricature by Picarol appearing in *La Esquella de la Torratxa* in October 1905. His prudent reply – "*Encare no estich ben decidit... El que resulti premiat en el Concurs*" [I am still not quite sure... whoever wins the prize.] – refers, like the other jokes on the page, to "*aixó del concurs de edificis y fatxadas*" [all about the prize for buildings and facades], the annual prize awarded by Barcelona City Council for the best building constructed in the city, which had been won in its first edition, in 1899, for the Casa Calvet by Gaudí, and what was for the time being in fact, in 1905, the last edition, for the Casa Lleó Morera by Domènech i Montaner.

In the three sketches that close the page, Picarol shows the moment of the prize giving. The smiling facades of some buildings lining the street await the prize in the first; those that, in the end, have not received even a consolation prize display their sad expressions in the last one. In the first scene the ornamental hip knobs of the buildings are cheerful such as the fantastic hats or even pointed crowns such as the merlons, buttresses and swirling rosettes, standing out from which is a pointed cone that even leaves the frame of the sketch. In the last one, in contrast, these happy and exaggerated shapes have had the smiles wiped off them, and even the gable end of one of the houses, a withering hairstyle with a parting in the middle, shows the downward drift of everything: of the tears dripping from the windows or the open doorways like mouths which, full of remorse, make pouting expressions as they fall to the ground.

Picarol, caricatures in
La Esquella de la Torratxa,
Barcelona, 13th of October 1905.

Esperant el premi. **L' aote de la condecoració.** **¡Ni un accéssit!**

Picarol, caricatures in
La Esquella de la Torratxa,
Barcelona, 13th of October 1905.

Even though, in reality, it is not very difficult to recognise a familiar air in these facades, or at least their location, the triangular gable is not a very common solution in the streets of Barcelona, except if we think of the Casa Amatller, completed by Puig i Cadafalch in 1900. One of the crying mouths, perfectly rounded, reminds us of the characteristic shape of the balconies on the third floor of the Casa Lleó Morera, with which Domènech, as I mentioned, won the prize for the best-finished building in 1905, whereas the others, softened and stretched by the wrinkles that drop from the nose, make us think of the keel-like openings of the gallery on the Casa Batlló, which Gaudí finished a few months later, at the beginning of 1906 and which, as is well known, was popularly known as the *"casa dels ossos"* [the house of bones], but also, though less movingly, as the *"casa dels badalls"* [the house of yawns]. And finally, the cone rising in the corner of one of the facades, what else does it remind us of in all this company except the cylindrical tower of the selfsame Casa Batlló, then perfectly visible, as was the gallery?

These facades in Picarol's caricature, in which a series of varied but very specific elements appear to have joined as a result of some sort of automatic reflection – obsessive forms of architecture, anthropomorphic compositions, *facies* deformed by a feeling, laughter or weeping (I do not exaggerate here) – therefore evoke, one alongside the other, a very specific place in Barcelona at the time, Autumn 1905, between the streets of Aragó and Consell de Cent.

On Picarol's page everybody has something to say about the "facade prizes" and everybody is talking about them: the gentlemen, ladies and the maids. In their question, those down-at-heel men also mention the names of the three architects that had built or were building their houses on this famous block. Famous for each of their causes, of course, since in reality it was not the prizes in which people were so interested, but in the architects themselves or, to be more precise, their rivalry. For example, a postcard of the period published by Jorge Venini under the title, *Passeig de Gràcia. Series of modern buildings*, shows us a perspective of these facades from a higher point of the opposite pavement. The explanation we can read on the other side is highly revealing: "This block of houses" it states, "is notable for its offering of different architectural styles, all of them original". It continues, with an unusual use of syntax, "During the time of construction of these houses it was commonly called the apple of discord (*apple – manzana in Spanish also means block of buildings*) because of the different architects involved and which one was liked the most".

This text, I emphasise, was printed on the back of a postcard, its function therefore linked to the card itself: on one side, to identify the landmarks so that Barcelona's inhabitants could recognise

their own city and identify with it; and on the other, to travel and be seen by people far away with a message from Barcelona, literally as a piece of publicity. This one, however, went further: in this case the explanation, very long-winded considering the usual lack of space available, deciphers the image way beyond what is expected. It does not only say what we are looking at, but it also gives it meaning. How are we to understand this opinionated form of *amplificatio* except as a direct demonstration of the city's collective subconscious, as a revelation of its *imagination* of the period, at that precise moment in time? The architectural automatism of Picarol's doodles did not reflect very different questions. These houses that we see, the postcard tells us, have taken part in a competition with each other, a living competition, with no other rules except the rivalry itself – or *discord* – and in which the jury is made up of the public opinion that passes by. These houses have been constructed like this for this universal and anonymous public, *all of them distinct and original*: to be enjoyed *more*.

But what are we describing here? The law of competition, of supply and demand, or a mass society? From the end of the ancien régime and throughout the history of the 19th century, artists saw how the forms of sponsorship through which they had traditionally related to the world were being replaced, as has occurred in other social milieu, by the laws of the market. The artist was no longer dependent on his personal relationship with a patron, prince or institution for whom he acted as a servant, jester, courtesan or civil servant. Neither could he rest his prestige upon the knowledge of collective disciplines that coincided with the ideological and symbolic programmes, also collective, of his clients or, in fact, even dream of the possibility. His profession, like any other, without any kind of *protection*, had become extended and his product, the work of art, had been definitively converted into merchandise and become anonymous, just like the bourgeoisie capable of consuming it and to whom it was aimed at through the newly created intermediaries: galleries, art dealers, magazines... In this new medium, the artist and his commentators, and it could not be otherwise, adopted perfectly rounded strategies, as *modern* as the functioning of the market itself:

The "apple of discord", postcard published by J. Venini, Barcelona, c. 1910.

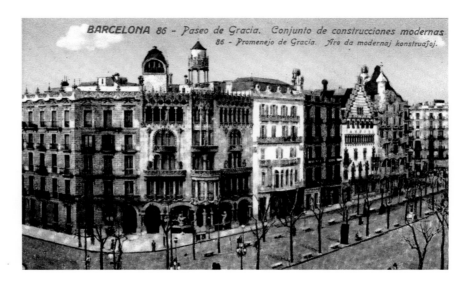

exorcisms launched against the conversion of art into merchandise, which attempted, rhetorically, to make the market's *necessary* modernity the greatest virtue of art. Bohemian ideas, the theory of *art for art's sake*, the scandal, the disdain for and insult to the bourgeoisie – all those forms so characteristic, in fact, of the aristocratically inclined high bourgeoisie of the second half of the 19 century – gradually defined, at the same time, the modern artist and his public. In what other way and with what other principles could a sector as marginal as it was important, the luxury goods sector, be monopolised? Here is where consumption reaches its highest of levels, by making it *significant* due to the artist's work. And the propaganda technique employed: the modern artist is an eccentric who does not work for the public but someone who imposes their tastes. In 1900, in the period of these *distinct and original houses*, the artist had already become a clearly defined type of person.

The great complexity involved in an architectural work, its high economic cost in terms of personnel and time and its heavy dependency on craftsmanship and technique, meant that the architect's work was linked to the institution or academy for a longer time and, therefore, to a certain extent, protected from the laws of competition. At the close of the century, nevertheless, the growth of the construction market in the big European capitals combined with the new representative needs of some urban societies that became finally based on mass consumption in terms of propaganda and spectacle, ended this situation. Thus, although with a delay, when all the ways of the modern artist had already been converted into stereotypes, the architect also had to become a follower of the religion of art for art's sake. And he did it, of course, with all the conviction of the neophytes. The *modern* architect is the person that not only takes on the responsibility of the planning and construction of the building, just as had occurred more or less until then, but also the person capable of going far beyond that, who invested the maximum creative effort in elements that had until then been minor or secondary, traditionally left to the craftsman or industry, and which now, suddenly, became of the utmost importance, becoming essential elements: handrails, grilles, lamps, doorknockers, locks, signs, weathercocks... It was all about a fixation for *authorship* which, logically,

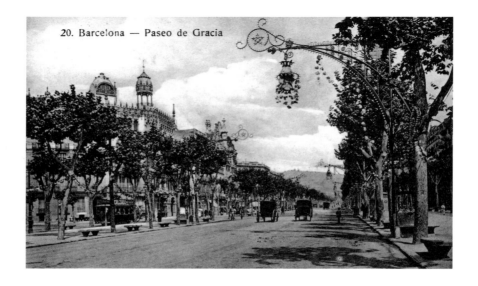

Passeig de Gràcia facing the "apple of discord", postcard, Barcelona, c. 1910

architecture had never experienced before, in the same way that that the architect had never tres-passed into so many spheres of life, also becoming responsible for the furniture, the vases, the upholstery and carpets, the crockery and cutlery and even, on some occasions, the dresses of the lady of the house.

In European cities, during the two decades that bordered 1900, there was a bourgeoisie, sometimes high class and sometimes not quite so high class, that was prepared to make this house, thought up in a flash, into something quite unique from the foundations to the lightning conductor. They aimed to evoke the magnificent mansions of the dandies of decadent society with their obsessive interiors, making them more than just unique but more literally driven by the *nervous life* of its inhabitants, in which everything had been personally selected from the world of the most sophisti-cated and richest objects and in which the tension of the entire universe, mixed with the mood of the owner, seemed to be condensed into one particular detail. This could be the frame of a small rococo mirror, in a Japanese fan, in a cameo or in a miniature. Some of these houses, like that of Des Esseintes, described by Huysmans in *À rebours*, came from the world of the imagination and others, like the *hôtel* that Edmond and Jules de Goncourt owned in Auteuil, were absolutely real – Edmond devoted a book to it, a kind of catalogue of his treasures full of impressions, it being no coincidence that it was entitled *La maison d'un artiste* –. They all had a common aim, however: to be exhibited as fortresses closed to the law of universal equivalence imposed on the outside world by merchandise.

They were treasures in the full meaning of the word, not only because they were unique and rare but also, above all, because they had been chosen from among those all over the world by an owner who had either been possessed by his objects all his life or had endowed his soul to them.

Naturally, the bourgeois houses of 1900 to which I refer were nothing but a parody, more or less exquisite, of these models and, if the truth were to be told, fully justify the investment made in them. We could say that the clients delegated to the architects-artists the expression of their personality

Passeig de Gràcia facing the "apple of discord", postcard, published by A. Toldrá Viazo, Barcelona, c. 1910.

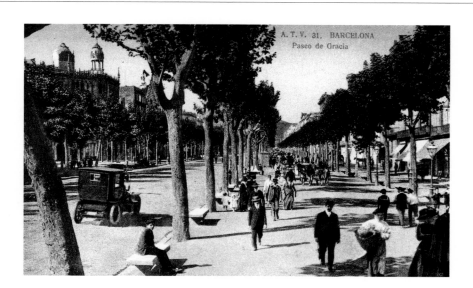

Monumental Door and Palace
of Illusions, illustrations published
in the album of *Le Panorama de
l'Exposition Universelle*, published
by L. Baschet, Paris, 1900.

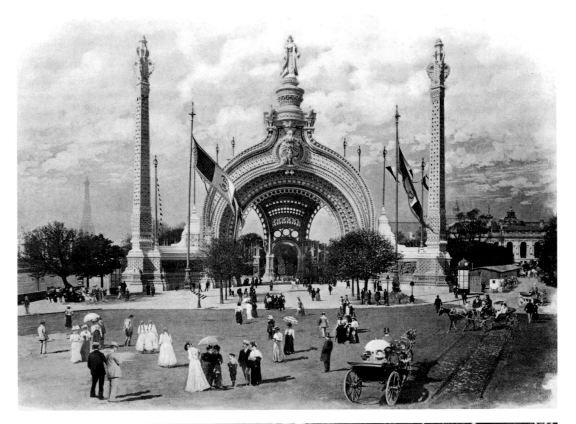

and finally, as a famous tale by Adolf Loos about "a poor rich man" so eloquently describes, which we will come to later, it was the artists who imposed their tastes.

The *fin de siècle* architect followed the model already drawn up of the modern artist. He is also an eccentric in rivalry with others like him in the luxury goods market. His sphere of work, however, turns him into a much more *dangerous* character, since through his work some of the most secret and terrible conditions of merchandise are revealed. What else could someone be who turned everything they touched into art – the house, the chair, the rug, the salt pot, life itself – other than the closest semblance of this metaphor of comparison and death that we can see in King Midas?

The modern architect and modern architecture became social figures and opinions were given before the facades raised in the streets as if facing a painting in an art gallery. When Barcelona City Council established the prize for the best building of the year, it was doing nothing more than closely following the example given by Brussels and Paris, where for the first time, in 1898, a prize had been awarded to a magnificent and eccentric work: the Béranger Castle by Hector Guimard. It is not very difficult to notice that what was at stake in these competitions had very little to do with the *publicae venustati* of ancient times and their idea of *decorum*. Instead of the suitability and comfort of the buildings regarding their location and functions, these prizes extolled, as we have seen, what was *distinct and original*. In other words the individualism and rivalry of the owners and architects involved, a rivalry that reached its climax in the great architectural exhibitions at the end of the century: at the exhibition of Paris in 1889 and, above all, in the delirium of that of 1900.

The fifty million visitors who passed through the extravagant buildings of the latter tell us of the clarity of extremes that the *art nouveau* architect moved in. On the one hand, the bourgeois salon, where everything must be unique and private: on the other hand, the multitudes, who transform this selfsame architecture, these selfsame supposedly elitist designs into a great popular show. These extremes, however, without paradoxes, are perfectly complimentary: they are exactly the same as those that oscillate – and *operate* – the cycles of fashion.

Blue Pavilion, illustration
published in the album of *Le Panorama de
l'Exposition Universelle*, published
by L. Baschet, Paris, 1900.

Junceda, caricature about the monument to Pitarra in Les Rambles published in *Cu-Cut!*, Barcelona, 3rd of January 1907.

Smith, "*El bufarut de l'altre dia*" [The gust of wind from the other day], caricature about the lampposts in Passeig de Gràcia published in *Cu-Cut!*, Barcelona, 1st of July 1909.

Situated at this point, and having assumed the role of modern artist a little late, when it had already evolved into a caricature, the fame of the *fin de siècle* architect and the fortune of his works could not have been more ambiguous: nearly always deplored by the serious press, ever-present in the satirical press and mandarin of what Flaubert wrote in *Bouvard et Pécuchet*: "*Les architectes: tous des imbéciles. Oublient toujours l'escalier des maisons*" [Architects: all idiots. They always forget the staircase in the houses]. This is undoubtedly the modern, *popular* form of success.

But let us return to Barcelona. It was in the closing years of 19 century, and not before, when an entire generation of the city's bourgeoisie decided to abandon forever the big houses in the ancient city where they had lived until then and move to the flats of the new buildings in the Eixample district. *New* buildings, to be precise, built for them and which, contrary to the large inherited houses from the old districts, were new homes to be shown off by them. They were buildings that were adapted to their *new* functional needs and, above all, their aesthetic needs. In 1895, Salvador Canals, in an eloquently titled article, "Those who are somebody", and devoted to the modern artist Santiago Rusiñol, wrote, "The bourgeois is no longer a manufacturer or a banker; he is a man with style". In the decades that covered the turn of the century several hundreds of these new buildings were built in the Eixample district. It was also not surprising that the fashion shops established themselves there from the very first moment, as did the photographer Audouard, for example, on the ground floor of the Casa Lleó Morera, or the cinematographic and phonographic firm Pathé Frères in the Casa Batlló. The great need for a collective legitimisation by this bourgeois generation and their particular desire for distinction added to the unprecedented quantity of constructions in the area. On the one hand quantity and on the other, quality as exasperation of a *new style*. It is not surprising that during these years, Barcelona not being the exception, this figure with airs of a grand bourgeois bohemian arose and, simultaneously, in the form of caricature and vaudeville style, came the modern architect, who was called a *modernist* here. It is also not surprising that during this time a great many architectural works became subjects of popular opinion. One only needs to thumb

through the satirical press again to find them: the lampposts of Passeig de Gràcia and the monument of Pitarra, by Pere Falqués, or the Sagrada Familia and, a little later, the Casa Milà, by Gaudí, are, among others, some of the better known cases. Nevertheless, none rank so highly in Barcelona as the case of the "apple of discord", in terms of the paradigm of this situation we are talking about: the evidence of *discord*, to be exact: the explicitness with which the rivalry between the architects was shown or, even more, their facades. These three houses were not only raised one next to the other, like paintings at an exhibition, but were also built, in a defining way, at a precise time and place. Passeig de Gràcia was, in 1900, the display case in which this bourgeois generation we have been talking about exhibited its new, modern habits of representation and consumption. In other words its own style.

The facades represented in Picarol's drawings were, need we be reminded, faces capable of showing their emotions. In 1906, in a caricature published in *El Diluvio* under the title "New Barcelona", Brunet – who years later produced the cruellest possible caricatures of the Casa Milà – showed some "modernist building projects ... which several artists will be building here". These projects were, once again, facades, and the majority of them also had facial expressions. To the strange entrances and rooftops spiked with towers and points – or cores – and the creamy or snowy roofs and the general softening of the forms were added the animals that lived in them and the plants that grew in them. It is not difficult to perceive in this mixture of enchanted castle, chocolate house, zoo and greenhouse, a basically Gaudí-like air, a comic mixture of the entrance pavilions of Park Güell and of the Casa Batlló, above all. In an even more explicit way, one of the houses is topped with the outline of the Montserrat mountain and crowned by several crosses: the fact that they are not four-

Brunet, "New Barcelona",
caricature published in *El Diluvio*,
Barcelona, 27th of January 1906.

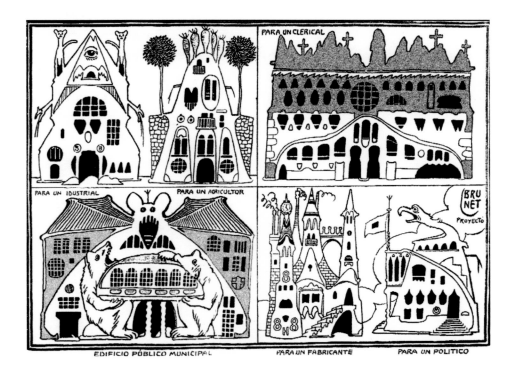

armed crosses does not detract from the clear reference made. The important thing, however, is that these projects – except one, which represents a "municipal public building" – are devoted to some typical characters: an industrialist, a farmer, a cleric, a manufacturer and a politician. Brunet not only laughed at the modernist style, but also at the pretension of making the house an expression of its owner's character through, naturally, the madness of some architects who were modern for being eccentric as much as they were eccentric for being modern.

Yet another caricature, this time published by Apa (Feliu Elias) in *Papitu* in the January 1909 issue, illustrates the way in which all the forms, symbols, even the seemingly most obvious and traditional, through to the most sacred, have become branded with the author's stamp, particularly in the case of Gaudí. Here the architect, showing the rector some plans, tells him, "*Veu, y a dalt de tot una creu perque Deu N.S. preservi al edifici del llamp*" [Look, and at the very top a cross so that God, our Lord, will protect the building from lightning], to which the rector replies: "*Si, si, molt bé; y a demunt de la creu un parallamps; no li sembla?*" [Yes, yes, very good, and above the cross, a lightning conductor, don't you think?]. What the architect imposed on his client was his feverish subjectivity, a juggling act in which he turned forms, symbols and meaning upside down, challenging traditional propriety which made the balance between these things the very virtue of the buildings. But, on the other hand, this is what the client paid for, an extremely expensive subjectivity.

The character from Picarol's joke, on seeing the competing works, had still not decided. This then, is what the market and its mechanisms are for: Domènech, Gaudí, Puig... who won the competition? In fact, in this competition Gaudí had an advantage.

When he began the project for his building, four years had already gone by since Puig had completed his and Domènech had begun his a year before. And what they had done, especially in the case of Puig i Cadafalch, in 1900, with the inaugural triangular culmination of the Casa Amatller, was to distinguish their buildings from the mass of conventional neo-classical constructions, which for forty years the Eixample district had been building. Indeed, this staggered gable end did not only brusquely interrupt the horizontal continuity of the balustrades on the neighbouring houses but also that of the whole Eixample district, which was his intention. Later on, Domènech sought the

Apa, caricature in *Papitu*,
Barcelona, 27th of January 1909.

18

same result with the form and unusual compositions of empty spaces in the Casa Lleó Morera and in its extraordinary decorative style. What both of them attempted to do, therefore, was to stand out from what the Barcelona *intelligentzia* of the time interpreted as the routine conformism of the buildings that filled Eixample and that lacked imagination, since the isotropy of the square blocks appeared to them, logically, as a monotonous place without perspectives.

Even in 1912, and as a commentary to some passionate architectural designs drawn by Josep Aragay, Francesc Pujols wrote in *Picarol*, "*Els arquitectes de la ciutat de Barcelona són: 1er, el senyor Gaudí; 2on, el senyor Domènech i Montaner, i 3er, el senyor Puig i Cadafalch. Quin és el més atrevit? No ho sabem. Tots tres encenen la ciutat en flames...*" [The architects for the city of Barcelona are: 1st, Mr. Gaudí; 2nd, Mr. Domènech i Montaner and 3rd, Mr. Puig i Cadafalch. Who is the most daring? We do not know. The three of them ignite the city in flames]. We will leave for another time the comments regarding the complex implications contained in the rest of the text, where our characters are compared to revolutionaries who burn churches and are presented as "*veritables arquitectes de la revolució contínua barcelonina*" [true architects of the Barcelona permanent revolution]. What interests us now is the image of the flaming buildings, an unconscious metaphor of the city unceasingly consuming itself, becoming a spectacle in itself. In other words, an image of the modern city-market, living and cosmopolitan, with which these intellectuals – often a long way from not only from the real material possibilities but also from the real desires of their bourgeoisie – dreamt of. These architects were thus called upon for their construction or, at least, their suggestion.

J. Aragay, "Blazing Barcelona",
drawing published in *Picarol*,
Barcelona, March 1912.

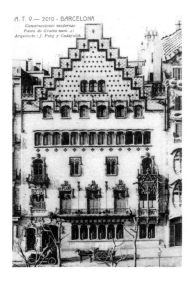
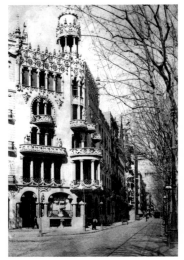
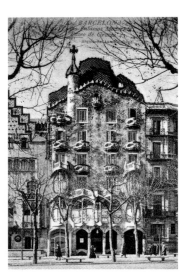

Casa Amatller, 1898-1900.
Postcard published by A. Toldrà
Viazo, Barcelona, c. 1910.

Casa Lleó Morera, 1903-05. c. 1906.

Casa Batlló, 1904-06.

Within this general perspective one should highlight the splendour of the houses designed by Domènech and Puig. There is an undeniable rivalry between their works, and both wanted to exhibit an individual originality and specific richness that came from both the architect and the client. Nevertheless, this was a rivalry that was in some way or other indirect, because their main aim, or higher aim, was to confront and correct this provincialism and lack of monumentality that over the years, according to them, had made Eixample an anonymous place without qualities.

Is this also true of Gaudí, the last one to arrive on the "apple of discord"? To begin with, it must be remembered that he was not involved in a new construction but reforming an already existing one with regular balconies supported on cornices and crowned with balustrades. The confrontation with the neo-classical rhythm of the Eixample facades was not therefore, in this particular case, just a deliberation but a problem of contact, and that is how Gaudí interpreted it: as a real effort, a physical task aimed at materially cancelling out the previous building. It could not be transformed by means of a simple superimposition, by clothing it in a new skin or a mask. This is because Gaudí did not see it as a composition but as a material mass which had to be vehemently fought against. Without knocking it down – this is the key question – Gaudí worked on it intensely in order to leave no trace whatsoever of the old house. Perhaps the image of the building workers hanging from the scaffolding, chipping away at the brick wall to reduce it and turn it into the undulating wall that Gaudí wanted to convert the surface into, is the most vivid one that can explain this confrontation: not as a general intellectual question, but as a physical battle breaking out right there, in that place and at that time.

In exactly the same way, in terms of contact, Gaudí understood the relationship his work had with the neighbouring houses, and of course, especially with that of Puig i Cadafalch. As has been pointed out on numerous occasions, Gaudí eliminated the balcony adjacent to the Casa Amatller on the top floor of his building. This allowed for the creation of a small terrace, a little set back from the facade, from which arises, opposite the dividing wall, the cylindrical tower that culminates in the cross.

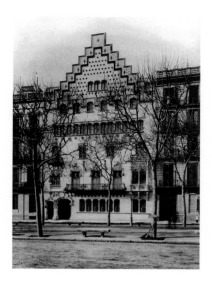

Casa Amatller, 1898-1900.
On the right is the house that would be
reformed by Gaudí from 1904 onwards.

Thus the two houses are at the same level at this point, in the same way that the sharp moulding
which frames the top part of the Casa Amatller is overlapped by that of the Casa Batlló, a soft strip
of stone whose points are closed in tight spirals. Then, at last, in the crowning of the building, Gaudí
repeats the triangular form of the Casa Amatller – unusual in Barcelona, as I have mentioned – but
now the wall has been transformed into an attic and the stiff and flat staggered wall has become the
undulating volume of a rooftop.

The contrast between the symmetrical gable end of the Casa Amatller and the ambiguous asym-
metry, the swaying to and fro of the Casa Batlló, gives the impression of a brusque movement. We
could say that the Casa Batlló, by means of this side movement in which one can still make out the
pre-existent form of the Casa Amatller, has quite literally snuggled up to it. More than find itself
next to the work of Puig, the delicate moulding of Gaudí touches it, like a furtive hand reaching out.
Nevertheless, at the same time, the roof of the Casa Batlló, its hat, is raised above the top part of
its neighbour and, even higher, overseeing the small terrace that joins the two houses, a tower is
raised, crowned by a four-armed cross, an already famous trademark of Gaudí.

Even though, additionally, on the other side of the facade of the Casa Batlló, a cylindrical moulding
appears to stop still or even fall against the cornice and mouldings of the neighbouring building,
forming soft accumulations of stone, it is clear that the unique aspects – the originality – of the Casa
Amatller were Gaudí's real interest. It is to this building, as we can see, that its complex forms in the
crowning refer to, and it is to this building that its movements attempt to approach. However, at the
same time and most importantly, it is this building from which it exhibitionistically separates itself.
The forms refer to it and preserve, in a very diluted way, like distant tracks or rather reflections in
a blurred or deformed mirror, some of its most outstanding forms so that the contrast, the separa-
tion that finally takes place between the two buildings stands out even more. In other words, the
originality of the Casa Batlló is defined, initially at least, but unquestionably, at the expense of its
neighbour, the Casa Amatller, as emulation – albeit exasperated emulation – or expressed literally,

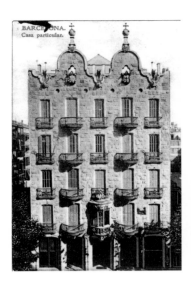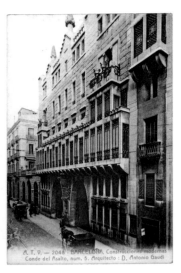

Casa Calvet, 1898-1900.

Palau Güell, 1886-1888.
Postcards, Barcelona, c. 1910.

its extravagance. Buried deep in the softened forms of the Casa Batlló lie not only the neo-classical building that Gaudí was entrusted to reform, but also the Casa Amatller, even though it still remains beside it.

In Gaudí's case, the order between the direct and indirect rivalry, of which we spoke about before in reference to the works of Domènech and Puig, is inverted. The pressing physical contact that he imposed converts that which is closest into the essential. Gaudí's rivals, those with which he consciously competed on this "apple of discord", could be no others than his peers: the modern architects. The way in which he, the late arrival as I have mentioned, dealt with the Casa Amatller, the way in which he devoured and absorbed it, in how he sunk it below the disproportionate, excessive – and soft – forms of his house, could not be more eloquent. As the text on the postcard stated, people asked each other while the buildings were being constructed, "*Which do you like best?*" The market, competition, is the new Eris who no longer needs anyone to ask her to leave this golden apple *for the most beautiful* here or there, over and over again, and Paris is now the public that pass by the street. The "apple of discord" or the place where, at the turn of the century, the rivalry between Barcelona's modern architects was demonstrated, where for the first time the new rules of a renewed profession were up for inspection, is definitely not so-named because first Puig and then Domènech built two exuberant houses with just five years and fifty metres separating them. It gets this name because Gaudí, by building the Casa Batlló, played his *discord* card against both of them to be precise. The "apple of discord" exists because Gaudí built the Casa Batlló.

Gaudí played the role of modern architect, *modernist*, to perfection. On the one hand, *above*, imposing his taste full of excesses in aspects directly concerning life – the private lives of his clients, above all, but also the private life of his city – and reaching the limits by behaving in the way of the bohemian artist, the grand end-of-century bourgeois. Furthermore, on the other hand, *below*, the *opinion* of his work held by an anonymous public, a public that corresponded to a society already based on consumption and the show, making him one of the most popular characters in it. At one

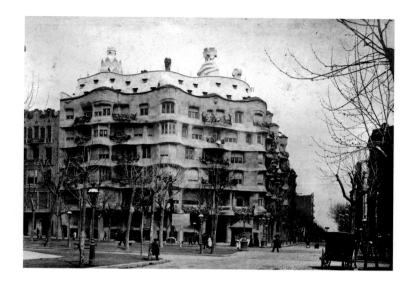

Casa Milà, 1906-1910.
Photographic postcard published
B. y P., Barcelona, 1911.

extreme, the apex of the luxury goods market represented by these extraordinary houses is a very small area, inhabited by very few potential clients: at the other extreme, fame, this modern popularity built from the opinion that arose from the illustrated press, of the caricatures or postcards – hundreds of different postcards of Gaudí's work were published during his life – was incredibly widespread. The two points of this arch pulled by Madam Fashion were occupied by Gaudí due to his prodigious genius and to the expense of his rivals: the Casa Batlló was, without doubt, his triumphal moment.

Nevertheless, and by no means of a fluke, Gaudí, as we know, had already been the first winner of the Council-run competition with the Casa Calvet and when the Güell Palace had been built, the press had praised its extraordinary originality, pointing out that the virtues of both the architect and the client or, to be precise, the sponsor, were reflected in the resulting work. In 1894, for example, Josep Puiggarí wrote, referring to Gaudí and Güell, that, "an artist, a man truly befitting this great name, should possess something essentially *sui generis*, thanks to which he is who he is and is no other". Some years before, in 1890, Frederic Rahola had emphasised that the main reason for the palace's success had been the way in which Eusebi Güell had, "let the artist move around with total freedom, trusting completely in his talent, without worrying about excommunication from the hoi polloi".

Gaudí is the artist, "a real eccentric", wrote Rahola. It is no surprise that years later Francesc Pujols placed him in first position among the architects of Barcelona, not that there were many to choose from: three to be exact. Neither should Gaudí's work be seen as a continuous self-challenge, always in *discord* with himself: inner rivalry but, at the same time, without paradox, being totally extroverted. In October 1909 Apa published in *Papitu* a caricature entitled "Cases fortes"[Strong houses] that showed two men – one of them is Pere Falqués, the architect of the lampposts in Passeig de Gràcia – talking in front of the facade of the Casa Milà under construction. "*Quina casa li agrada més, senyor Falqués, aquesta den Milà, la casa den Batlló, la casa Güell, la casa den Calvet...*" [Which

house do you like best, Mr. Falqués, this one of Milà, the Casa Batlló, the Casa Güell, the Casa Calvet...?]. Falqués's reply, *"la casa Ballarín"* [the Casa Ballarín, dancer] is irrelevant today. What is important is this impressive list of works and the public's question: which one do you like most? Like the paintings in a modern exhibition, *l'art dans la rue*: it is *eccentricity* itself that must be continually surpassed.

Without doubt, the Casa Milà ended up as the culmination of this race. Built on a corner, on an extraordinarily large site compared to what was the custom for the Eixample district, and surrounded by polemical discussions and lawsuits, it was more caricaturised, more photographed and more visited by the tourists of the period than the Casa Batlló. It was here, however, as we have seen, where Gaudí's *popularity*, this particular form of success in modern society, became definitively established. It was more open and immediate than the Güell Palace. It was built in the centre of the city, unlike the far off Sagrada Familia and the even farther away Park Güell, both unfinished at that time. It was much more extravagant and fantastic than the Casa Calvet and, in brief, in the strict sense of the word, more commercial than all his previous works. The Casa Batlló was also, in all probability, the first place that the public – this new judge – was truly aware of the correspondence that existed between Gaudí's strategy as an artist and the excessiveness of his forms, in which originality or imagination are presented as figures of super-consumption.

At the Universal Exhibition of Paris in 1900, when *modern style* architecture, turned into the setting for the biggest concentration of multitudes and goods ever seen, triumphed and, at the same time, was panned by the press and ridiculed by the satirists, the old metaphor of the patisserie – a comparison par excellence of this super-consumption we are talking about – became more fashionable than ever. In April 1900, for example, in *Le Figaro*, Caran d'Ache published a caricature, "Le cordon bleu", in which he shows us the inside of a kitchen with an enormous cake on the hob, made up of a series of strangely-shaped arches, domes and towers from the buildings in the Exhibition. Many years later, in 1933, when writing the draft for his famous article "De la beauté térrifiante et comestible de

Caran d'Ache, "Le Cordon Bleu", caricature published in *Le Figaro*, Paris, 9th of April 1900.

Apa, "Strong houses", caricature published in *Papitu*, Barcelona, 6th of October 1909.

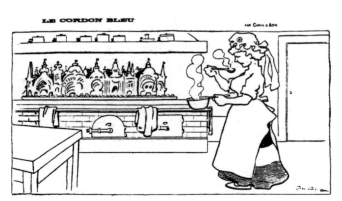

l'architecture Modern Style", Salvador Dalí referred to *modernism* in general and the work of Gaudí in particular with the expression, "*the Barcelona patisserie*". He was doing no more than confirming the relevance of this metaphor in particular relation to this architecture and, therefore, the persistence of its extraordinary success.

I greatly suspect that, just like other professions linked to the consumption of bourgeois luxuries – like art or architecture – the patisserie must have experienced an age of splendour at the turn of the century. With materials as fluid and malleable as sugar, cream or chocolate, and with such bright toppings, so similar to precious stones, such as glacé cherries, the bakers were able to create, just like today, great masses which, whether scaled pyramids or enchanted castles, either in the shop window or on the table, represented a temptation for the eyes and then all the senses. Moreover, in its ephemeral sweetness, it became the definitive culmination of the idea of consumption in its most radical version, that of cannibal. It is no coincidence that a fevered desire makes hungry children find neither juicy steaks nor abundant salads in the wood but a house made up entirely of chocolate and sweets. This was also the case for the rapturous shop windows of bourgeois desire at the Paris Exhibition or in Passeig de Gràcia. Seeing the way in which the *1900* architects had deformed the materials, making them lose all their tectonic qualities, their contemporaries used the metaphor of the patisserie for these buildings made of cake. This was true even by 1929 when Francis Carco wrote about La Pedrera and before which, in 1910, in a caricature by Junceda, a small boy exclaimed, "*Papà, papà, jo vuy una mona grossa com aquesta!*" [Daddy, daddy, I want an Easter egg as big as that one]. This is definitely not referring to a soft, sweet or kind image like that of the cakes. On the contrary, it is contemptuous and cruel, and derives from the intuition that the public, anonymous and wishful, had of the way in which architecture had become just as any other product on display in the marketplace. In fact, in this comparison of architecture with the patisserie, the perception of a real obscenity is hidden: that which implies the need for architecture to exhibit its own independence and traditional virtues before the eyes of the world in order to occupy the privileged spot it deserved

Junceda, caricature published in
Cu-Cut!, Barcelona, 23rd of March 1910.

Cornet, caricature published in
Cu-Cut!, Barcelona, 1st of February 1912.

in the new shop-windows of bourgeois representation. Here the *firmitas* and the *utilitas* were no longer necessary qualities and the *venustas* had become reduced to the subjectivity of an eccentric taste on principle.

No other architect took this condition that the market demanded from all the products that circulated in it to the extreme that Gaudí did: to be convincing representations that everything is possible. Once again a caricature, this time by Cornet, published in *Cu-Cut!* in 1912, shows us the Casa Batlló as a paradigm of the situations we are talking about. Between the trunks of two cut trees, Gaudí's house, perfectly recognisable despite being inverted, is raised converted into a quivering mass of crème caramel or jelly that overflows on its sides, covering the neighbouring houses. The lintels are made of cream and the cornices, sugar friezes; the tower and chimneys, ice cream cones; the roof, flakes of chocolate. A passer-by with a stick exclaims before it, "*Vaja, sembla que això de tallar els arbres ho facin expressament per a que certs arquitectes ensenyin les vergonyes*" [Well, well, it seems that this tree-cutting lark has been done specifically for some architects to show off their shame]. Gaudí himself was undoubtedly referred to in a joke by Opisso, also published in *Cu-Cut!* some years before, in 1909, in which a couple of elegant characters from Passeig de Gràcia comment: "Woman: *Quina llàstima que no hagin esporgat també les arbres del altre cantó! aixís se veurien les cases.* Man: *Oh, si precisament lo que convé és això: que no's vegin*". [Woman: What a pity they haven't pruned the trees on the other side as well. Then you could see the houses. Man: Oh, this is just how it should be: this way you can't see].

Gaudí, as Josep Carner described in a rhyme to which we will refer to later, "*cada hora —no s'hi val— / fa una cosa genial / i no deixa viure en pau / l'home savi ni el babau*" [every moment, he has no right / he does something that's very bright / and does not leave in peace and quiet / the wise man or the man of slight]. He was, in fact, the perfectly modern architect: the inextricably eccentric and popular figure that walked the tightrope in the full arch of the market. His architecture, above all from the Casa Batlló onwards, was displayed in its shop windows without any possibility of stepping back-

Passeig de Gràcia facing the "apple of discord", photographic postcard published by Busquets, Barcelona, 1908.

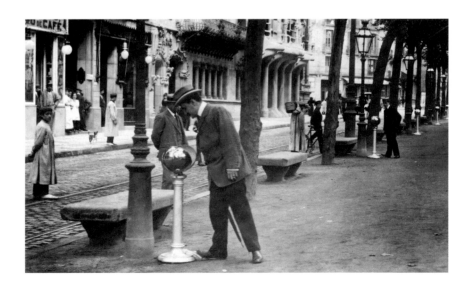

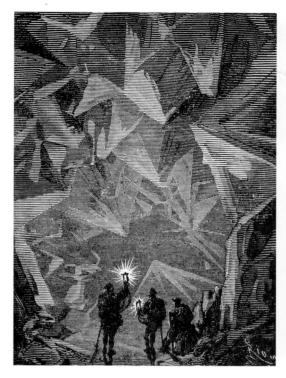 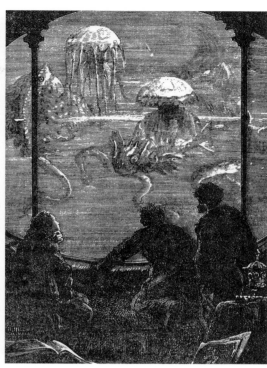

Riou, illustration for the first edition of *Journey to the centre of the earth* by J. Verne, published by Hetzel, Paris, 1864.

De Neuville, illustration for first edition of *Twenty thousand leagues under the sea* by J. Verne, published by Hetzel, Paris, 1869.

wards, as agreeable to look at as it was dangerous. I know of a strange photograph from 1908. Along Passeig de Gràcia, opposite the "apple of discord", some apparatus have been placed, made up of a pedestal crowned by a very shiny ball. At the time the photo was taken, people from all walks of life are standing curiously before it, watching an elegantly-dressed man – the photograph, after all, was sent as a postcard to Enrique Morell, a famous Barcelona tailor – who is operating a pedal placed at the base of the contraption. On doing so, the ball opens and the man peers inside. At the bottom we see the lower floors of the Casa Amatller and the Casa Batlló. I do not know what is happening, but the architecture is undoubtedly reflected in this gleaming sphere. Could we ask for better snaps or more dazzling metaphors of the conditions of their show? Architecture was seen as the great curiosity that recreated the deformed mirrors of a city converted into a spectacle of merchandise.

Nevertheless, is it not the universal equivalence that merchandise imposes on society to which, in a vicious circle as perfect as it is perverse, Gaudí's evolutionist, individualist and brilliant work – *sui generis*, as his contemporaries said – aimed to oppose? Within vicious circles turns, in the bourgeois world, the explicitly redeeming performance of the artist. Entering the private corners of the Casa Batlló is to place oneself in the most spectacular of all since what Gaudí suggested to us by abandoning the open and indifferent space in the street is a journey to the deepest innermost parts, towards the very beginnings.

We enter into a lobby without corners or edges, a cave illuminated by an ivory-coloured light that seems to come out of the softly curved ceiling and walls. The pale grey skirting, made from

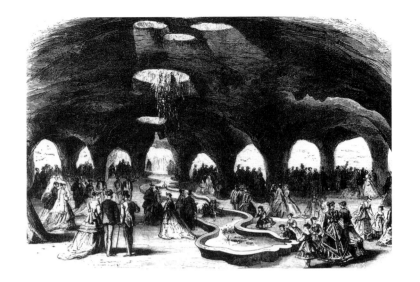

Cave and aquarium at the Universal Exhibition of Paris in 1867, published in *L'Illustration*, Paris, 19th of October 1867.

soft-pointed ceramic pieces, almost becoming the mark of its own, distant model, as if it had been polished by years of erosion, leads us towards the right and to the base of the staircase and the beginning of the courtyard. The banister repeats, between each upright, the transparent outline of one of those polyps, for example *tubulariae*, that the illustrations from the books by Ernst Haeckel had made popular amongst the end of the century artists. We see them shrinking and expanding, rising against the strong current that forms the wooden wave of the handrail, curved on the hard iron pillar, with clearly defined outlines, on whose coppery corbel the rivets and wrought iron strips seem to have become coral reefs. If we look above us we can see how the ceramic work from the courtyard gradually changes from the pale blue of the lowest floors to the dark blue of the highest ones. Between these smooth ceramics have been distributed, here and there, the pieces we saw in the lobby, whose blunt points occasionally sparkle like drops in which the light fractures. From the heavens to the sea, we quite literally sink upwards, to the bottom of the sea.

To the left, a bulbous ivory door leads into the Batlló family's private lobby. Once again we are in the continuously enveloping smooth-walled cave. The stairway is a succession of giant vertebrae, the great spinal column of a monster, a dragon or a whale which, stranded here, occupies all the space. The banister revolves around a golden crosspiece wrapped in metallic strips and topped by a glass ball and a crown: perhaps a lost sceptre, but also the tentacles of a hidden animal or its own splash. Climbing the staircase, these images are strengthened in the upper lobby. Bathed in light that falls from the shapeless skylights, the wood of the banister meanders like the course of a deep and dark inner stream.

Seabeds and caves: were these not some of the most successful and popular attractions at the Universal Exhibitions? Against the *plein-air* of the pavilions, scattered like unlimited variations of style, of the history of continents, countries and races, through the endless extensions of the exhibition and against the panoramic view proposed by the captive balloons, the viewpoints and the towers, which culminate in the total elimination of obstacles, in the birds-eye view way beyond any

Casa Batlló, Upper lobby, c. 1927.

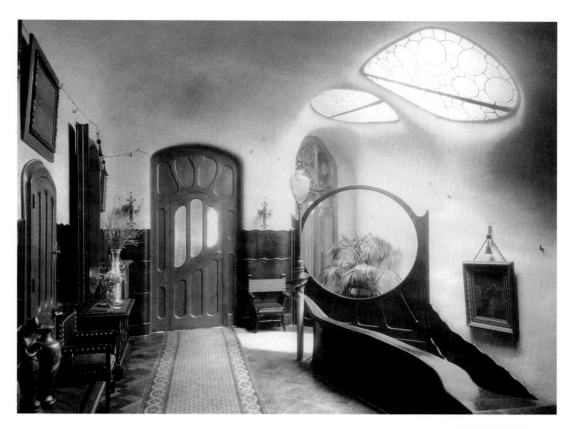

Main lounge, c. 1927.

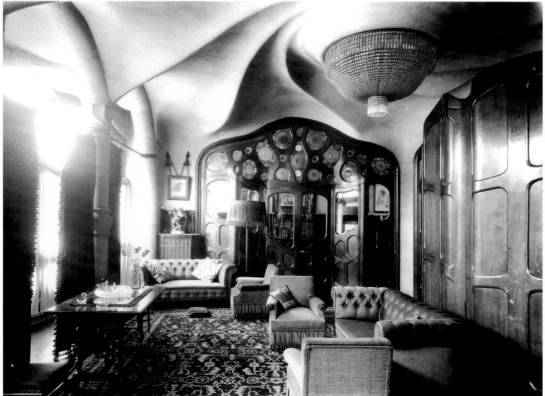

Dining room, c. 1927.

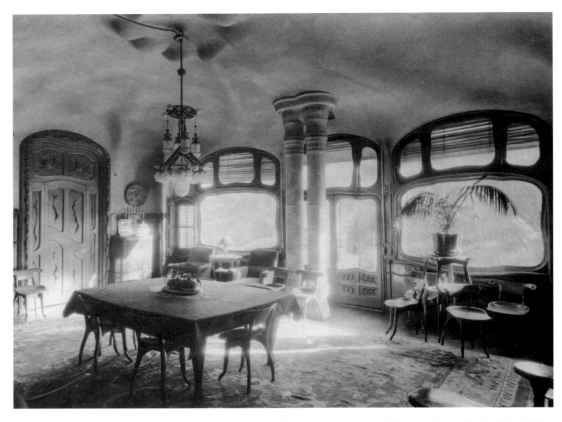

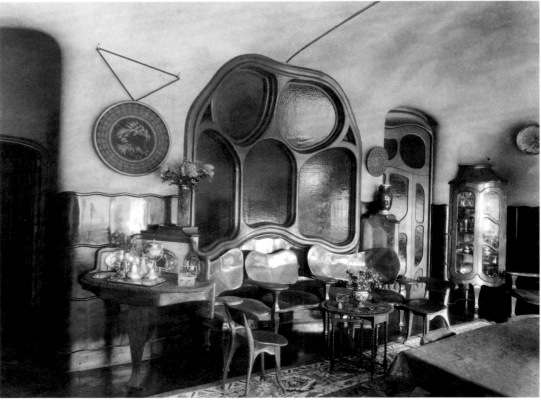

horizon of the Eiffel Tower, these underwater grottoes allowed the visitors to the exhibitions, tired of transparent light and open air, to return to the interior, to a closed-off place where they could dream about, in the time of Darwin, not only the restoration of whatever origins – that of man, the species, the earth – but also of the recovery of shadows, of lights tinged with colour, of their bodies bathed in these stagnating atmospheres of the aquarium. In the popular epic poems of progress, in the novels of Jules Verne, for example, the movement of the conquering man, the modern hero, always has two directions. One of them is cosmic, towards an open and limitless distance of new continents or outer space. The other is more intimate, towards the cave in which life is recovered and protected, towards the maternal womb of the earth, the first home from where men can look down on the unconnected outside world that they themselves have created. Nature, reason and history recover their virtues in this real home that the cave provides, returning to the origins of life in the amniotic liquid at the bottom of the sea.

The Casa Batlló wishes to be man's underwater cave which circulates amongst the multitude of the city and merchandise: the place where one can find one's inner self or at least, the fantasies of what we think is the *ego*. Jellyfish, corals, underwater streams, antediluvian fossils: this was, obviously, and how could it be otherwise, in *1900*, a neurotic reunion that culminates in the tiny corner, soft and warm, a cave within a cave, of the chimney. This is a spot that takes on many forms. In the softened centre of the dining room, for example, the level ceiling is condensed into the shape of immense drops, whereas the almost liquid sinister mouldings on the pair of columns – inspired as on many occasions by the Patio de los Leones (Lion's Courtyard) in the Alhambra – are once again subject to very slow erosion processes. On the other side, in the main salon, which opens out to Passeig de Gràcia through the gallery, the ceiling has been converted into a vortex, the eye of a whirlwind. Through the basically green and blue tones of the coloured glass windowpanes – marine blue, sky blue and indigo – and undulating frames, the light penetrates these rooms on the main floor, bathing their aquatic surfaces with aquarium light.

Looking over old photographs of the rooms in the Casa Batlló, it is impossible not to notice they have with some of the descriptions of the *fin de siècle* house par excellence, the *demeure* understood as a place of inalienable property, the mental space of the ego and of its real possessions, nervous, radical interior: from Huysmans to the Goncourt, from Montesquiou to the Marquise of Castiglione, from Pierre Loti to D'Annunzio... Baudelaire, in "The Double Room", spoke of a room "*qui ressemble une rêverie, une chambre veritablement spirituelle, où l'atmosphère stagnante est légèrement teintée de rose et de bleu*" [that resembled a dream, a truly spiritual room, where the stagnant atmosphere was lightly tinged with pink and blue]. In the Casa Batlló, the popular images of the grottoes from the universal exhibitions, visited by millions of people at the festival of merchandise, are to be found with the atmosphere of the spiritual house, and whose aim is exactly that of opposing this grand festival without quality. Nevertheless, as we have already mentioned, one condition of the rhythm of fashion is that it must unite the most distinguished and select with the popular. What occurs in the Casa Batlló is the same as occurs in the *maison d'artiste*, to the shelter at the end of the world of decadence. When Huysmans describes in his novel, *À rebours*, the dining room of the

home of Des Esseintes, in which the windows have been replaced by portholes which do not open to the outside but to interposed aquariums that the light passes through, what else can we think of but the *Nautilus*, Captain Nemo's submarine, the place of retreat of a free man, of a prince who, against the world, has voluntarily buried himself away with all his treasures? These treasures – paintings, jewels, books, extraordinary items of furniture – are suddenly lit up at exactly the same instant when we realise we are in a submarine, with the green and oscillating light of the seabed. This light penetrates through the large oblong hatchways, authentic windows separated by thin columns, like those illustrated by De Neuville in the famous plates of the original edition.

The lobbies and rooms of the Casa Batlló – cave, seabed, aquarium – thus belong to this end-of-century family: the radical – or neurotic or hysterical – interior of the *maison d'artiste*, to this great imitation of what is private. Nevertheless, unlike in the great decadent models, the artist in the Casa Batlló has not been its owner, choosing all the objects one by one like authentic projections of his *wild* sensitivity. It has not been created by the person who dwells in it (that is if they really do dwell in it) but by its architect.

In these old photographs, what is it that co-exists alongside the furniture designed by Gaudí? Vulgar rugs, common lamps, run-of-the-mill chairs, dark paintings hung all over the place, all kinds of *bibelots* and even ancient chairs with Spanish style arms. Everything is mixed up in bric-a-brac so typical of a bourgeois flat – you could say that it was in fact in bad taste –. The legends that tell of the constant battles between Gaudí and Batlló throughout the construction are clear to see in the view of these rooms, which give the impression of housing two completely different interpretations of living. That of the artist, who has designed the caves, the seabed and the wooden furniture and that of the owner who has placed his possessions, as ever, wherever they will go, in these places.

I previously referred to the tale by Adolf Loos, one of the fiercest enemies of the architect-artist, entitled "Von einem armen, reichen Mann" [About a poor rich man]. Its leading character has built and decorated a house, down to the finest detail, for one of the most illustrious professors of the Viennese Secession. From this moment onwards his house is complete in terms of both *harmony* and *fullness*, but then so is his life. He can now no longer receive gifts or buy new things and there

Casa Batlló, Corridor, c. 1927.

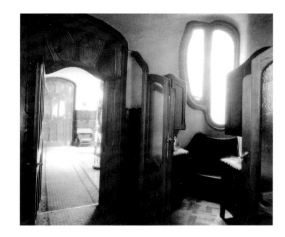

is no longer anything he can fall in love with. He is finished: he can have no more desires. At the end of the story, Loos shows him wandering around like a ghost in front of the shop windows of the city, looking at the goods on display that can now never be his.

The fulfilment of the super-consumerist dream – the *maison d'artiste* – petrified the market. Baudelaire spoke of a room with a *stagnante* atmosphere. Was this impossible standstill in time, this isolation, not what the turn-of-century architect attempted to produce? The cave, the aquarium, the *windowless house* that, separated from the anonymous flurry of the city, hanging from the laws of market equivalence, exasperated the virtues of its exceptionality. The conflict between this house and daily life is clear: in this house there could be no *inhabitants*. Nevertheless, it is in this precise conflict, as we have seen, where the *modernist* architect attained his eccentric prestige and popularity: his modern advantages.

Gaudí himself is the star of a home-made version, quite literally in this case, of the "poor rich man" tale in the earlier mentioned rhyme by Josep Carner. Here we see a certain Mrs. Comes, with her recently decorated house, receiving a surprise gift. It is an Erard grand piano that does not fit in the room, although it is not clear whether this is only due to its size. A "*subtil*" [subtle] neighbour exclaims, to this effect, on seeing it, "*¡El piano no és d'estil!*" [The piano has no style!]. The grand piano, therefore, neither fits the room nor harmonises with the decoration: it is either one thing or the other. Neither does this house admit objects from outside. It is also complete in terms of harmony and space. The rhymes started with the listing of the extraordinary works by Gaudí: the Sagrada Familia, the Park Güell, the Casa Calvet and Casa Batlló, which "*burxa el neci espectador*" [excites the foolish onlooker], and the Casa Milà, in which "*es pot dir que el va aixafar*" [it could be said it squashed]... How eloquent! Such is his prestige that Mrs. Comes calls on Gaudí to solve the problem. Now it is clear that the problem is more one of style than of size. "*Sense fer cap dany a l'art / ¿on posem aquest Erard?*" [Without damaging the world of art / where can we put this piano Erard?]. Gaudí's reply, after having measured the entire room, looked below the rugs and moved all the chairs around is, "*toqui el violí*" [play the violin]. Faced with the genius of the artist the client must change their tastes: like the onlooker, the client is also a fool.

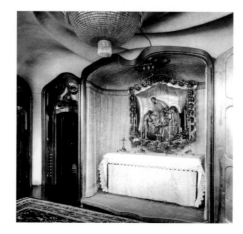

Chapel in the main lounge, c.1927. The Holy Family is by J. Llimona, the frame by Gaudí, the candelabra by J. M. Jujol, the tabernacle by J. Rubió i Bellver and the Christ on the Cross by C. Mani.

The anecdote to which these rhymes refer is the decoration work Gaudí carried out between 1901 and 1904 on the flat of the Marquis of Castelldosrius for his marriage to Isabel Güell, who was a pianist, but at some time or other it had been rumoured that she was connected to the construction of the Casa Batlló. It is certainly not true but it is, nevertheless, significative because, in all honesty, to whom could Gaudí dedicate the construction of this underwater cave, this *womb*, except himself, to his own identification as the original creator, as God himself?

Let us study for a moment one of the smallest objects in the Casa Batlló: the oak chair designed by Gaudí for the dining room (and allow me, dear reader, to describe it using a piece I wrote some time ago). Firstly, the wood from which it is made seems to have lost its compactness, its solidity or in other words, its very wood-like qualities. The seat spills over to the sides and the back and the chair's substance is concentrated on the edges, as if it had been pushed out like dough after having been sat on by someone. From the back project some handles on whose points there is a circular hollow, as if on picking the chair up our thumb did not meet with sufficient resistance and the chair's material has been taken with it, pulling it and leaving it with its rounded thumbprint. Finally, the legs double up and twist around themselves as if, softened, they suffer the burden of the chair's weight. Some forms, therefore, have been imposed on the material, removing its qualities, turning it into an indifferent recipient. It is not the material that speaks through its qualities but the form alone that explains them. In fact, is not this chair the translation into wood of some ceramic moulds?

This said, however, we are only explaining part of the meaning of this small work. In reality, this form is also the consequence of an action, or rather in this case, of the pressure created by the weight of a person on it. The form, then, even in taking away the substance contained in it, is not an explanation in itself, as we believed, but in fact speaks to us of something else. It tells us of a weight, a body, and the pressure of a hand, of some fingers that are still present in the prints they have left behind. In this chair, therefore, made from an unexpectedly softened wood, are marked the weight and fingers and why not, we might ask ourselves, of Gaudí. The result could not be more

A. Gaudí, dining room chair in the Casa Batlló, 1906. (Museu Gaudí, Barcelona).

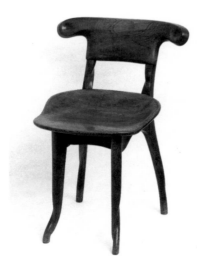

disturbing: the Batlló family had to sit on *his* chair, on his living mould. This is the meaning, although the legends relate that Gaudí used his workers to obtain these forms on the soft clay moulds.

By leaving the stamps of his body, sticking his fingers into a chaotic material, what is Gaudí doing except restoring the act of the creator, who not only gave form to mud but, by blowing over it, brought it to life? Is this not the most traditional – and most religious, most *fin de siècle* – image of the inspired, possessed artist? The material disappears as such, surrendering to the force of the artist, *trans-formed* by him. This is why Gaudí's forms are as immediate as a fingerprint: they come from a gesture that does not admit corrections, pentimenti, because it is, directly and at the same time, the creative gesture and the gesture of the Creator. In the end there is no design to be found in them, just transmission. Such is the origin of a series of forms that go well beyond the representation of the world or its mere imitation. These forms are offered for divinity. All the legends about the inspired artist, the artist as *alter deus*, are based on what is expressed by this handprint or Gaudí's weight on inert material: this is the source of his *enthusiasm*, his furor and these virtues of genius and, obviously, of his particular *naturalism*.

From the very smallest, the doughy chairs, the ceramics like larvae in the lobby, the eroded moul-dings of the columns, through to the biggest, the stairway like fossilised backbones, the rooms like caves, to the vortex of the ceiling in the main room, all is presented as the original mass, the raw material to which the artist inspires the form, or rather the principle of the form to which the amorphous material necessarily tends towards, that which the material desires. The celebration of nature is the celebration of the myths contained within it, the myths of origin and of truth. Caves are the maternal bowels of the earth and the sea is the means by which everything springs to the beginning. Gaudí's world, in reality, is not a house, in this case the Batlló house, but the *perpetuum mobile*, the continuous origin: the place in which God and the artist exchange their powers, and also the place in which creation and the Creator are confused. The interiors of the Casa Batlló are a mental aquarium in which the irrational, the magmatic is celebrated, just at the moment when the artist stops it with a gesture, an instant, to create the form that the formless yearns for.

Here, however, the forms hide more than they reveal. In reality, this exaltation of a primordial, tre-mendously sophisticated nature, by means of a no less sophisticated recreation of itself, constitutes one of the bases of *fin de siècle*, decadent aestheticism, capable only of finding the imitations and not the real virtues of the world. Baudelaire wrote in *Les paradis artificiels* that, "*la vraie réalité n'est que dans les rêves*" [true reality can only be found in dreams], and Huysmans, who made Des Esseintes prefer "*après les fleurs factices singeant les véritables fleurs, des fleurs naturelles imitant des fleurs fausses*" [after artificial flowers ape real flowers, natural flowers imitate false flowers] and he repeated that the test of true genius consisted of being able to "*substituer le rêve de la réalité a la réalité même*"[substitute reality for the dream of reality]. Is this substitution not the same as that which was offered to the masses in the universal exhibitions or, quite simply, in the shining shop windows of the cities' shops?

The artist's aim is to occupy the crown of this great sham. Just how far can he reach in his dream, his confusion between the generating force of nature, of the ideal material and the *representation* of this force that is his creation, his work? In Gaudí's case the answer is very far indeed.

Let us once again look closely at a small piece: the apartment doors. Made in oak, like the previously mentioned chairs and also, like them, softened in appearance, standing out on them are sharp, clearly defined stars which again send us to the farthest away points that the movement of cosmic creation can reach. Yet at the same time, also arising from this mass in an insinuated form are some lengthened shapes with rounded ends, from whose sinister suggestion it is difficult to escape. They are bones: tibias. In the magma that awaits its form, given to it by the creator, we are able to envisage the moment when the greatest and most brilliant concentration of material takes place, but also notice the insinuation of what lies beneath it: the skeleton. Is this the subject of the most public and representative part of the house, the gallery?

In other parts I have already spoken about the process of liquefaction that the stone experiences here: waves, wrinkles, folds, holes on rounded edges and great drops held in suspension. The stone has lost its tectonic qualities and appears incapable of not only forming the construction itself, of standing upright, but also of supporting its own weight. Transformed into lava, it follows the descending course imposed upon it by gravity, flowing down as if, on this occasion, the hands of the architect or his attempts to blow it back into place had been defeated. From this process of softening the stone, of decomposition of the material's compact body, only the hardest parts remain: the thin columns, the tall tibias that gave the popular name to the Casa Batlló, the house of bones, bones almost dry but still preserving some stuck remains of the flesh that once belonged to the body, as if to make visible the process of putrefaction from which they had arisen. I am not at all surprised by the familiar air they have with those of the "modernist cemetery" which Corominas, one of the illustrators more concerned with fashion at *Cu-Cut!* had published, and in 1902 at that! Moreover, the path that has taken us to this vision of *putrefactio* can also be taken the other way. These remains of flesh are perhaps, on the contrary, the budding of a new blossom and the bones, the tibias, interrupt some spaces whose vulvar, genital form is clear to see. Behind them, in the main

Casa Batlló, ground floor
and gallery in two photographs
from 1907 and 1908.

Corominas, "Times to come",
caricature published in *Cu-Cut!*,
Barcelona, 30th of October 1902.

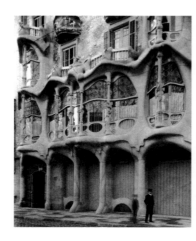
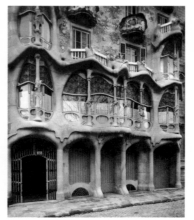

room of the Batlló home is the maternal womb, the generator of life – after all, the uterus, according to the medical profession of the time, was the origin of hysteria –. Here is the turmoil of creation which, from the ceiling, is reflected in all parts, from the small whirlpools of differently carved shapes in the wooden doors through to the many that would have covered the floor if Gaudí had finally used the hexagonal floor tiles designed for this project but which could only be placed later on in the Casa Milà. There are spirals in which marine beings, octopuses or starfish revolve. From the abysmal depths to the heavens, the matter – *mater, matrix* – continuously revolves in creation. It is not unusual here, therefore, that the image of putrefaction, whose traditional symbolism, always expressed in funereal terms, like bones, refers, nevertheless, to both the end of life and its rebirth. Or rather, referring to the ability of matter to regenerate itself.

The Casa Batlló is, on the one hand, an enormous *vanitas* in the most elegant street in Barcelona and as *vanitas*, reminds one, arising unexpectedly from the luxury of the bourgeois home, of the ephemeral nature of things and their destiny, death. On the other hand, supporting the open doors of nature's womb, is the image of germination, of the beginning always repeated in all things. Nature's power, represented through its eternal metamorphosis, *seems* to be the theme running through the Casa Batlló; time devours matter and the matter, regressing continually towards chaos, yields form unceasingly in the turmoil of its *perpetuum mobile*. Gaudí, wrote Francesc Pujols, "*defugint compromisos, arriba fins a la prehistòria*" [evading commitments, reaches prehistoric times]. Or even beyond for that matter: can there be a better justification for the obstinate existence of the artist?

Pere Vivas has pointed out to me a detail in the Casa Batlló that seem as insignificant as it is extraordinary. It is also to be found on the oak doors of the apartments. Unlike the numbers normally used – the floor number, the door number – these are shown with letters but, once again contrary to common usage, they are not the same, *A* and *B* for each landing, but starting from the bottom with A on the first floor until I on the top floor. On each landing, the crowns of the iron handrail form a circle with three points engraved, a trilobe form, except in one in which the circle contains a spiral: the door corresponding to apartment *G*. The *G* has a spiral form and the spiral is an ancient symbol related to the growth of the universe and its evolution: the form of the nebulous, of the

A. Gaudí, hydraulic floor tiles designed for the Casa Batlló but used in the Casa Milà, produced by Escofet & Cía.

Gaudí's workshop in the Temple of the Sagrada Familia, photographed by Ferran and published on the death of the architect in *Gaseta de les Arts*, Barcelona, 1st of July 1926.

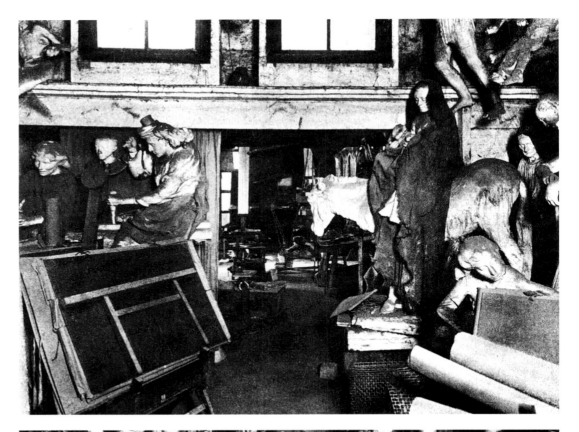

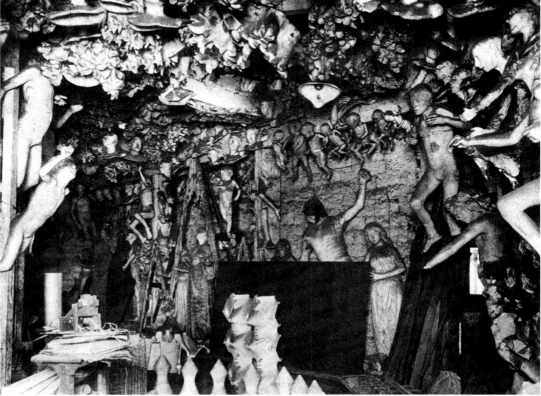

cosmos in movement. This is the first letter of generation and of genesis; and also of Gaudí: in the artist's initial is the whirlpool of everything that has been created.

Gaudí, such a strict believer, confusing Creation and Creator, and confusing Creator and architect, in other words being led astray by pantheistic heterodoxy and becoming arrogant, is taking the typical temptations of the turn-of-century artist to their extreme: the vortex of the whirlpool is the apex of the market.

The artist has the power to stop the form, but in converting its changes into metaphor, it is petrified, making him, as I have mentioned, a new and terrible Midas. The chocolate house will end up being changed into a treasure of hard diamonds which cannot be eaten. Dissolving one's soul into the imitation of nature is not the same as selling it, although, passing certain limits – and the decadentists knew this only too well, always being ever-willing to be hypnotised by the beauty of hell – it is difficult to know whether the inspiration comes from God or the devil.

The architect and the devil is the name of a twee moralising children's story published by Jordi Català (Jaume Bonfill) in the *En Patufet* collection. On the cover, a drawing by Lluís Malloll shows us the devil offering some plans to a young man: the finger pointing upwards shows us the glory he is offering him in exchange, naturally enough, for his soul. The origin of all this is, of course, a competition. The king of this country has decided to build a palace which, it goes without saying once more, must be eccentric and always new, and that "*fugís de les construccions ja conegudes (i) mai no envellís*" [is nothing like any building already standing and never ages]. Obviously, our architect, absorbed by his creative desires, removes himself from the outside world and becomes "*irascible i eixut*" [irascible and surly]. Nothing exists for him except "*alló que constitueix la seva obsesió*" [his great obsession], his work. Nevertheless, once he has sold his soul and won the competition, his popularity is such that it can only be compared with "*en el propi gaudi*" [pleasure itself]. Later, of course, come the regret, the tears of contrition, the forgiveness and the secluded retirement. In other words, true glory.

Casa Batlló, the front door to apartment *G* and the finish of the stairway banister, in the form of a spiral.

Finishes of the other flats in trilobe form.

The doorbells of the flats in the lobby

Ll.Malloll, Cover for *L'arquitecte
i el diable*, by J. Català, published for the
collection in *Patufet*, Barcelona, c. 1920.

A. Gaudí, Temple of the Sagrada Familia
and, in the foreground, the Escuelas, c. 1916.
Negative on glass plate, 14.4 x 11 cm.

It is highly significant that in Barcelona in the early decades of the twentieth century, Faust was represented by an architect, the life of whom, incidentally, coincided perfectly with the myth of Gaudí, who after the Casa Batlló project, increasingly came into conflict with his clients. He was dismissed from the works on the cathedral in Majorca, having been accused of disregarding other people's opinions – of arrogance to be precise –. He was dismissed from the Casa Milà project by a client who refused to accept the imposition of his symbols and became wrapped up in legal proceedings involving astronomical sums of money for the time. He became the most *expensive* artist, totally unaffordable in fact. At a specific moment in time he abandoned the world – after also having been a bit of a dandy in his youth, as his legend persistently recounts – and closed away in his workshop, surrounded by hundreds of plaster casts, of an abundant quantity of material and under the shadow of the Sagrada Familia, the new cathedral, the last great temple, he now worked only for the higher class of client that the quick-tempered architect, the chosen one, deserved: he was the architect of God, as his contemporaries named him in the end.

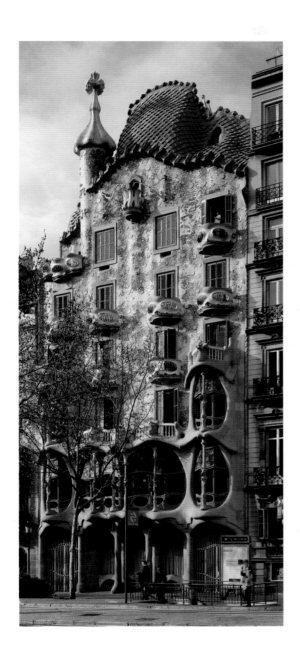
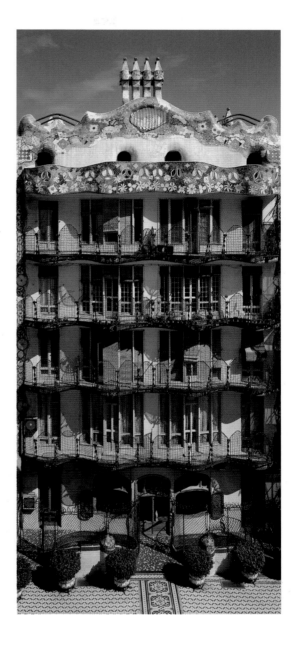

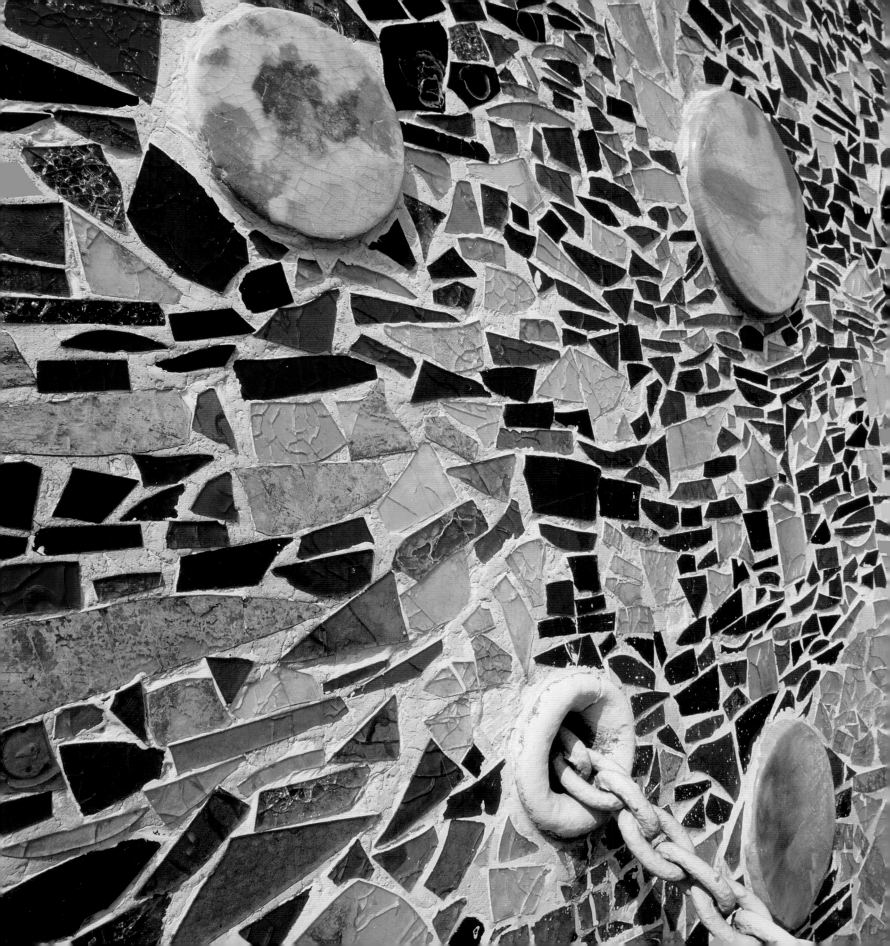

FACADE

On many occasions, the colour of the facade of the Casa Batlló has been compared to the sea and, as it happens, it is not only indigo, bluish and greenish, but also has the luminosity of water which, crossed by the sun's rays, becomes transparent and captures the movement of the shadows on the stones and the bright sand on the seabed. This effect is achieved through the *trencadís* (Gaudí's mosaics) of coloured glass and ceramic discs that cover it, and thanks to the undulating form of the wall also produces the sensation of a giant curtain in movement.

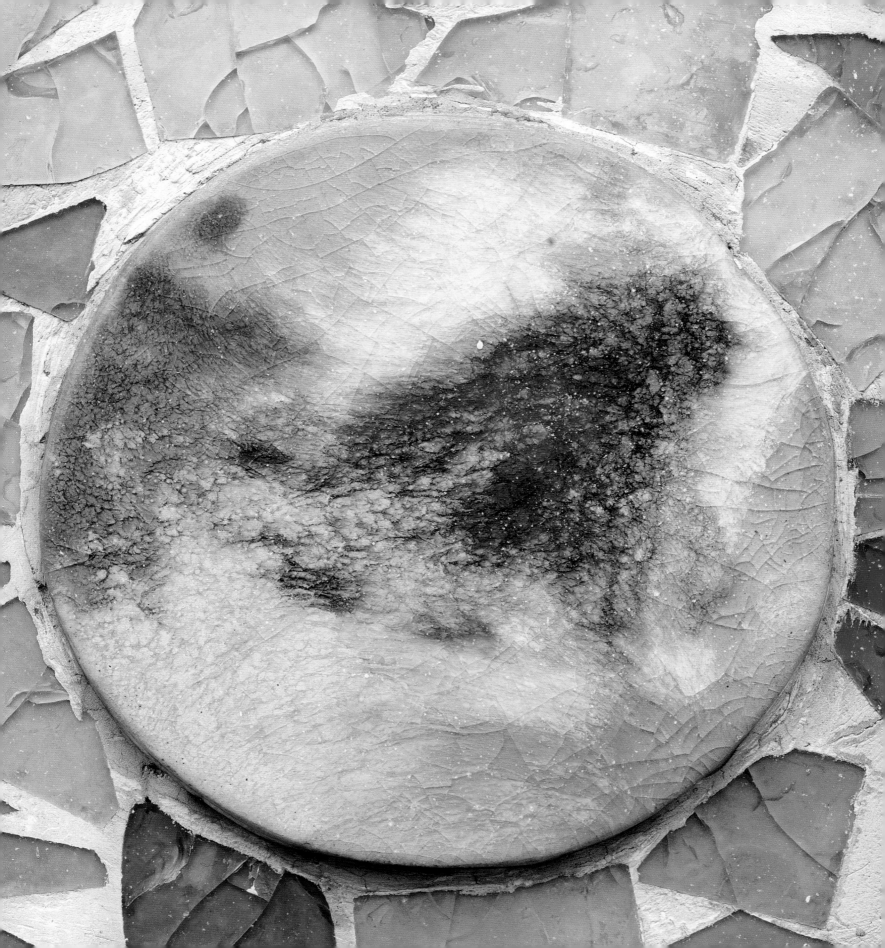

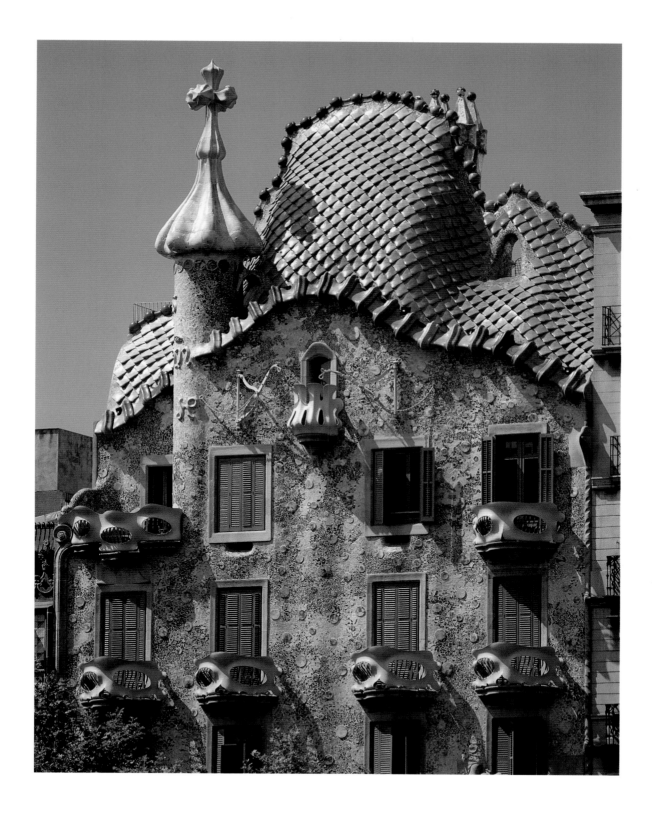

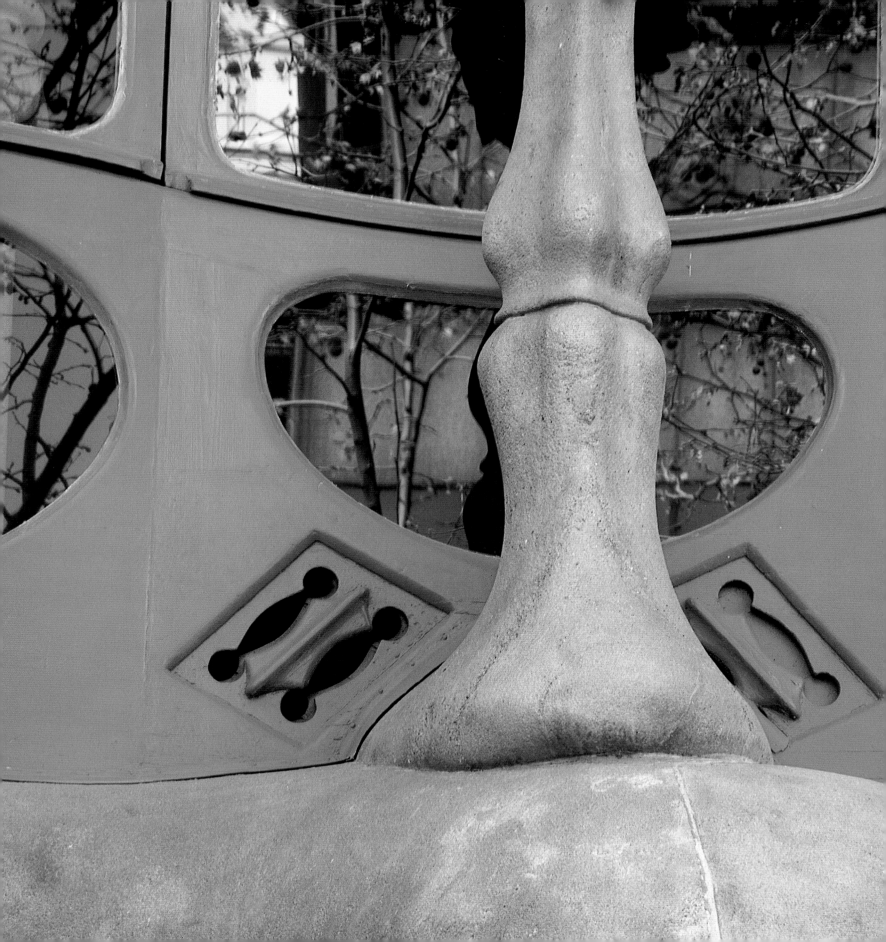

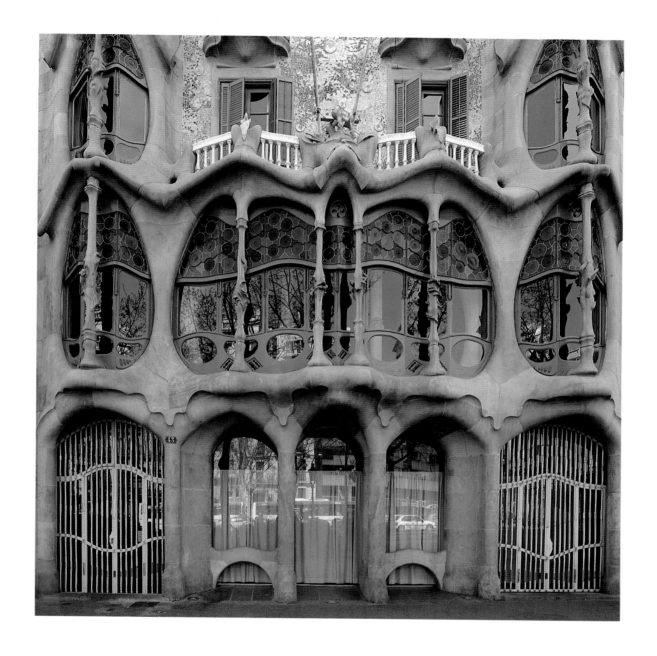

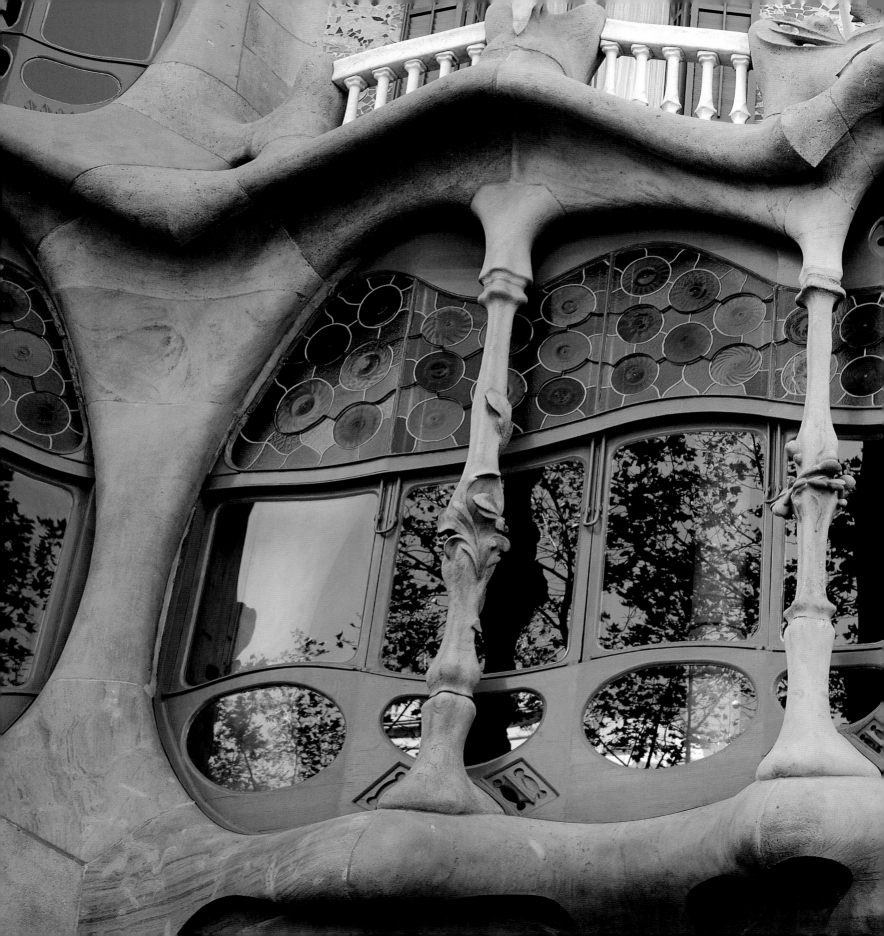

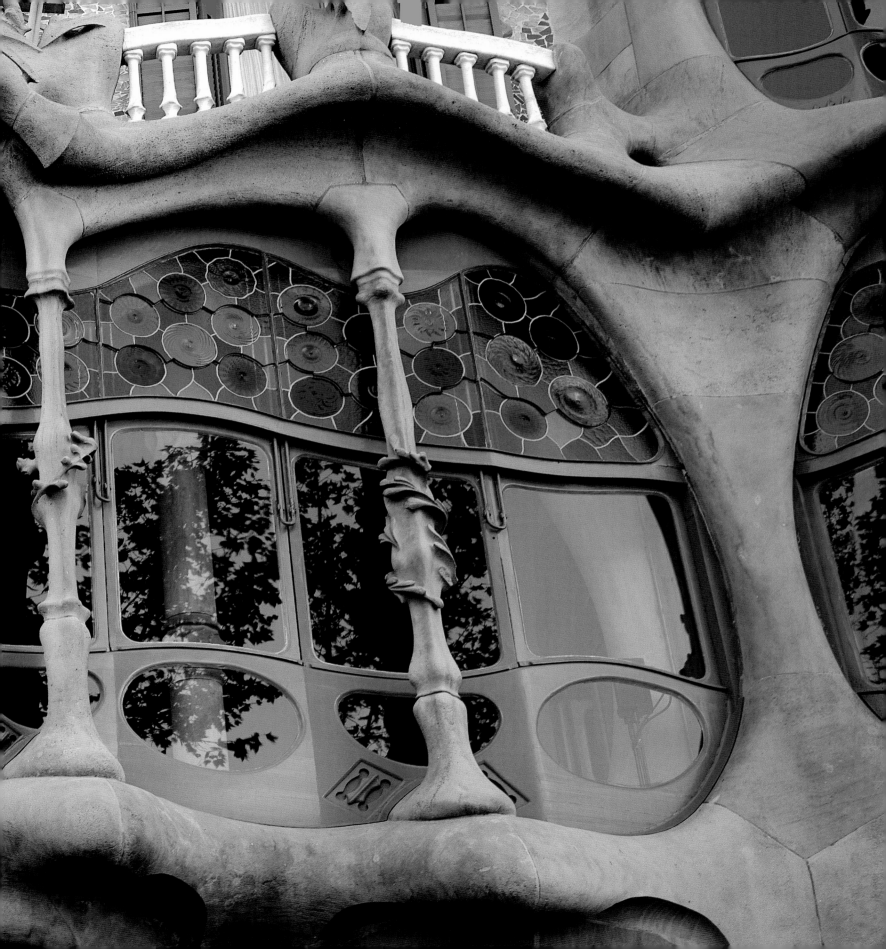

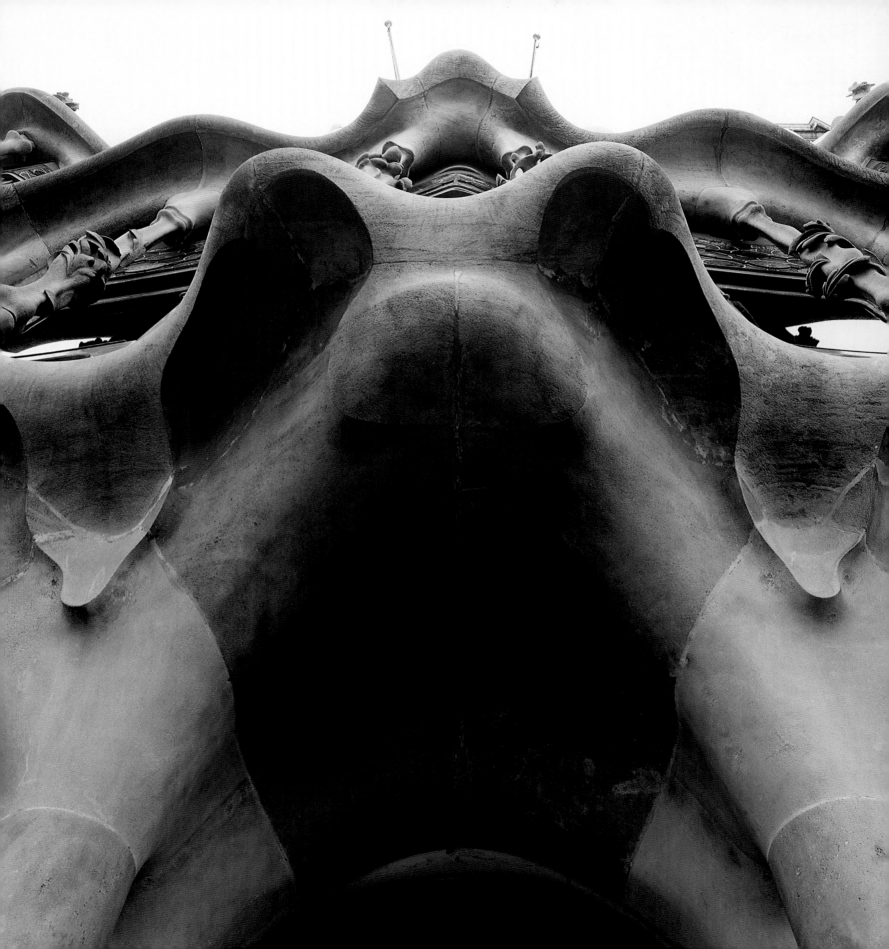

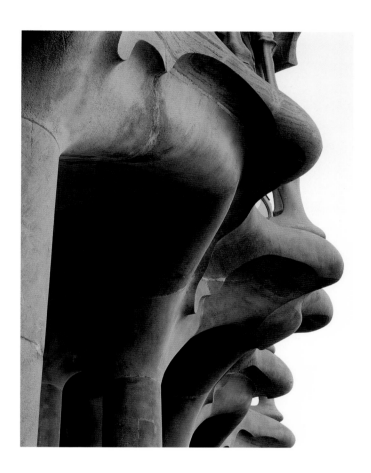
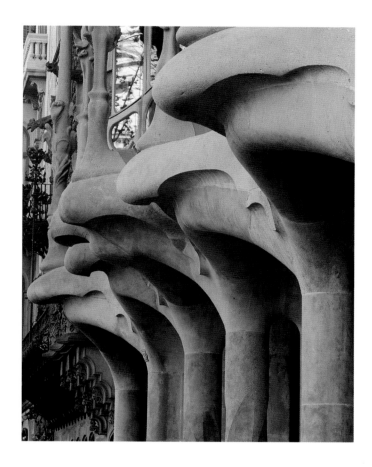

Behind the gallery are the main rooms of the Batlló family's home. The slender columns of sandstone from Montjuïc which seem like tibias have given the house the popular nickname of the *House of bones*, whereas the warped shape of the empty spaces, that remind one of open mouths, turned it into the *House of yawns*.

The balconies, made from Montjuïc stone, represent a worn out shell, while the cast iron rails, painted ivory and gold, seem like masks. Therefore, while the shell is associated with the marine-like aspect of the facade, the mask does so with its curtain-like shape, in such a way as the *trencadís* of colours now converts it into confetti thrown by a gigantic carnival costume.

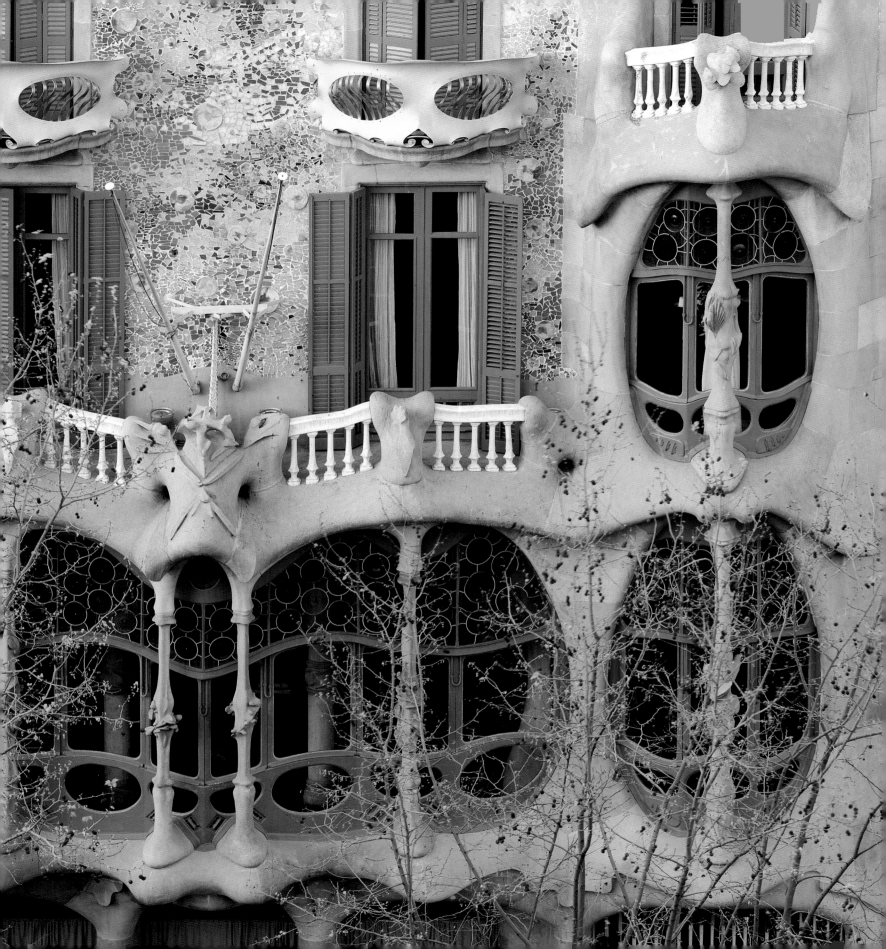

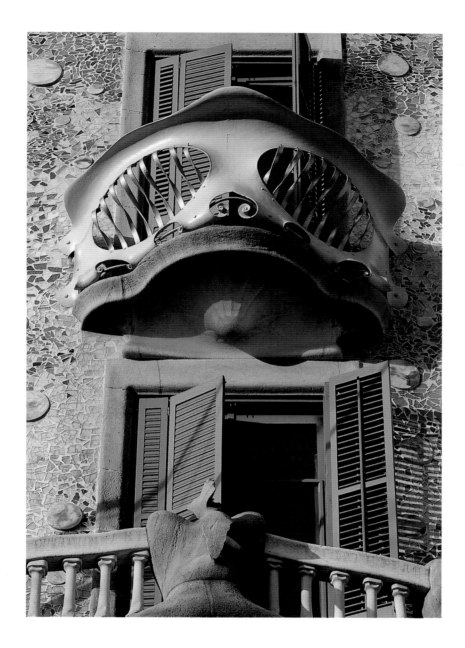

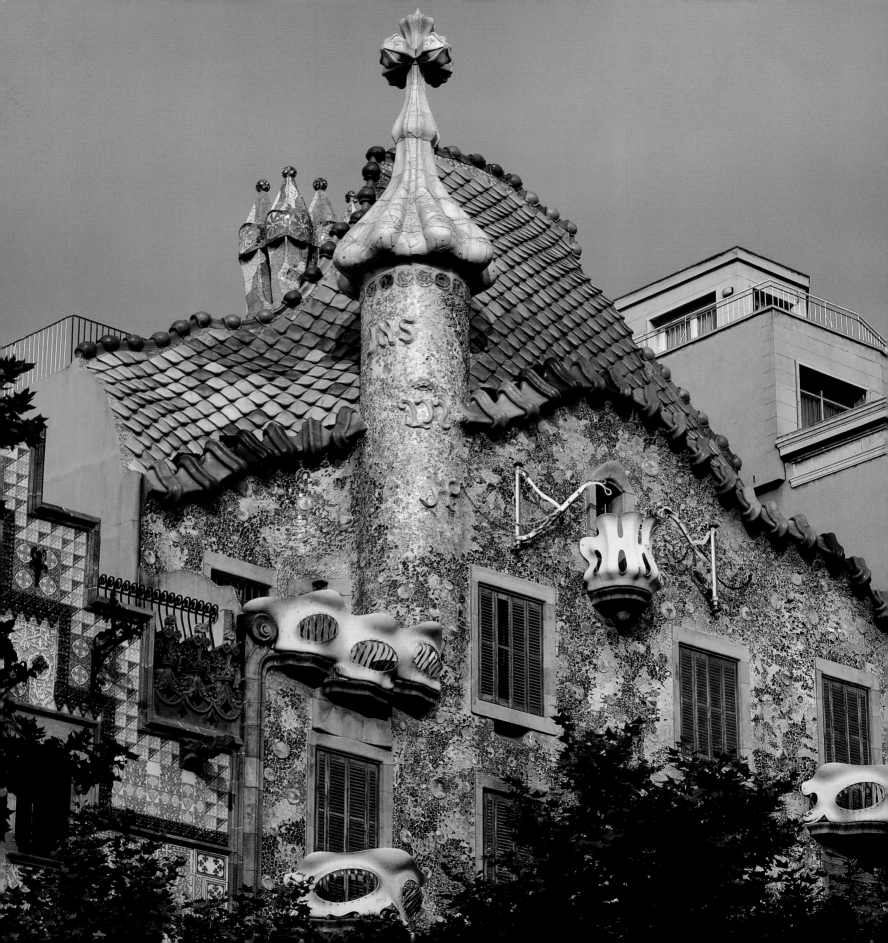

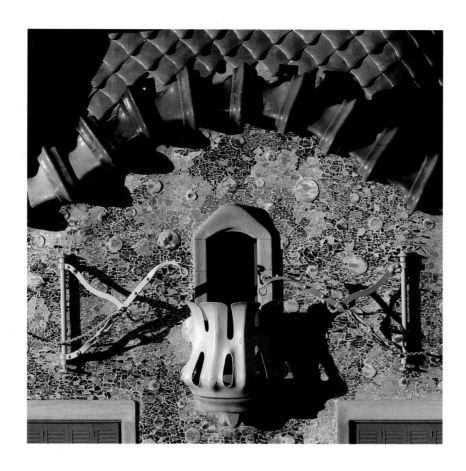

Alongside the Casa Batlló is the Casa Amatller, built by Puig i Cadafalch in 1900, and a little lower down, on the same pavement, is the Casa Lleó Morera, completed by Domènech i Montaner in 1905. The closeness in space and time of these three exceptional pieces of work by *Modernism's* most famous architects meant that this series of houses became known as the apple of discord, a play on words referring to the famous myth concerning Paris and the golden apple, with the word apple, or manzana in Spanish, also meaning a street block.

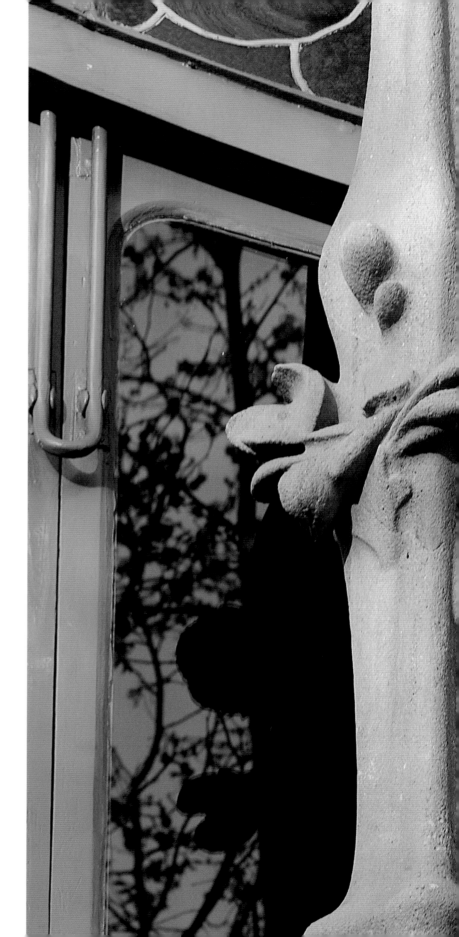

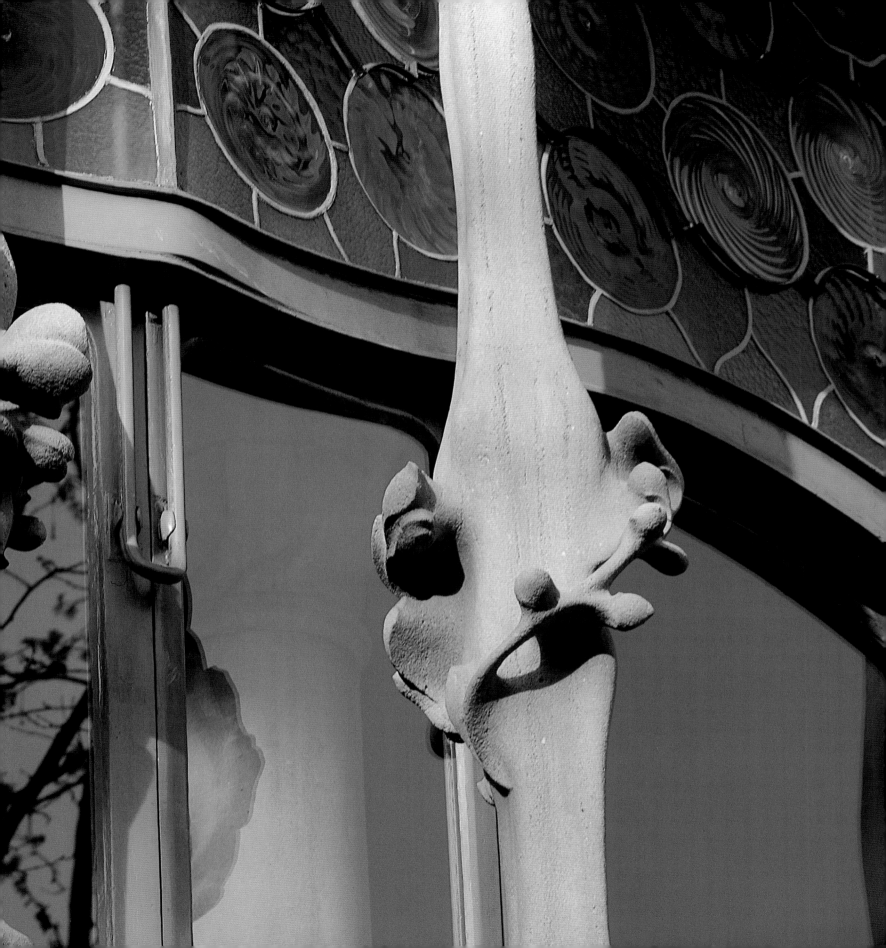

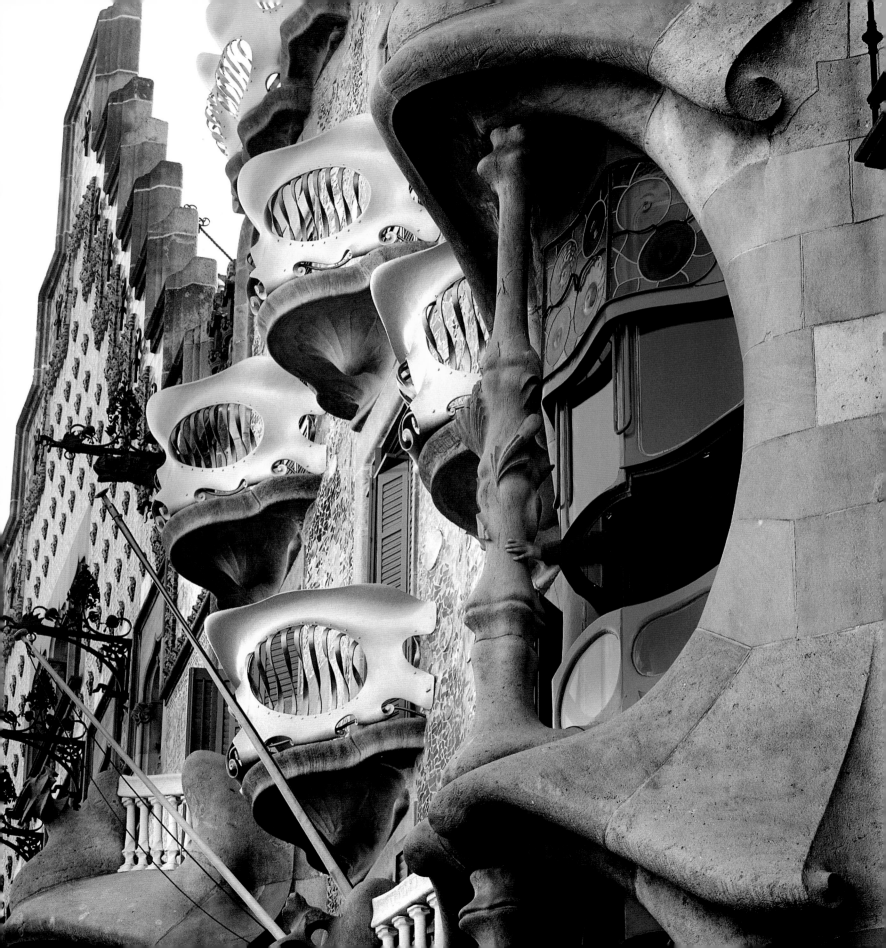

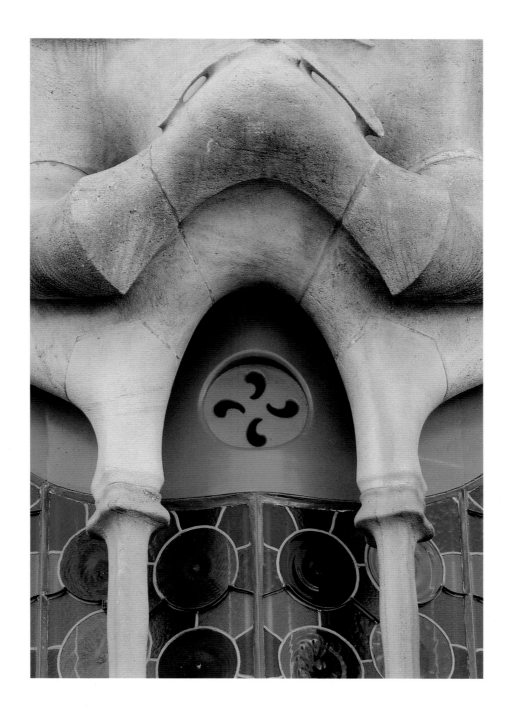

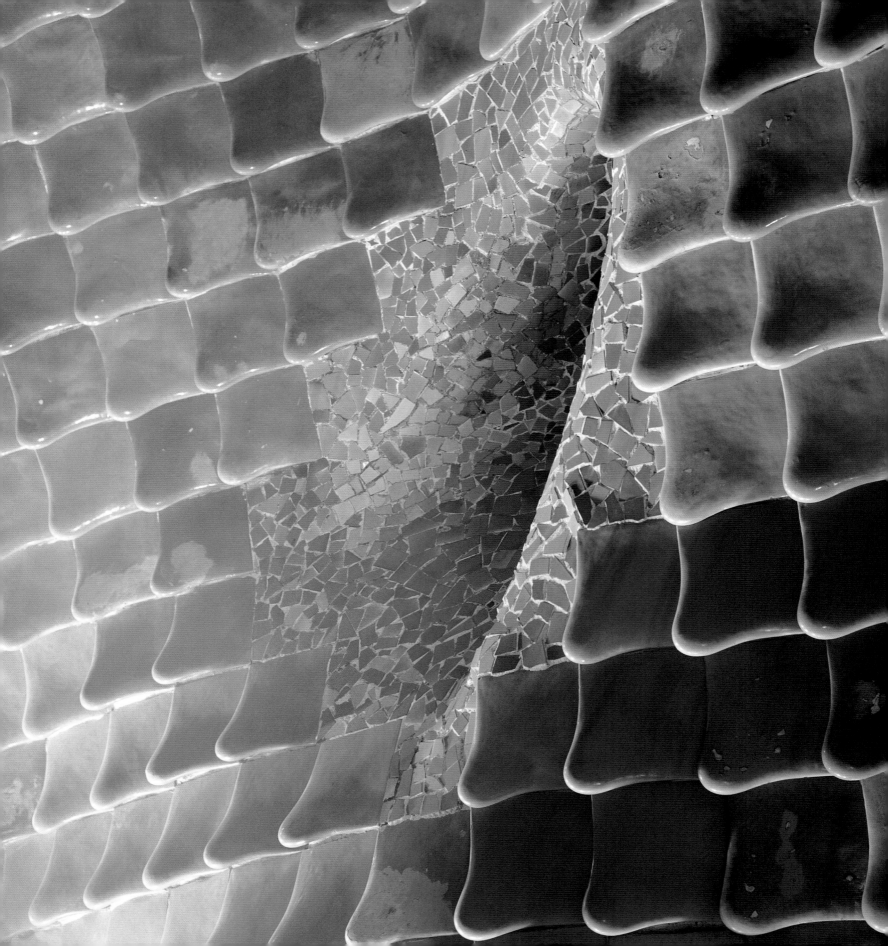

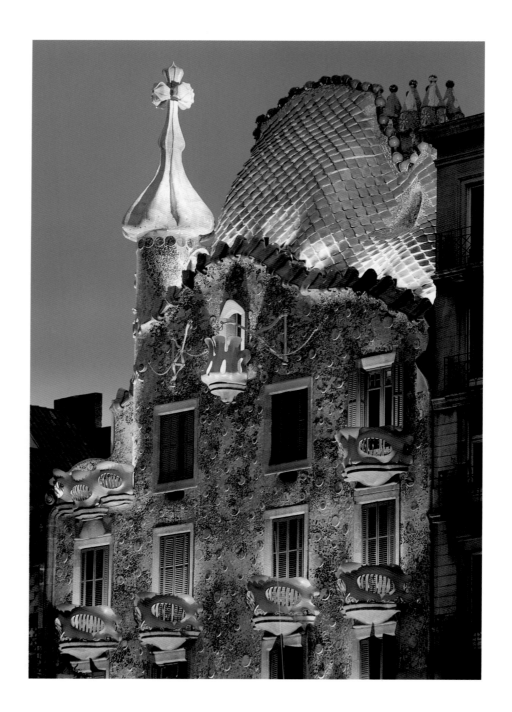

The facade is topped by a small cylindrical tower that culminates in a four-armed cross and an undulating roof covered on the side facing the street with large ceramic pieces of differing tones of electric blue that form scales. Popular imagination has often compared it to the back of some prehistoric animal or of the dragon slain by St. George, represented by the straightness of the tower and the cross. It also reminds one of the mountains of Montserrat, and especially the Foradada rock, or the outline of some hills on the outskirts of Santa Coloma de Cervelló. Finally, there is a likeness to the harlequin's cap, which would complete the costume intimated by the masks of the balconies and the confetti of the *trencadís* of the coloured glass.

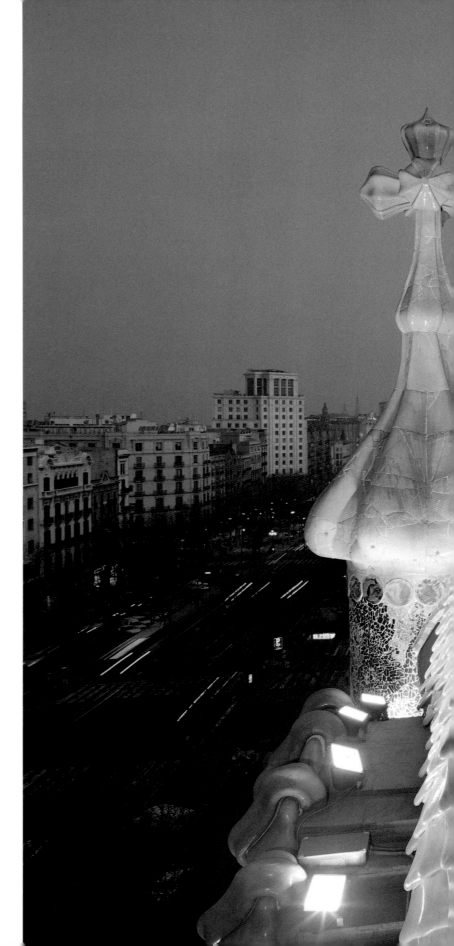

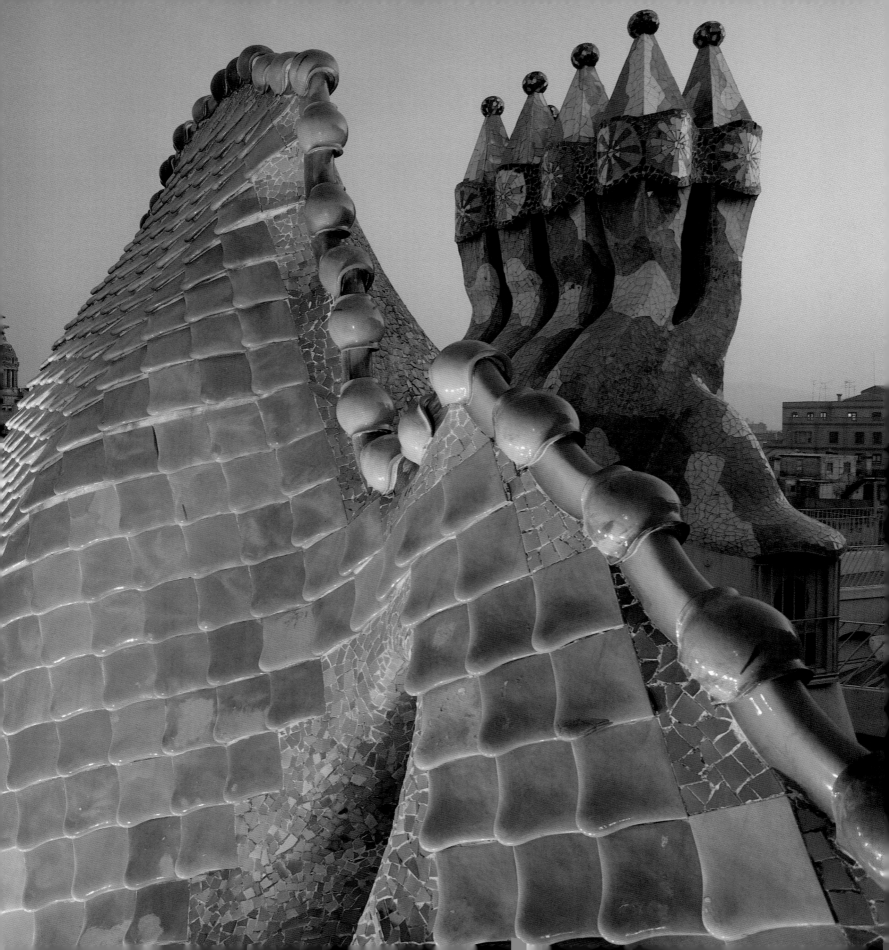

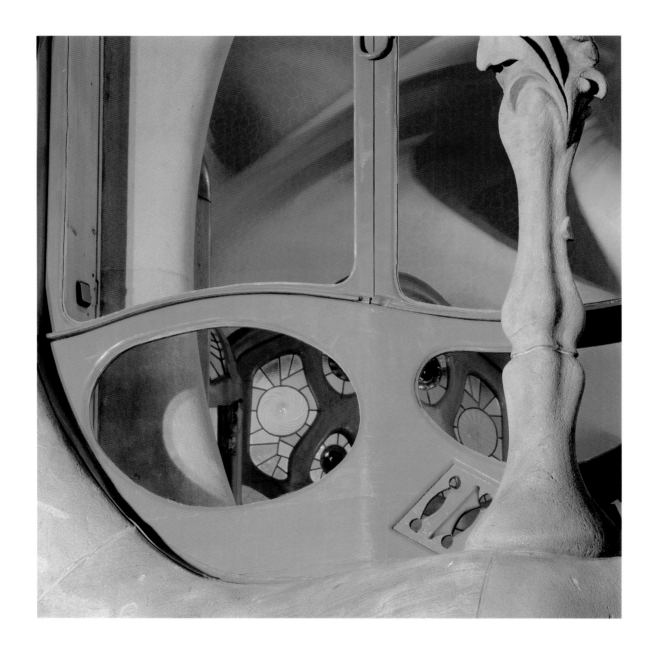

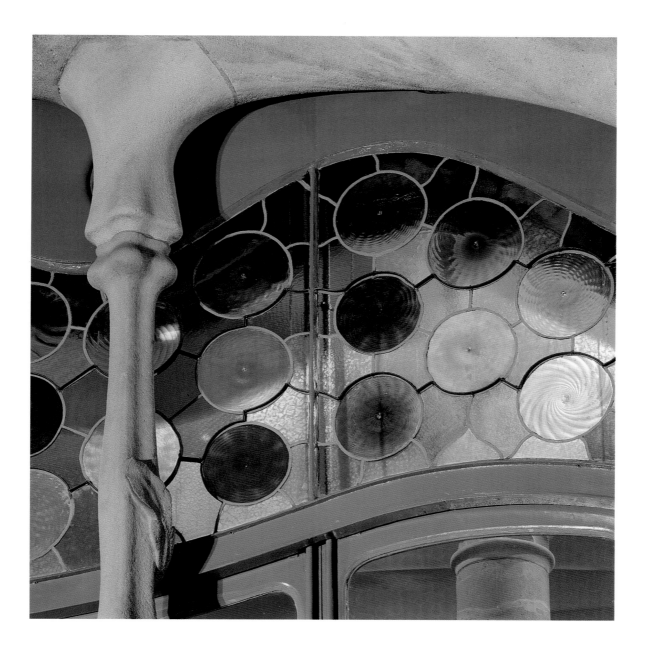

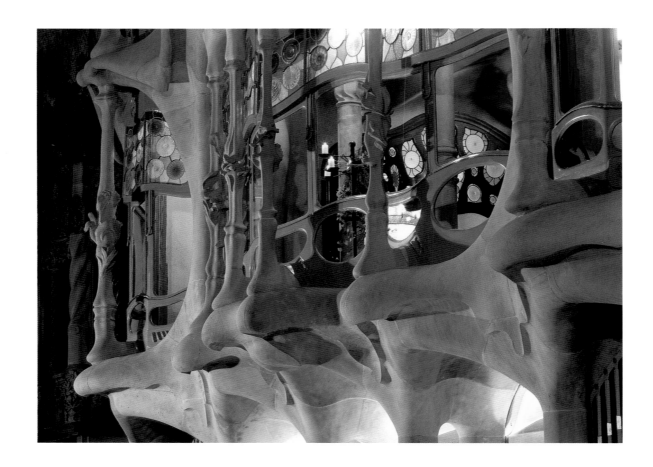

On the gallery, the Montjuïc stone seems to have been liquefied, forming wrinkles and hollows, as if it were lava, as a prelude to what would be the theme of the other house built by Gaudí in Passeig de Gràcia shortly after, the Casa Milà, otherwise known as La Pedrera.

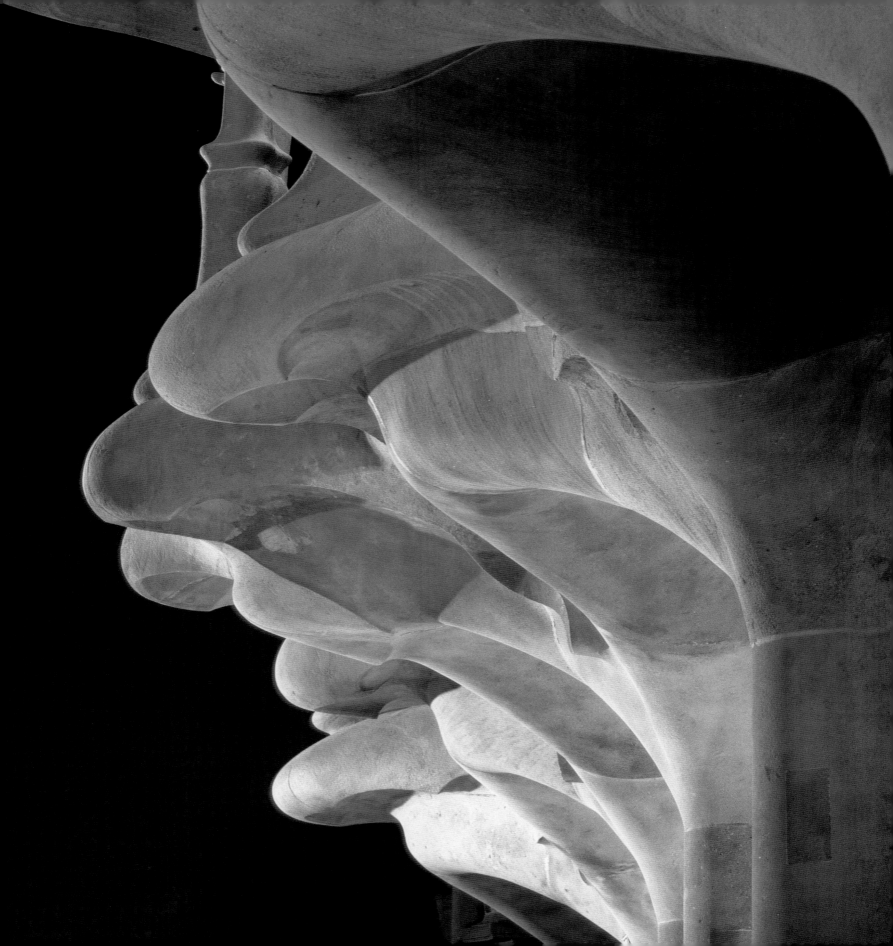

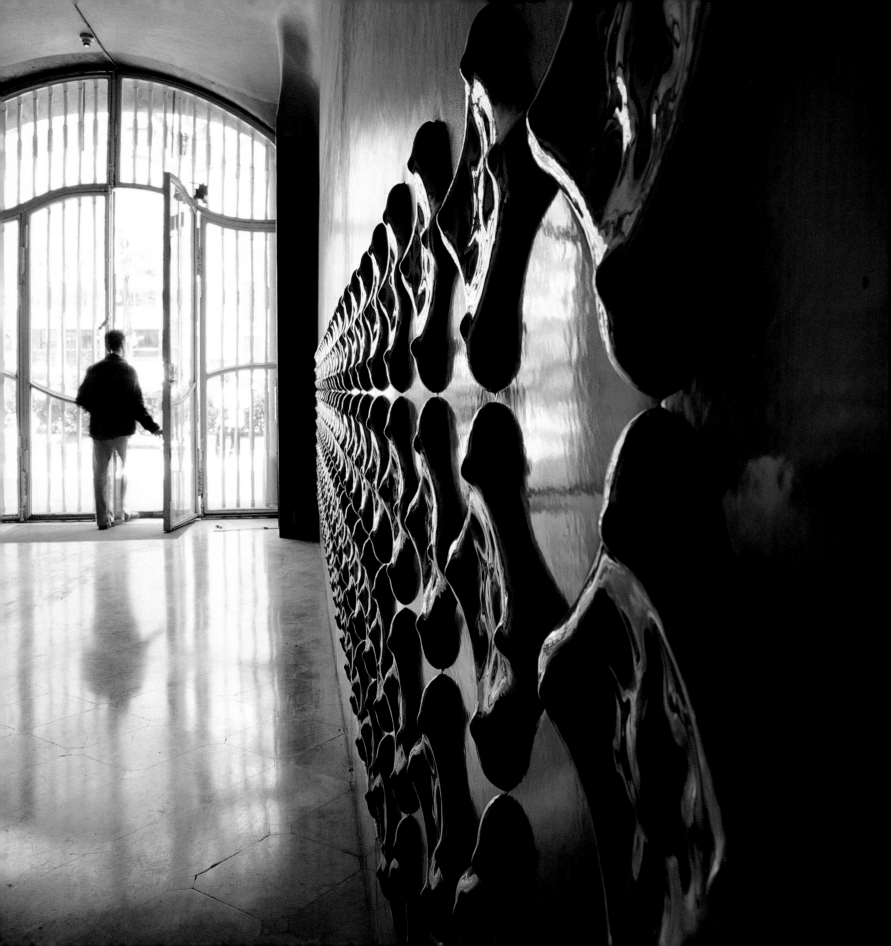

LOBBY

The lobby leads the visitor towards the foot of two stairways: one private, behind the iron portal, leading directly to the first floor where the Batlló family lived: the other public, giving access to the other flats. The walls, plastered in distinct tones of a soft pearly grey, do not have edges, meeting with the ceilings in continuous soft curves. The wall skirting alternates between very lightly coloured, sky blue and grey smooth glazed ceramic tiles and others in relief that appear eroded by water and the elements.

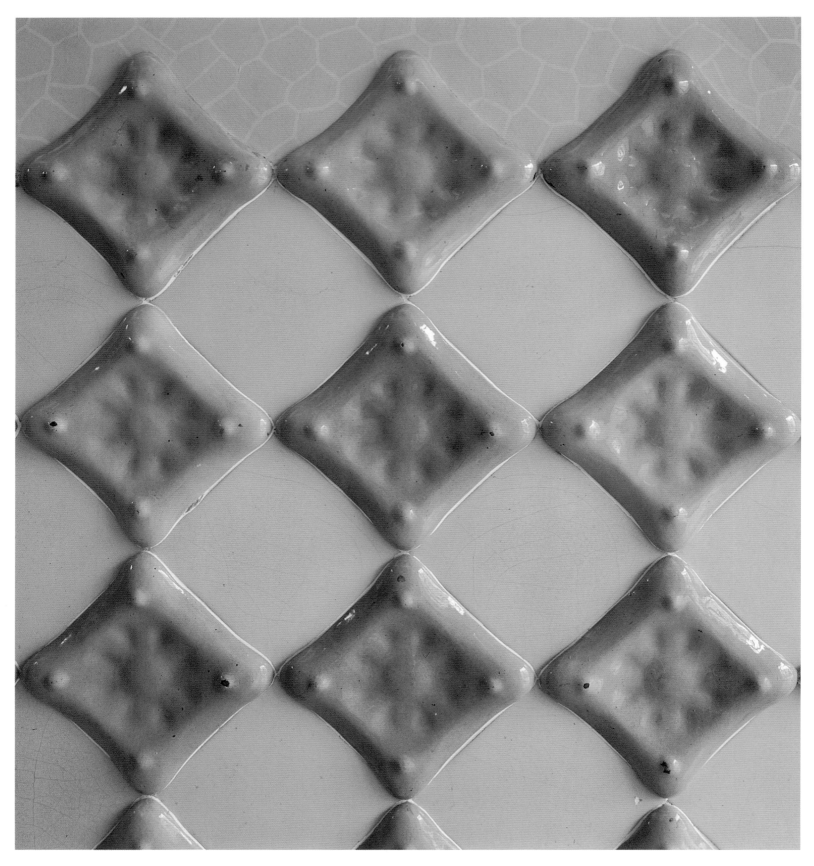

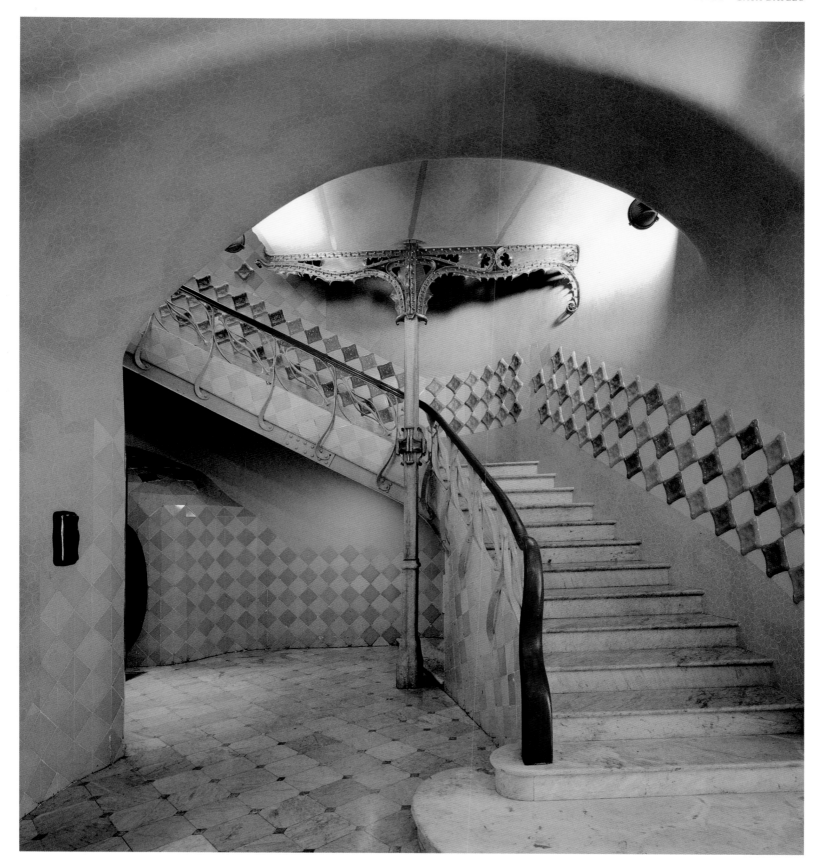

To the left, the private lobby portal and the concierge's lodge and to the right, the foot of the residents' stairway. The handrail on the latter is made of oak and forms an undulation reminding one of the movement of a whip or of a waterfall frozen in time. The beam supporting the wall is made up of riveted iron of a golden and copper colour, as if it were a coral or some metallically sparkling aquatic plant.

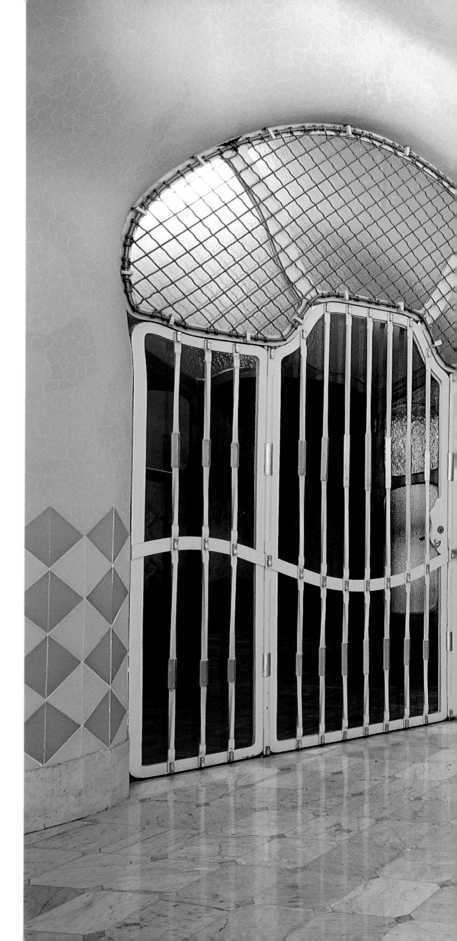

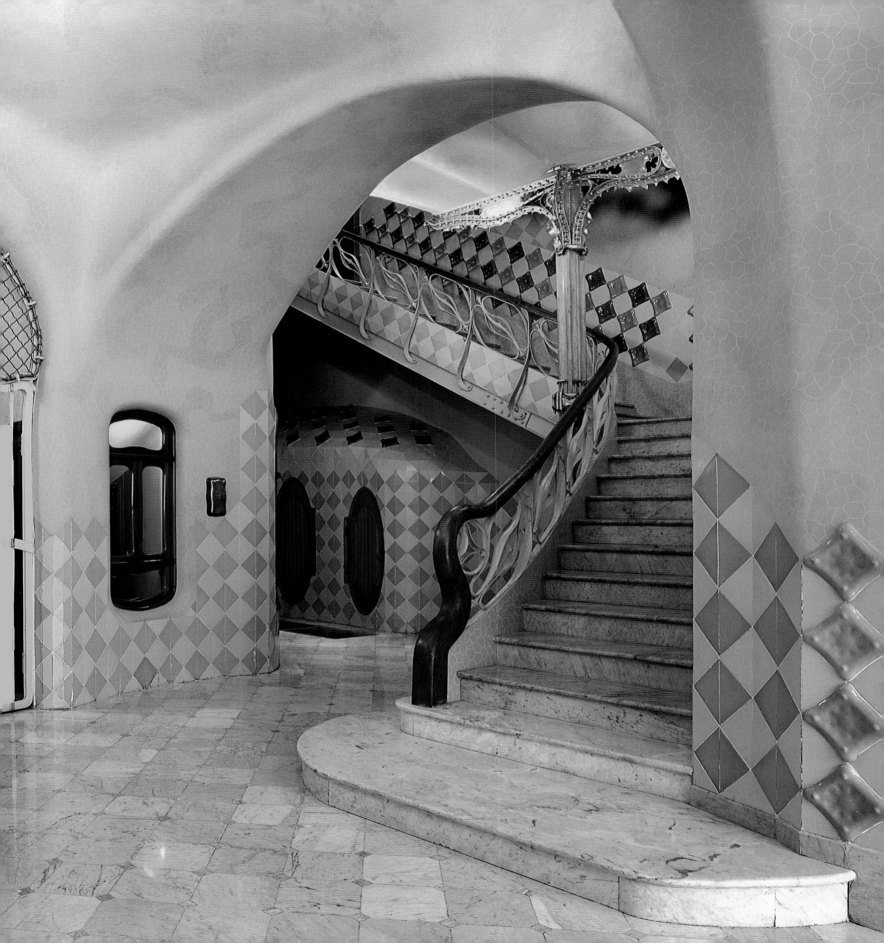

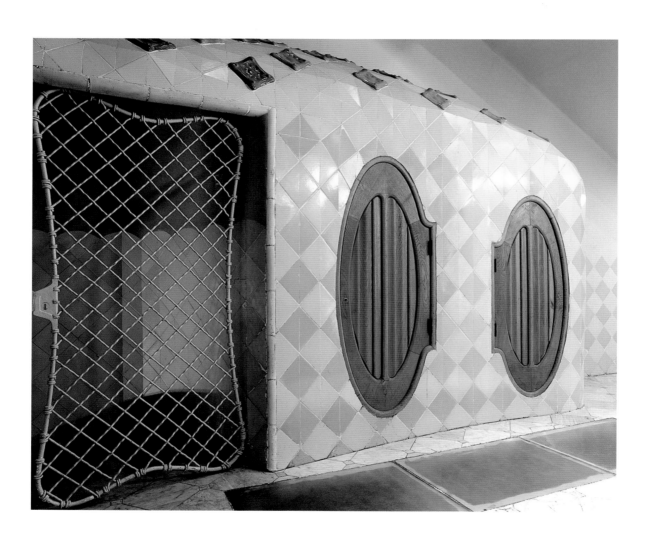

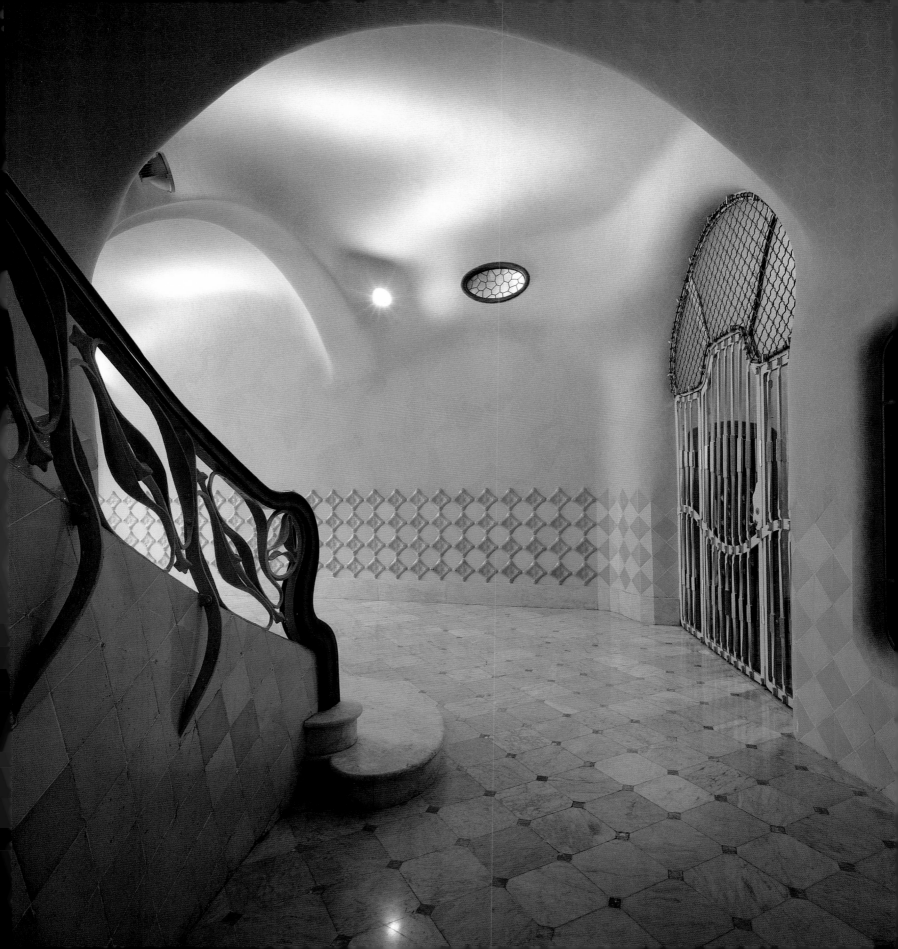

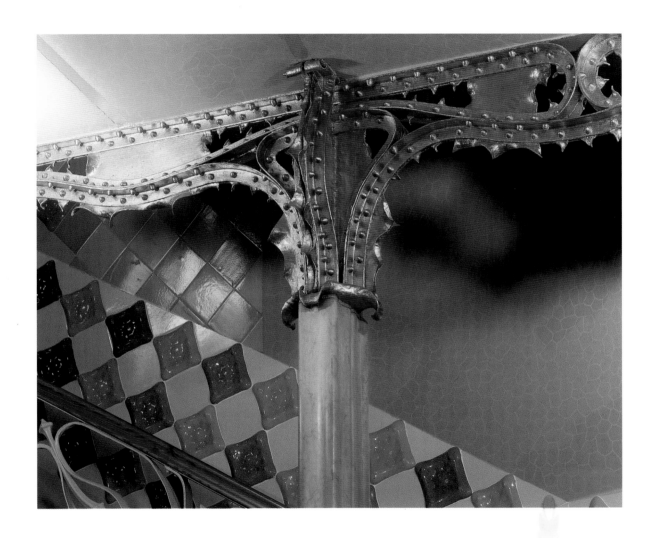

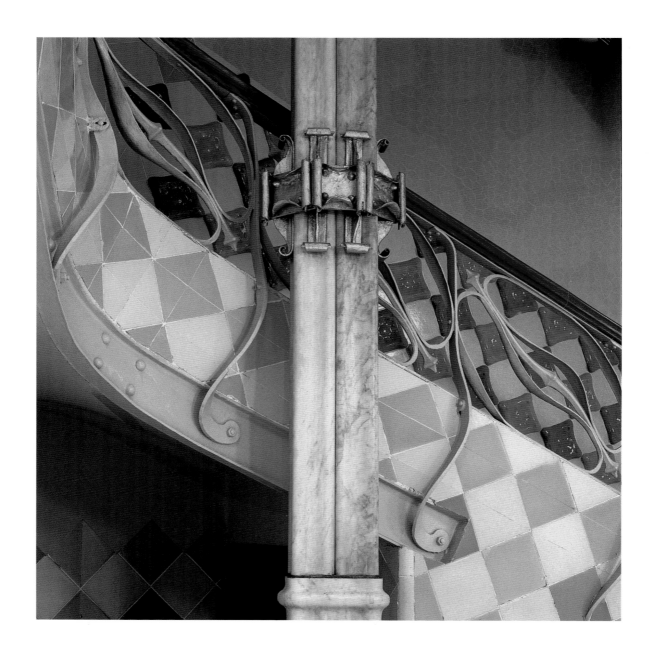

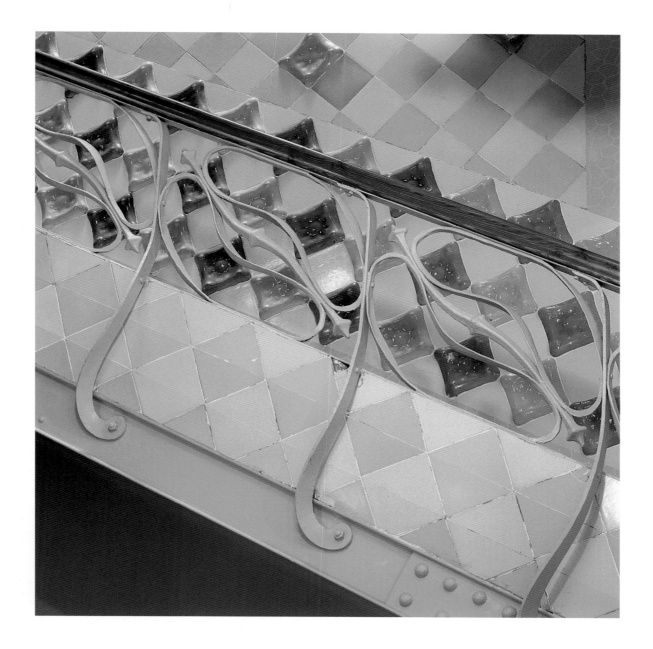

The light enters from overhead and glides across the plastered lobby and the ceramic tiles of the courtyard, across the undulations of the walls and ceilings or the bulging walls and through the elongated, rounded and curved hollows. All this together gives the sensation of a cave whose bluish atmosphere evokes that of an imaginary underwater grotto.

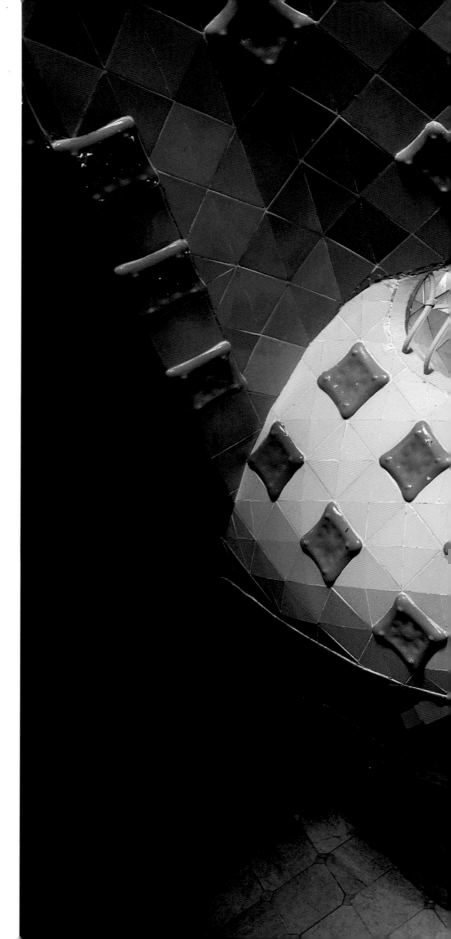

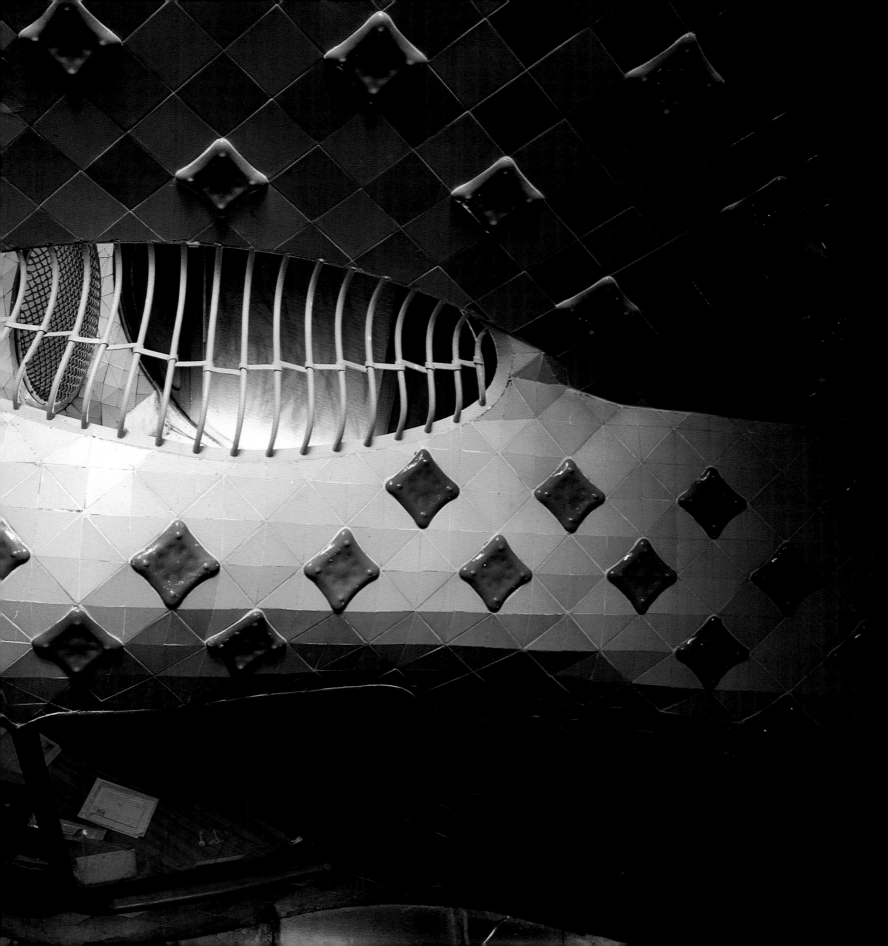

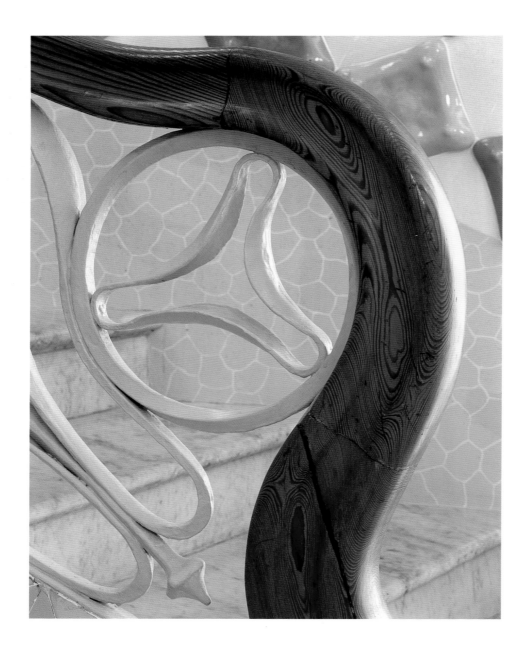

The stairway drops like an underground spring that channels its course along the worn hollow that it has eroded itself away with the passing of time. The walls bulge and curve following the stream, letting it pass, towards the light coming from the portal. The rounded hollows seem to have been produced by nature, throughout this selfsame process of erosion, like the eyes of other secondary grottoes.

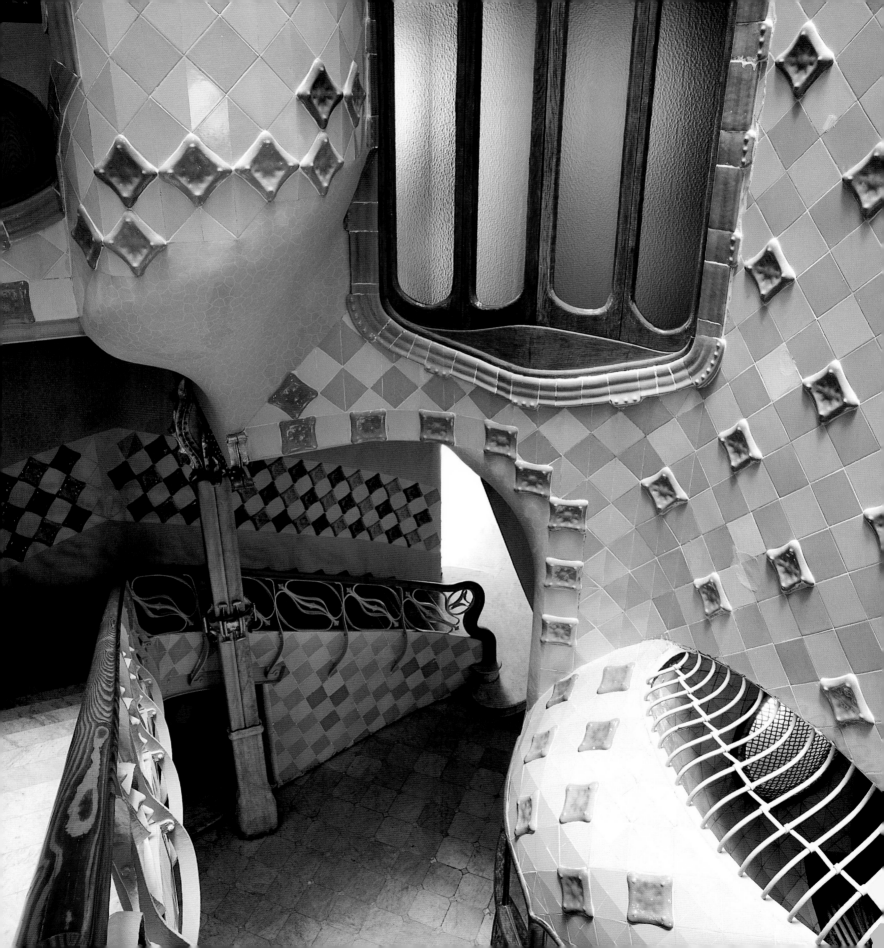

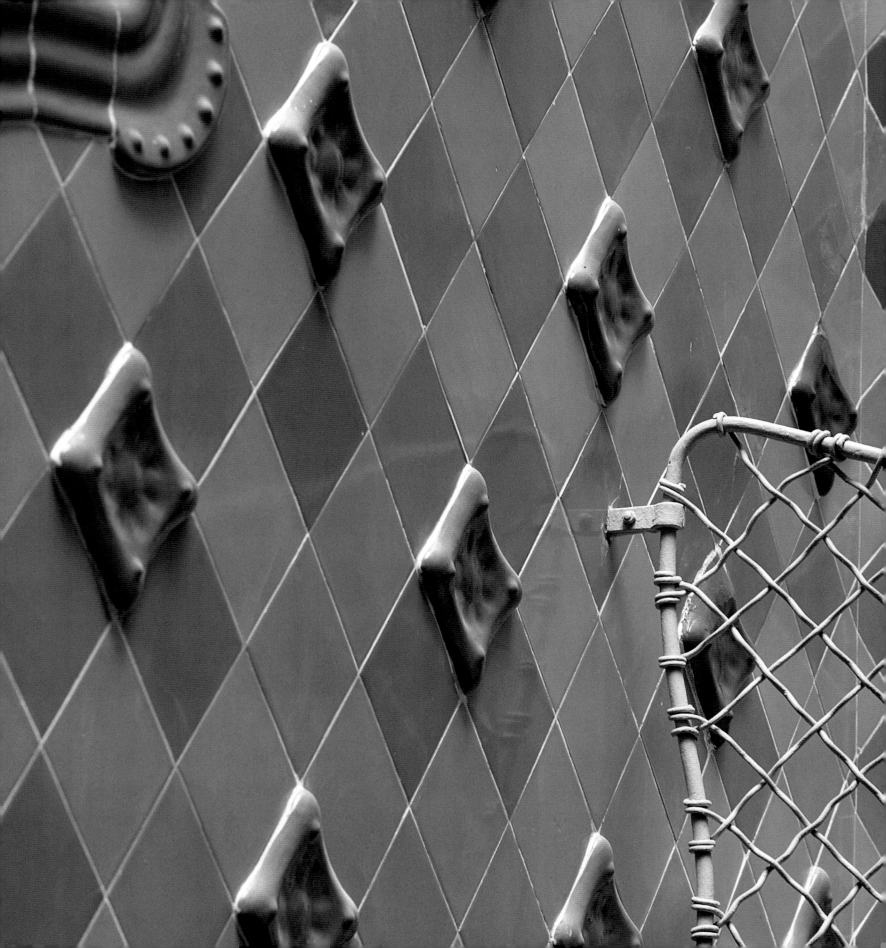

CASA BATLLÓ

RESIDENTS' STAIRWAY

The residents' stairway leads to all the different flats, two on each floor, and climbs around the lift and between the spaces of the two wells, opening up to them and thus following a scheme quite common in blocks of flats in the *Eixample* district of Barcelona. Nevertheless, in this case, the chromatic treatment of the walls, covered in smooth and relief tiles and gradually increasing in intensity from whites, pearl greys and sky blues on the lower floors to navy blue and cobalt on the higher ones, causes a spatial effect of completely new nuances. One could say that when, from the lobby, we look upwards to the well we are seeing, in an unexpected climbing direction, the bottom of the sea.

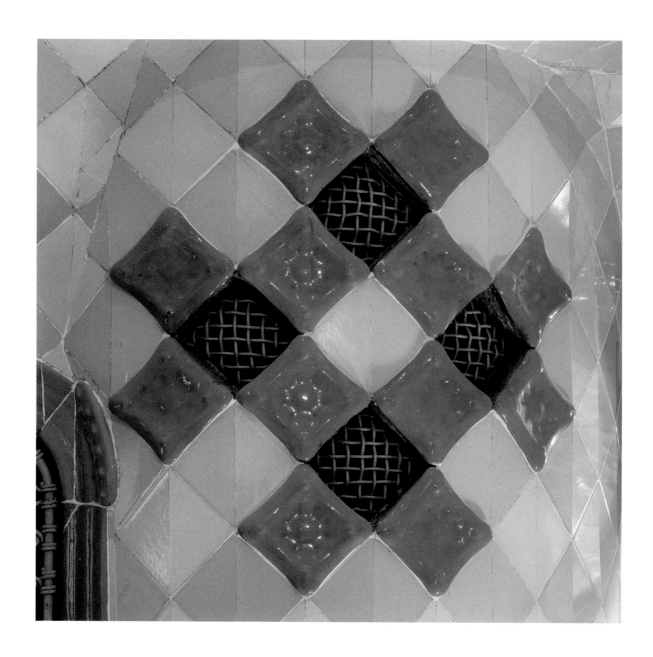

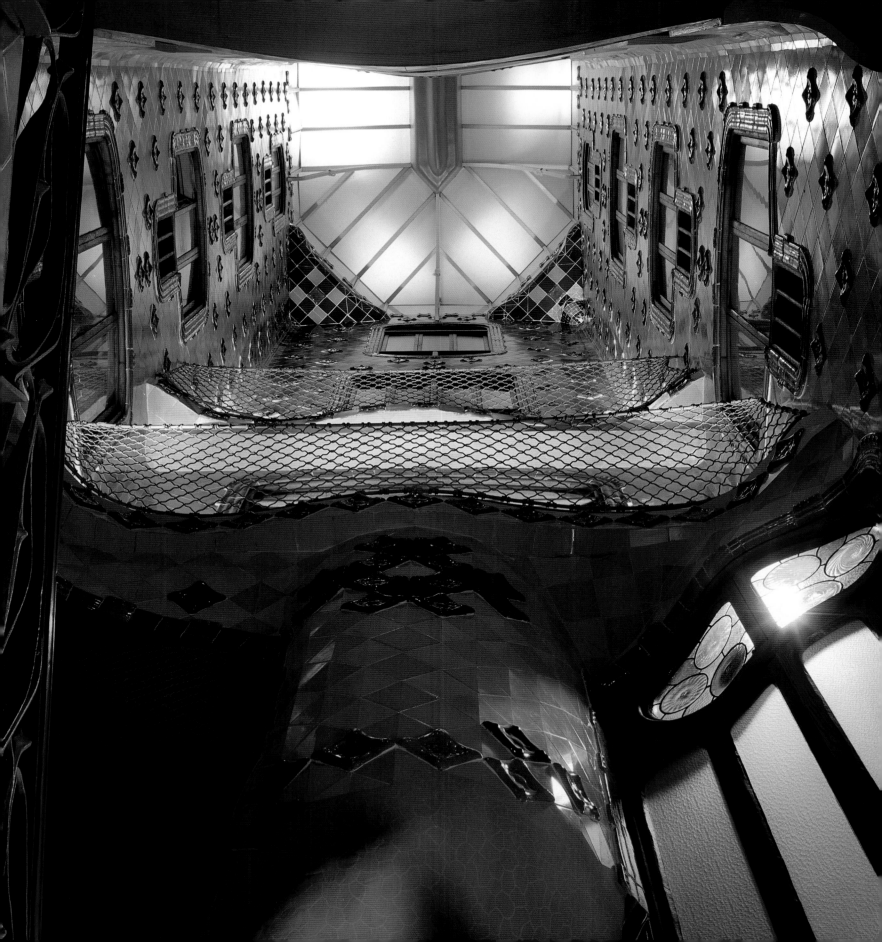

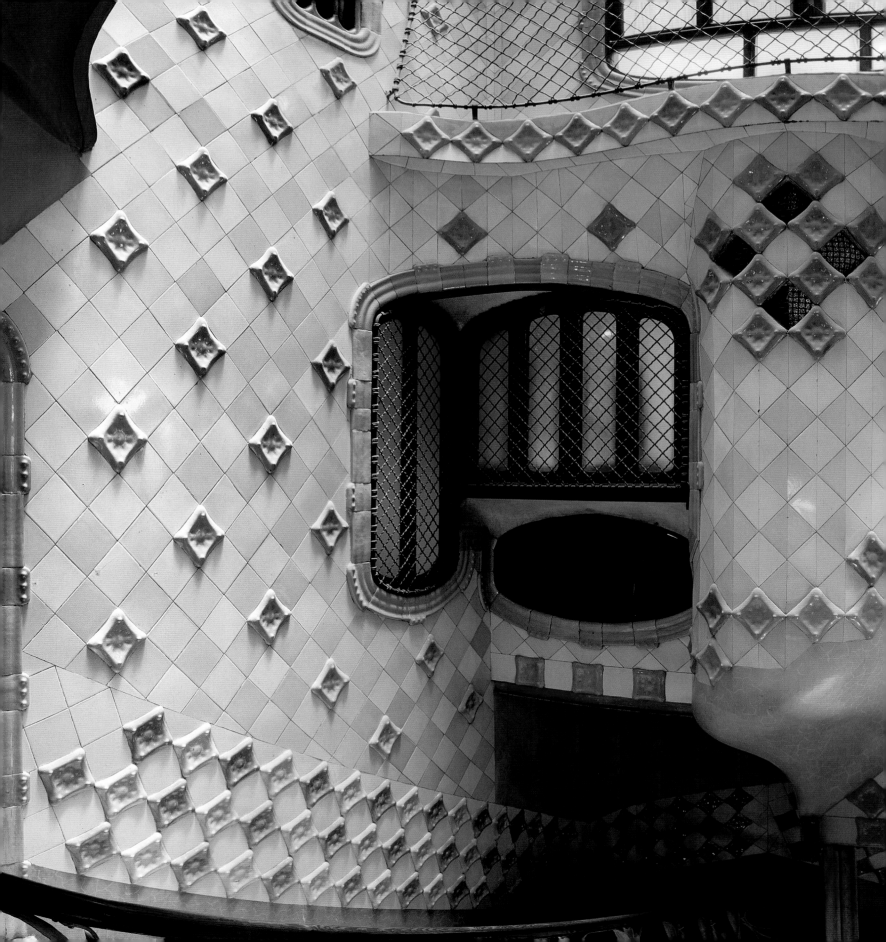

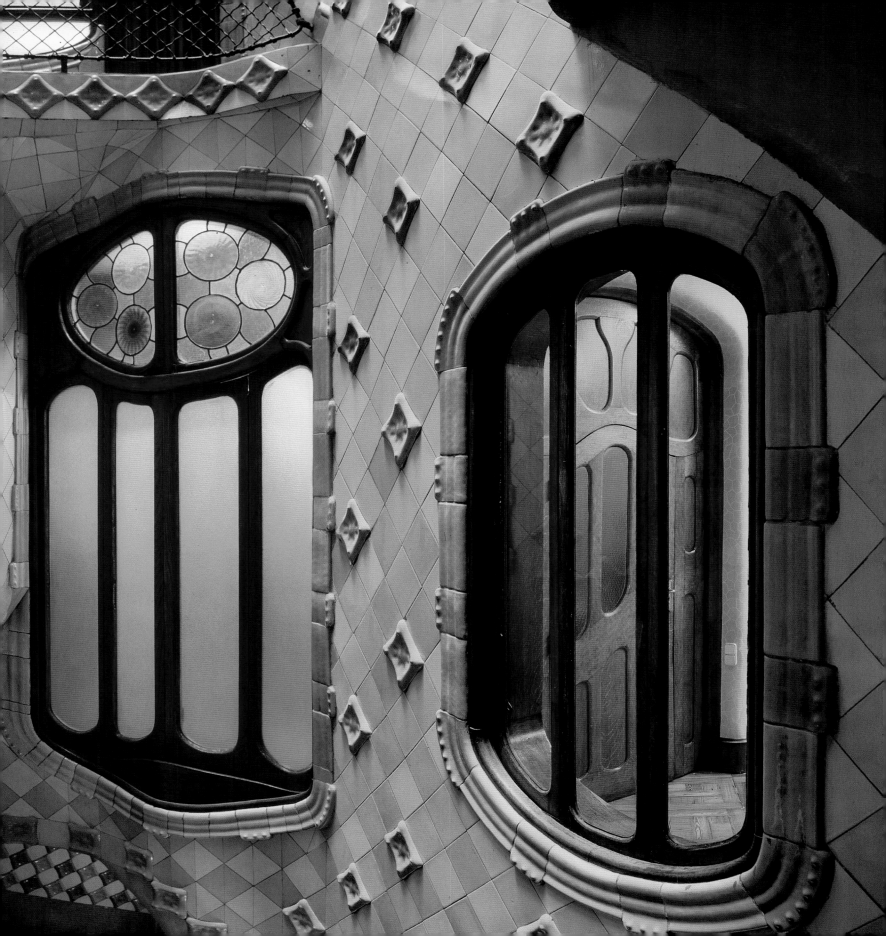

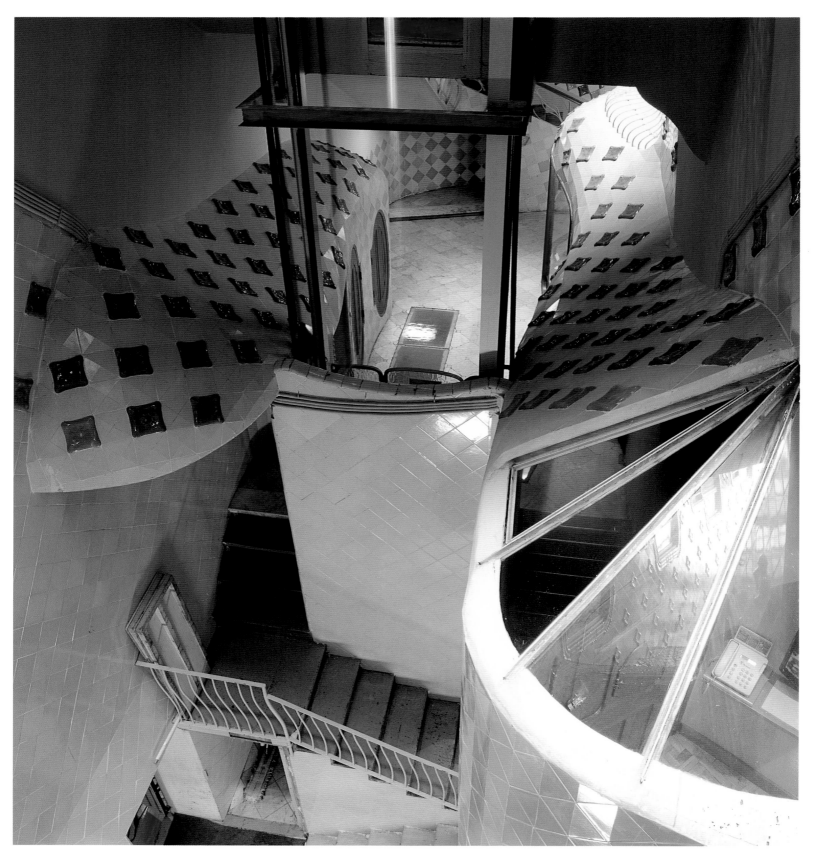

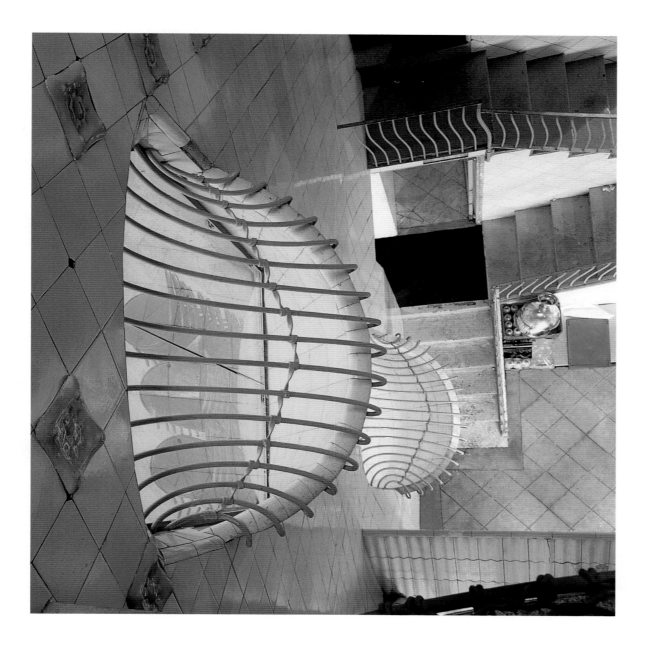

The first landing, after the longest section, corresponds to the service door of the first floor. By passing this point the first turn in the stairway is reached, from where the rear well can be seen, reaching below to the building's basement, where there were storerooms and other rooms of the ground floor shops.

Its chromaticism is not the only thing that characterises the court-yard's singular spatiality. By means of a terraced projection of some rooms on the first and second floors, Gaudí has managed to create a narrower section in the lower part and a wider part at the top, as if this funnel shape represents the quantity of light that the courtyard is capable of collecting and channelling. Also regarding the light which they can capture, the windows on the lower floors are larger and decrease in size on the higher floors. This further creates an impression of perspective acceleration when the court-yard is seen from below and avoids the sensation of a bottomless well when seen from above.

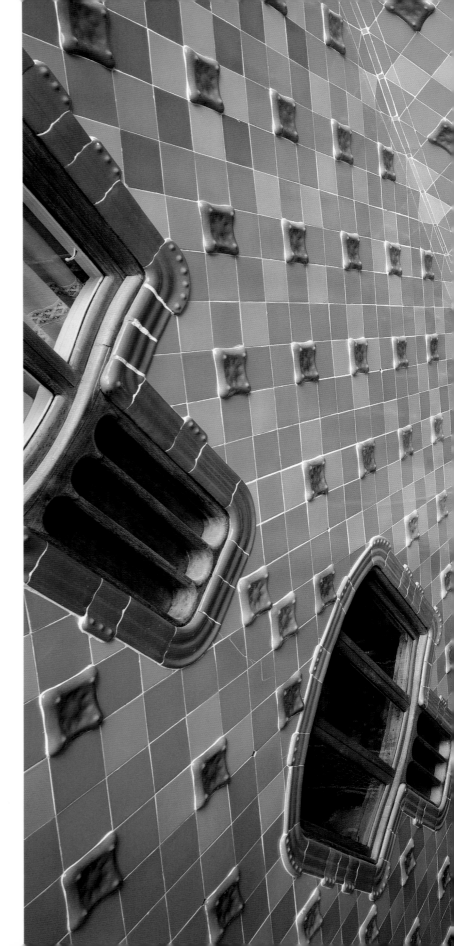

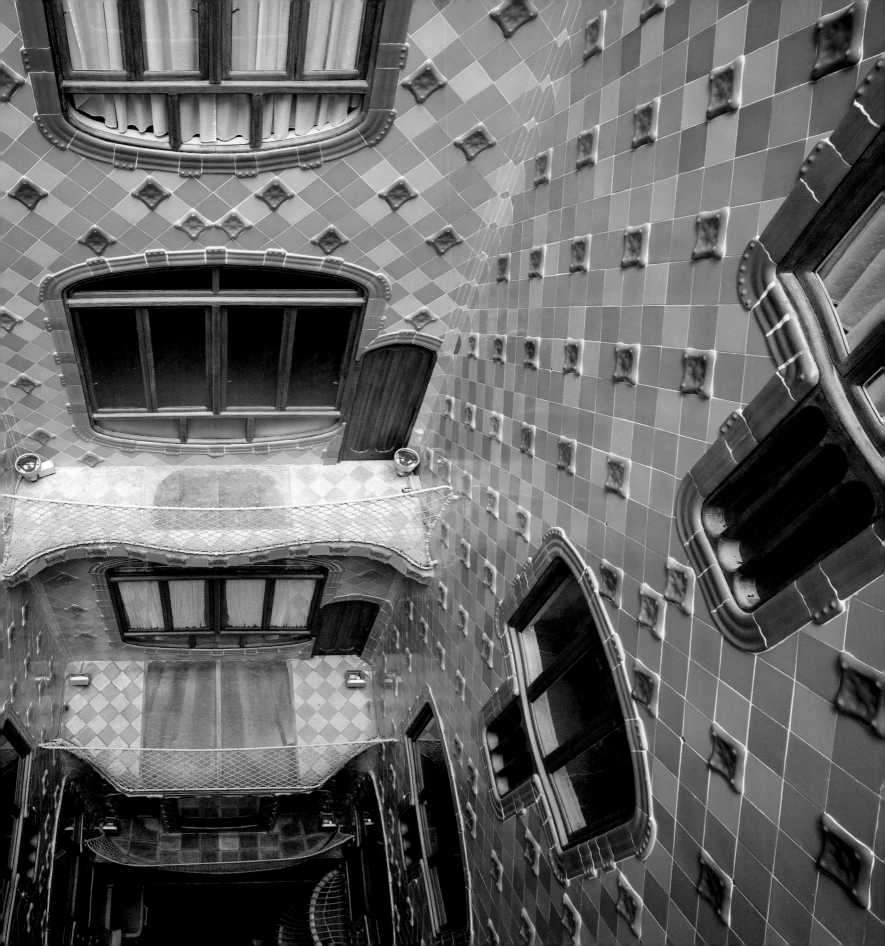

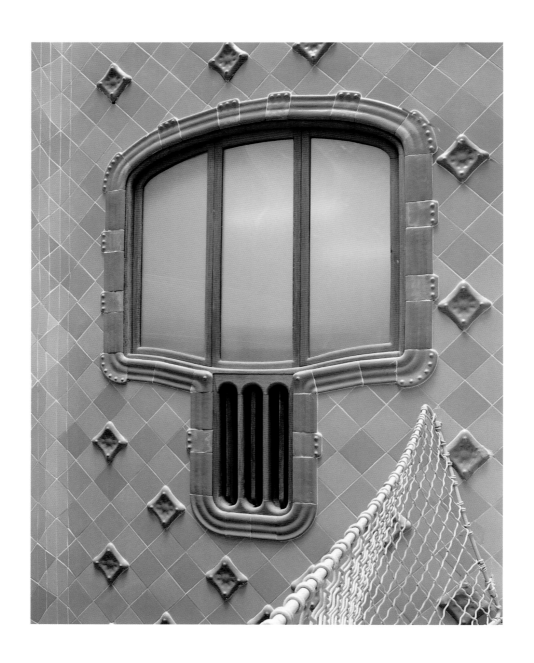

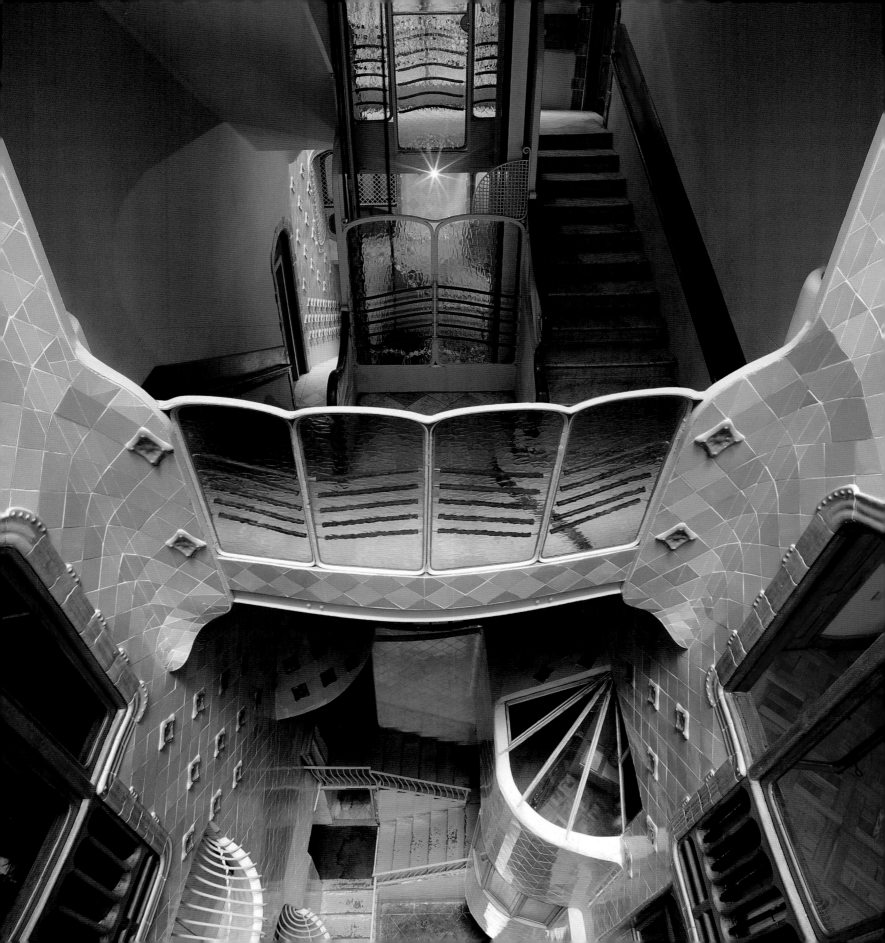

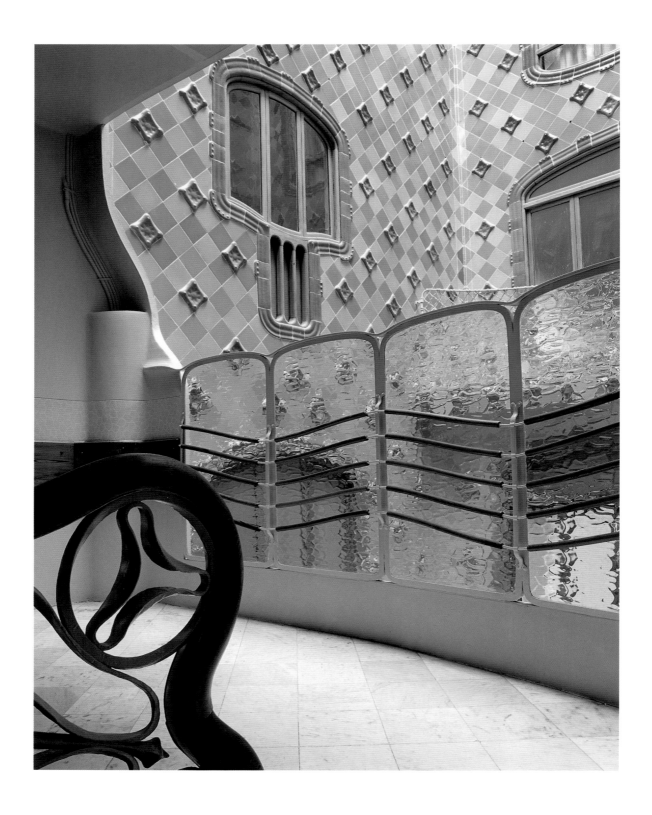

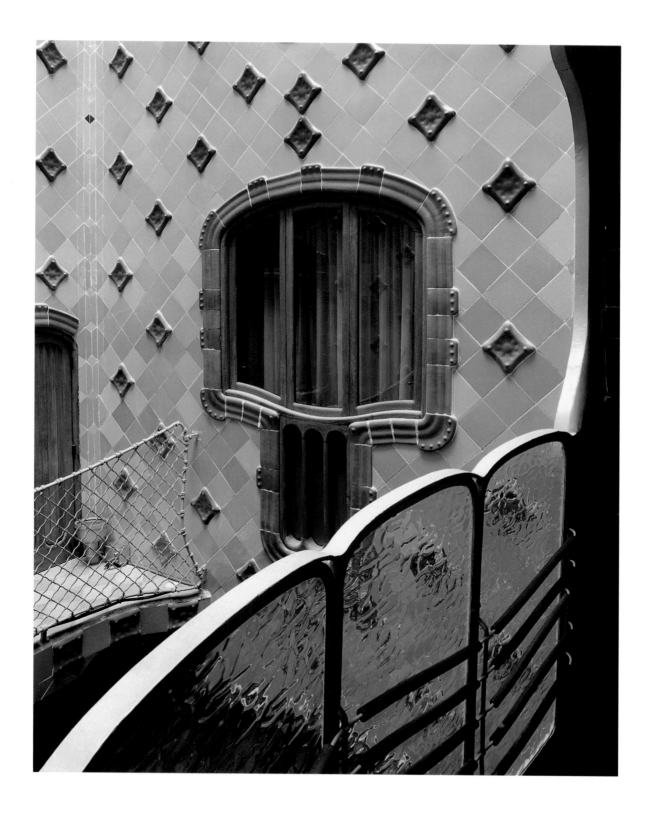

The flat doors have not been numbered in the usual way, but follow the letters of the alphabet starting at the bottom and going up. On reaching door G, the initial of Gaudí and of genesis or generation, the top of the rail, which on the other floors is in a three-lobed form, was replaced by a spiral.

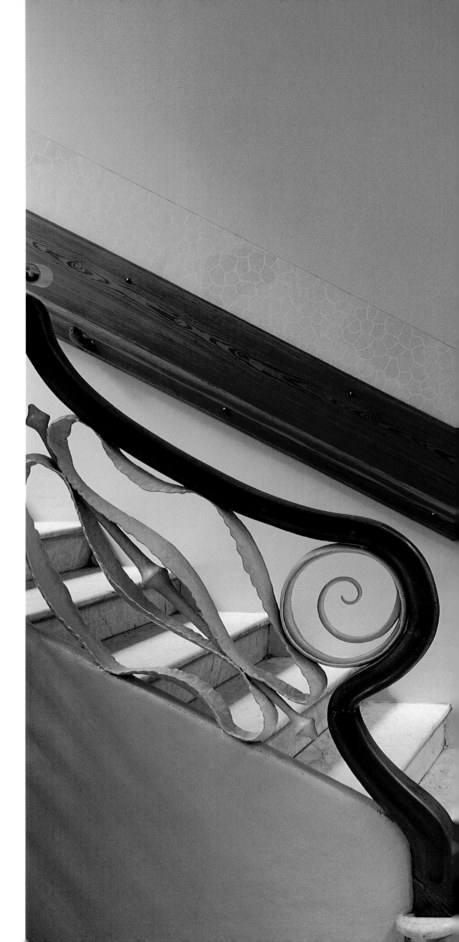

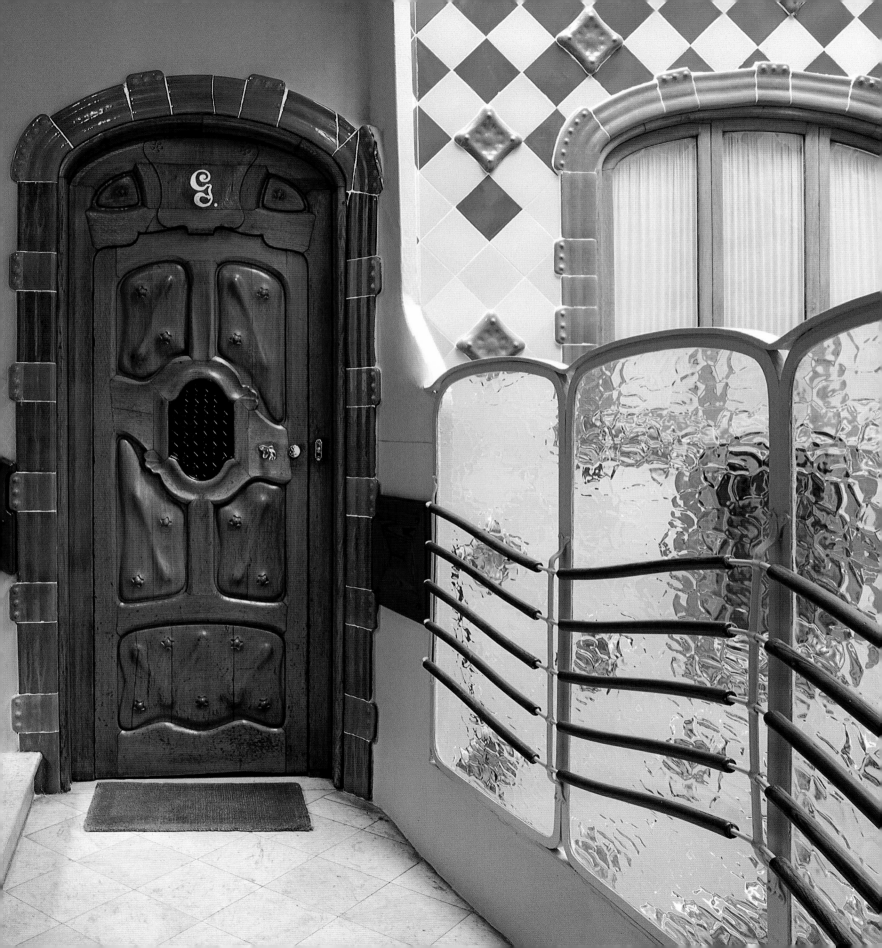

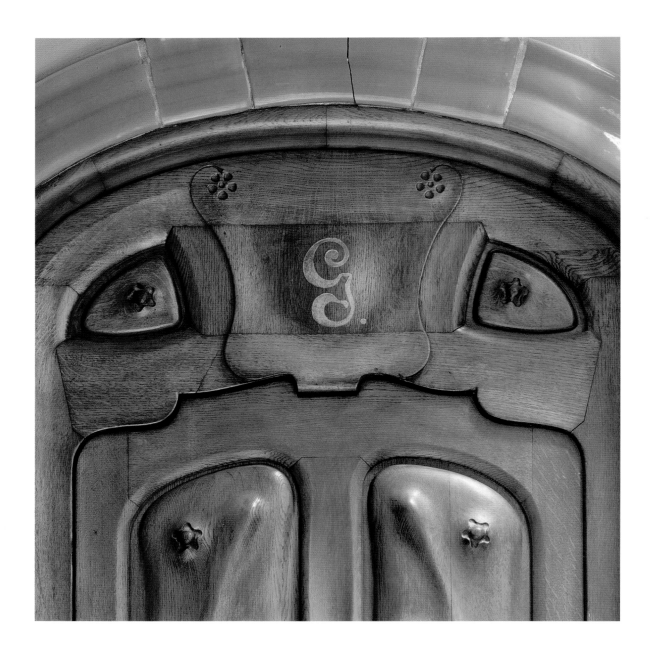

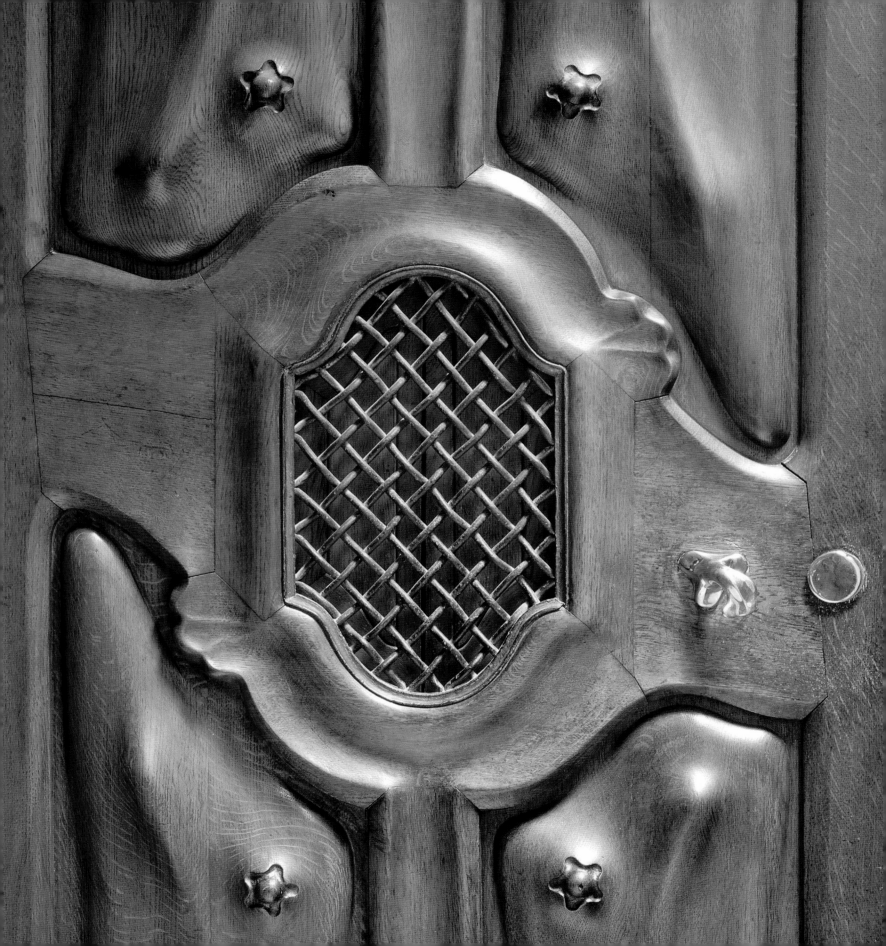

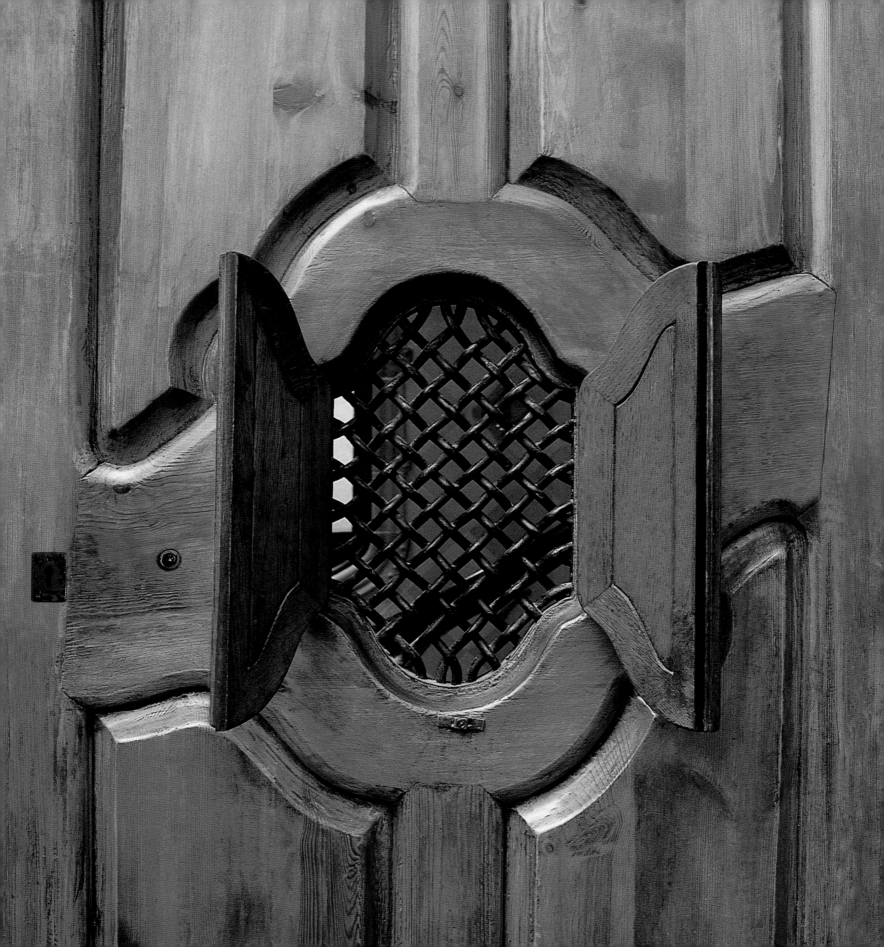

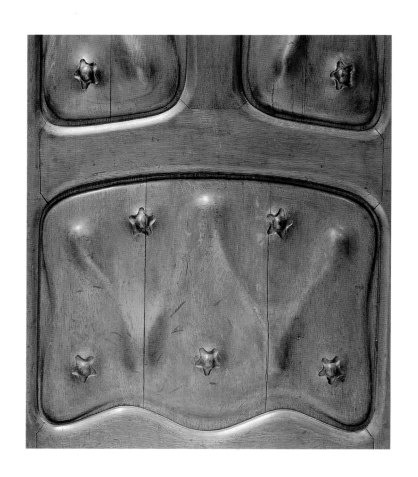

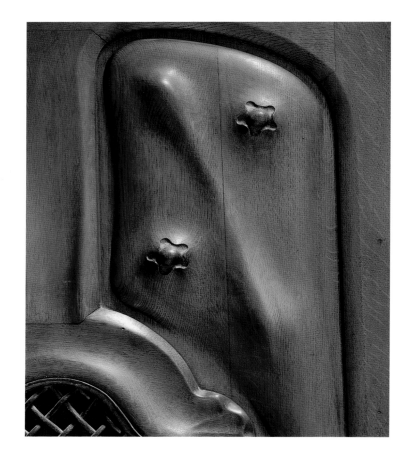

 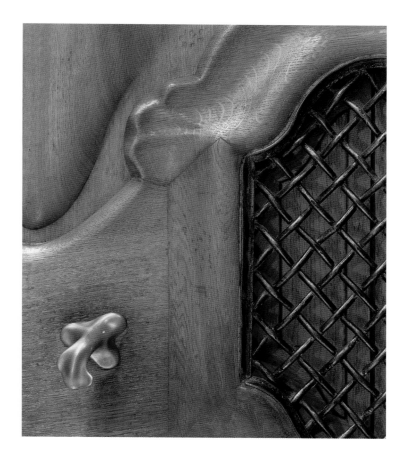

The oak doors of the flats are carved with soft relieves that appear to be struggling to rise up from the bottom of a pasty mass, and which represent tibias and flowers. Thus, just like in other parts of the building, through the image of that which dies and that which sprouts, Gaudí evokes the idea of the regeneration of matter. Besides this, the iron fittings of these doors, like the interior carpentry of the house (handles, latches, doorknockers...), were designed by Gaudí, moulding their forms in clay and later casting the final pieces in brass.

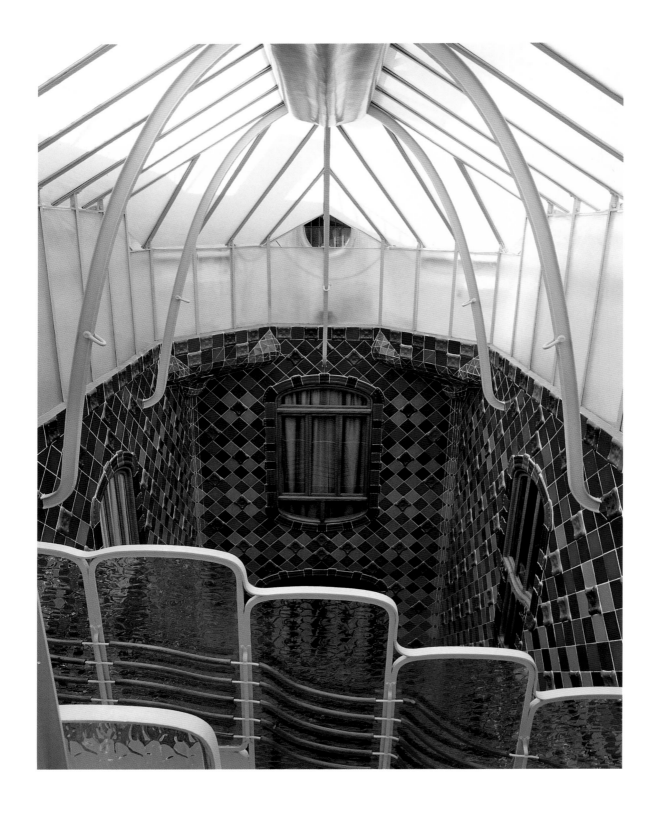

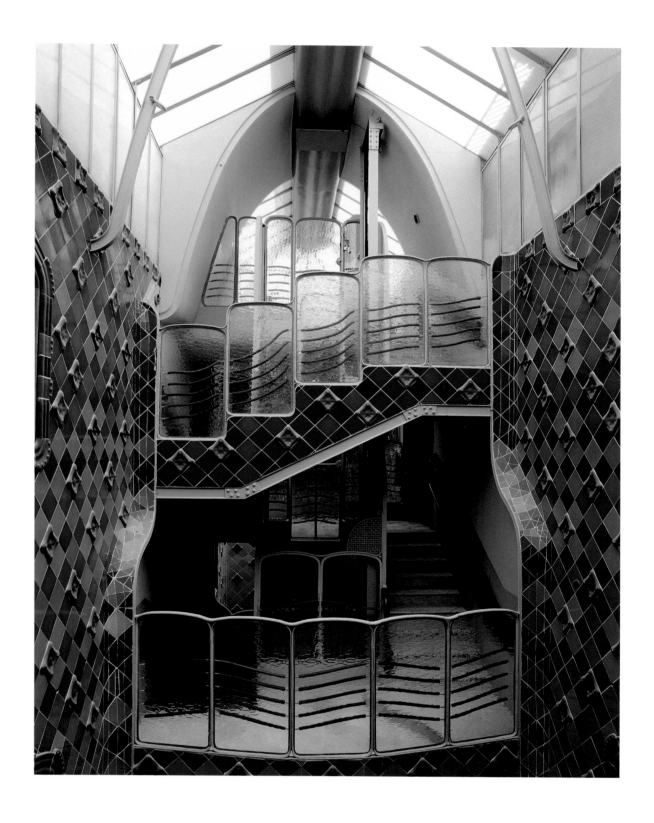

The chromatic graduation of the courtyard, dominated by cobalt and dark blue in the higher part and by sky blue and pearl grey in the lower part, is inversely related to the intensity of light that falls from the overhead skylight, which is supported by an iron framework which has been given a parabolic shape.

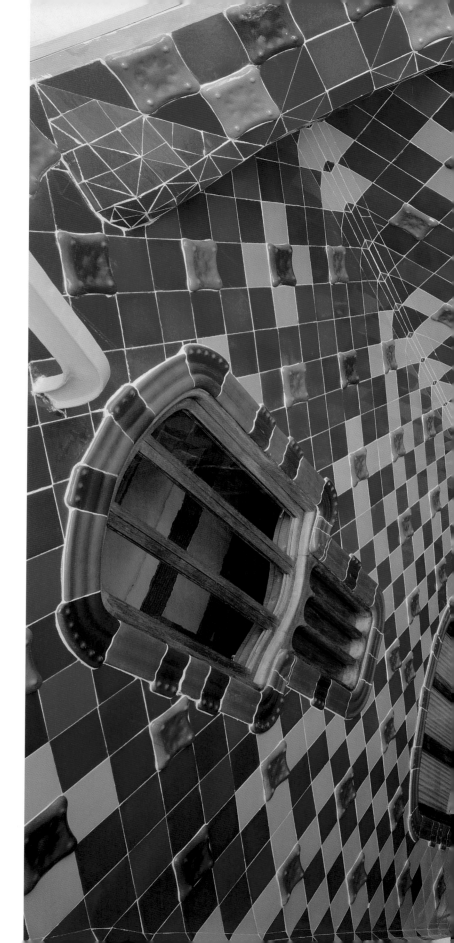

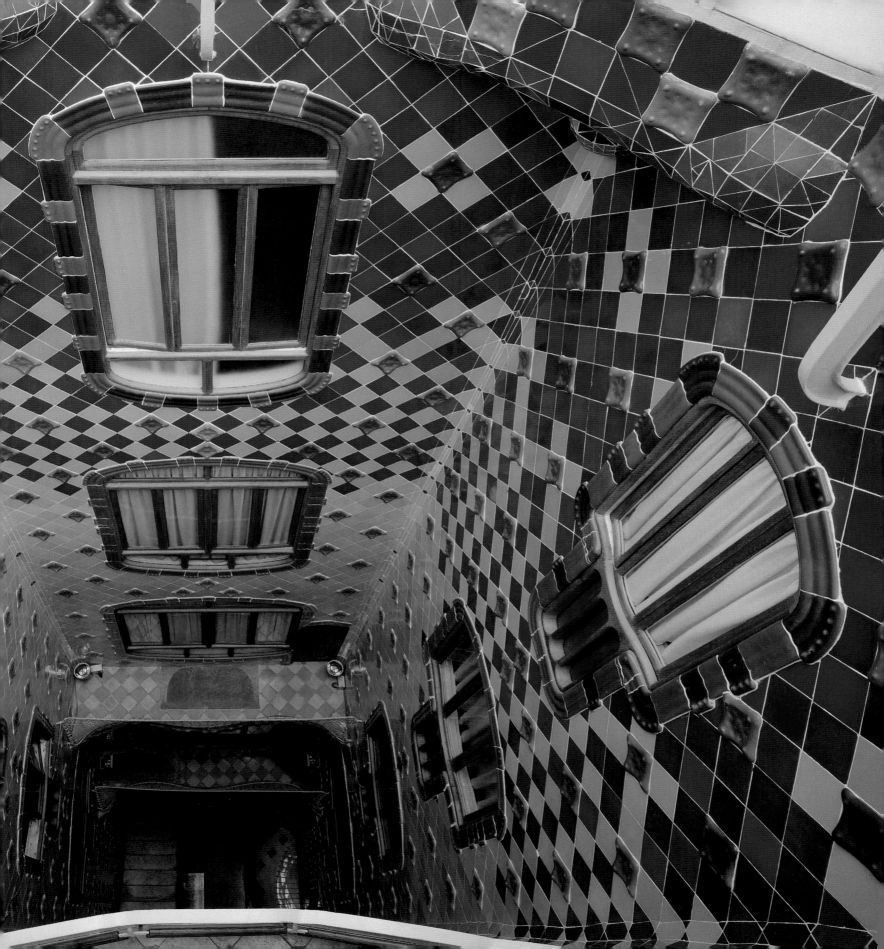

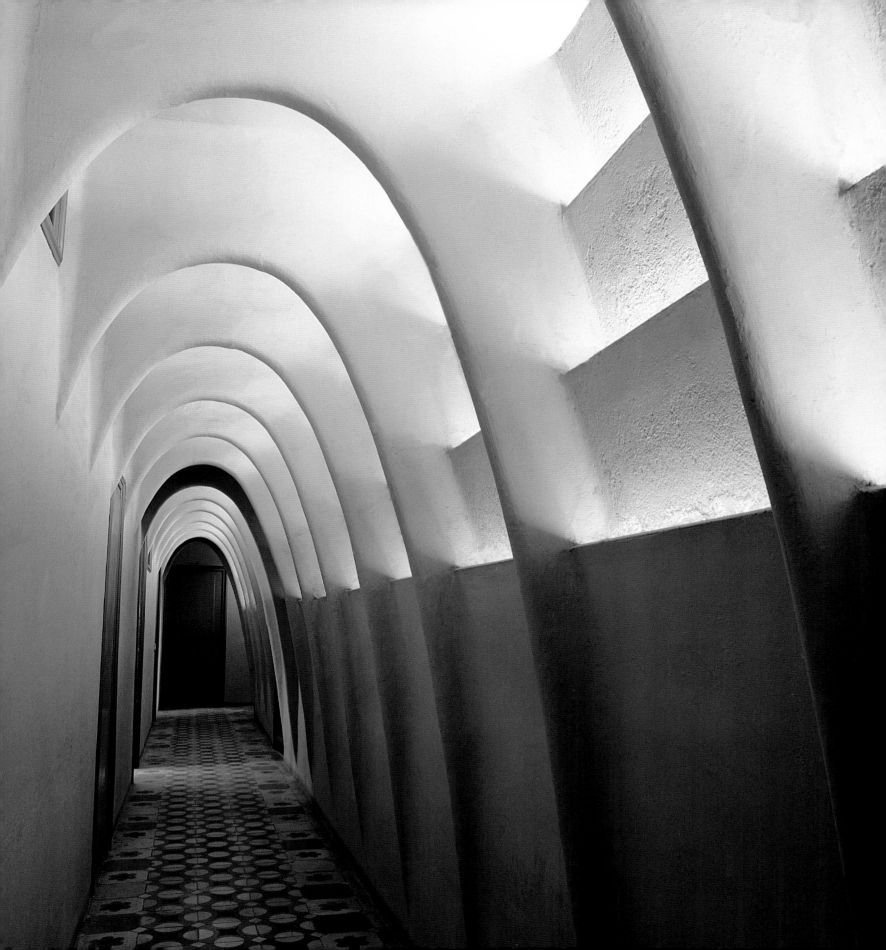

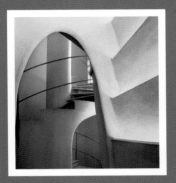

Attic

The top floor of the building is an attic built by means of a bricked-up parabolic vault, plastered and painted white. The wells surround it and it was used as a storeroom, washroom and a place for hanging up clothes to dry. A spiral stairway leads up to the flat roof of the terrace and, from a stairway inside the cylindrical tower, to the small corridor that opens out on the facade facing the street, right on the cornice of the building.

Below the undulating roof that crowns the facade is the widest area of the terrace, which has an exit onto a small balcony. Above this is another attic, also with a bricked-up vault, in which the building's water tanks are housed. The sensation caused by this succession of arches is that of a thoracic cavity, finding ourselves within a giant ribcage, perhaps that of the ceramic dragon we see outside.

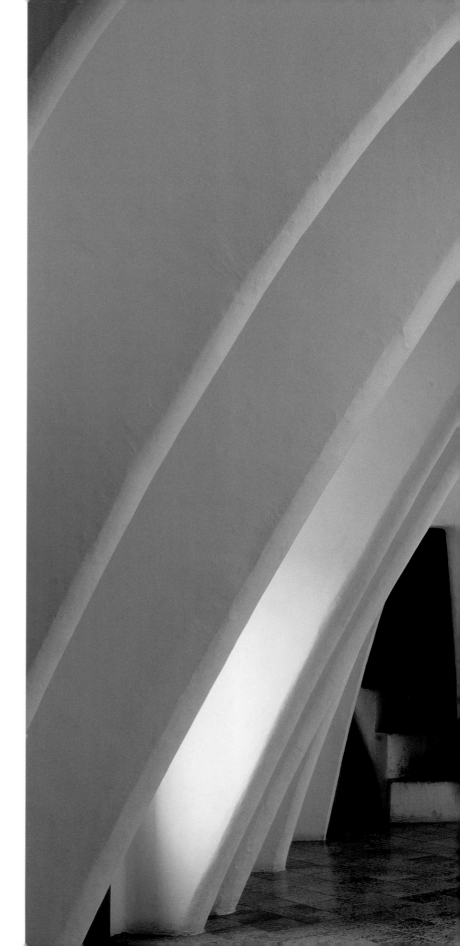

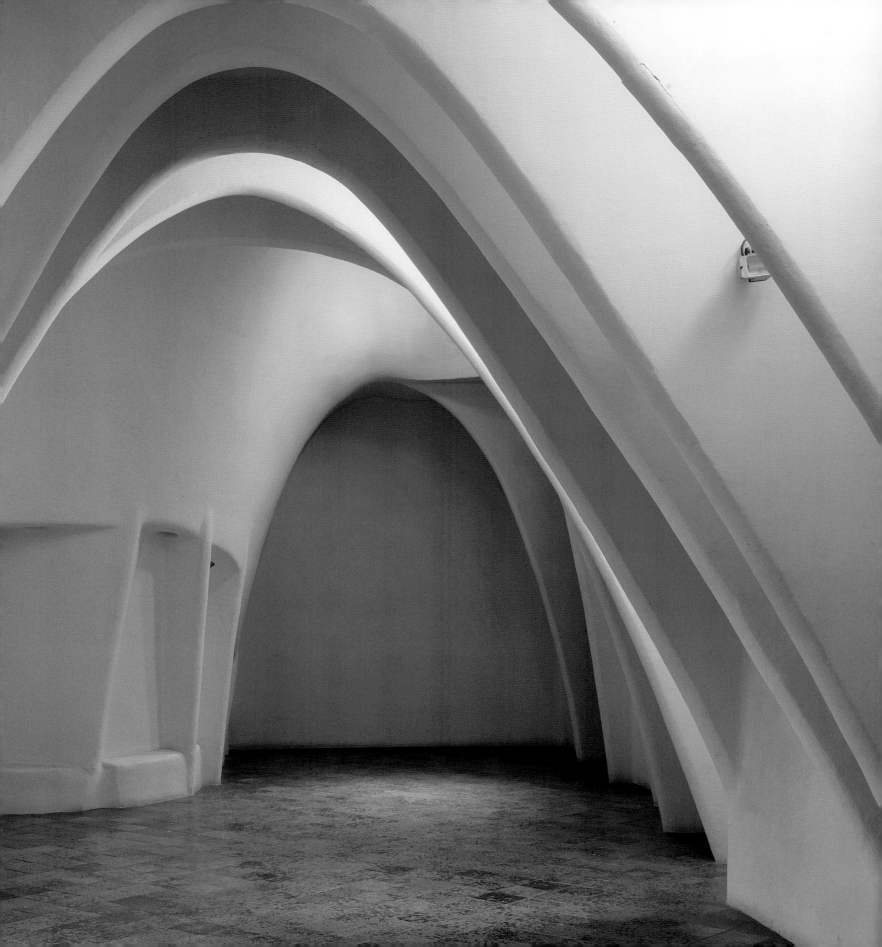

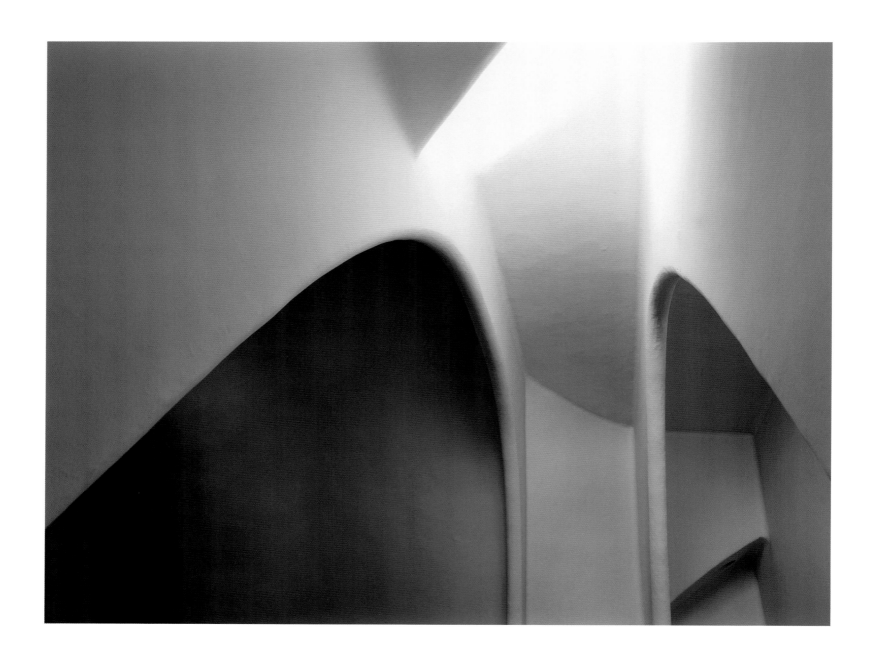

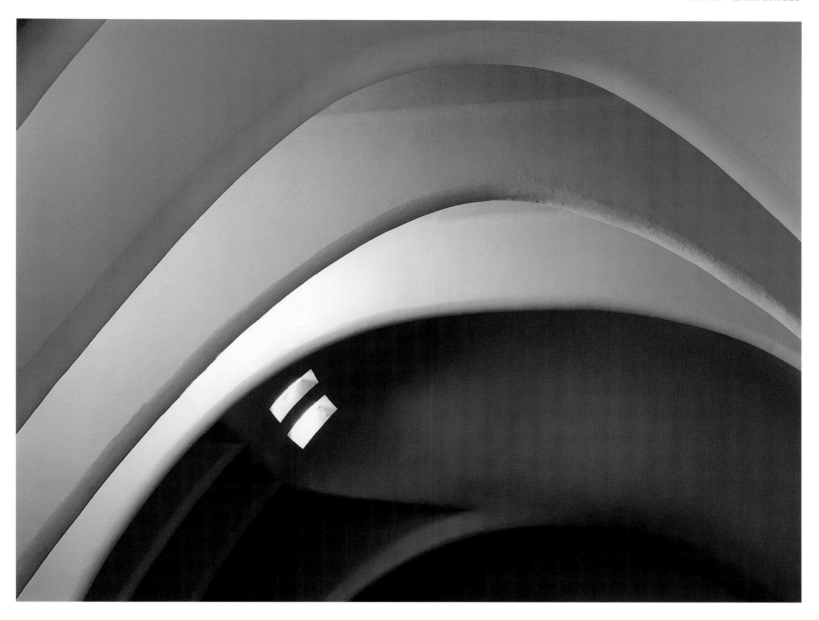

The perspective of parabolic arches of the bricked-up vaulting creates a diaphragmatic space typical to Gaudí's work. In can already be seen in his early works, for example in the wooden arches of the Mataró Workers' Housing Estate or those of the interior of the stables produced for Eusebi Güell. They would reach their crowning moment in the rooftops of the Casa Milà, of which these are a rehearsal.

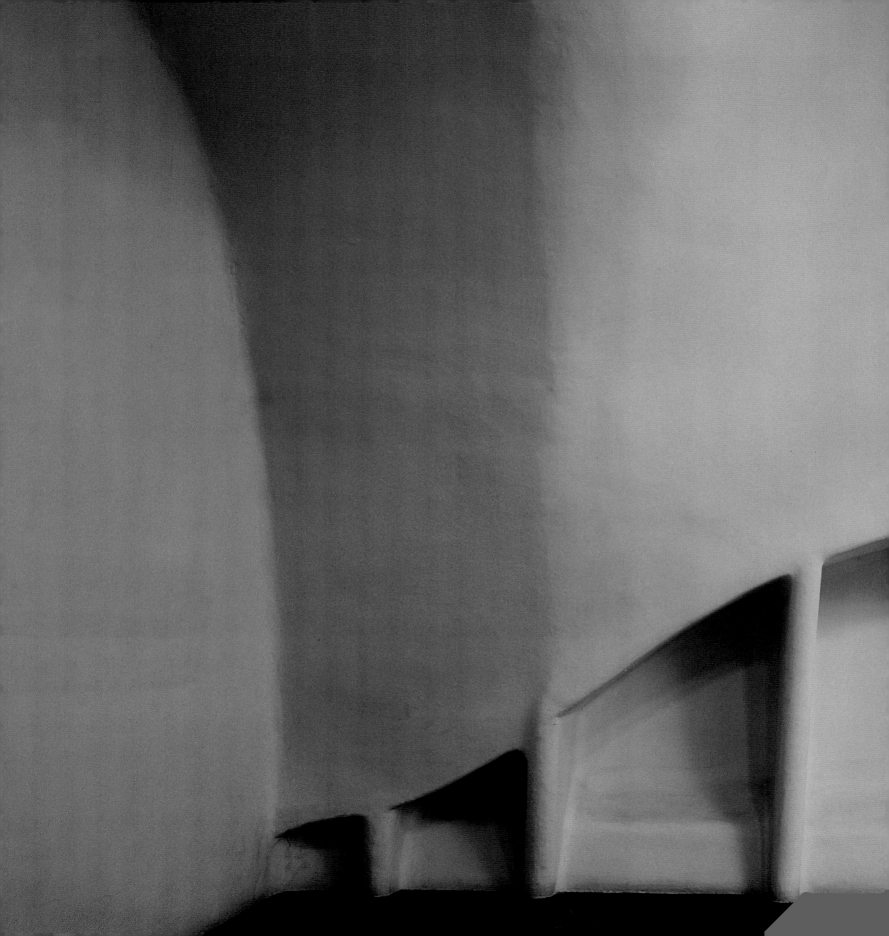

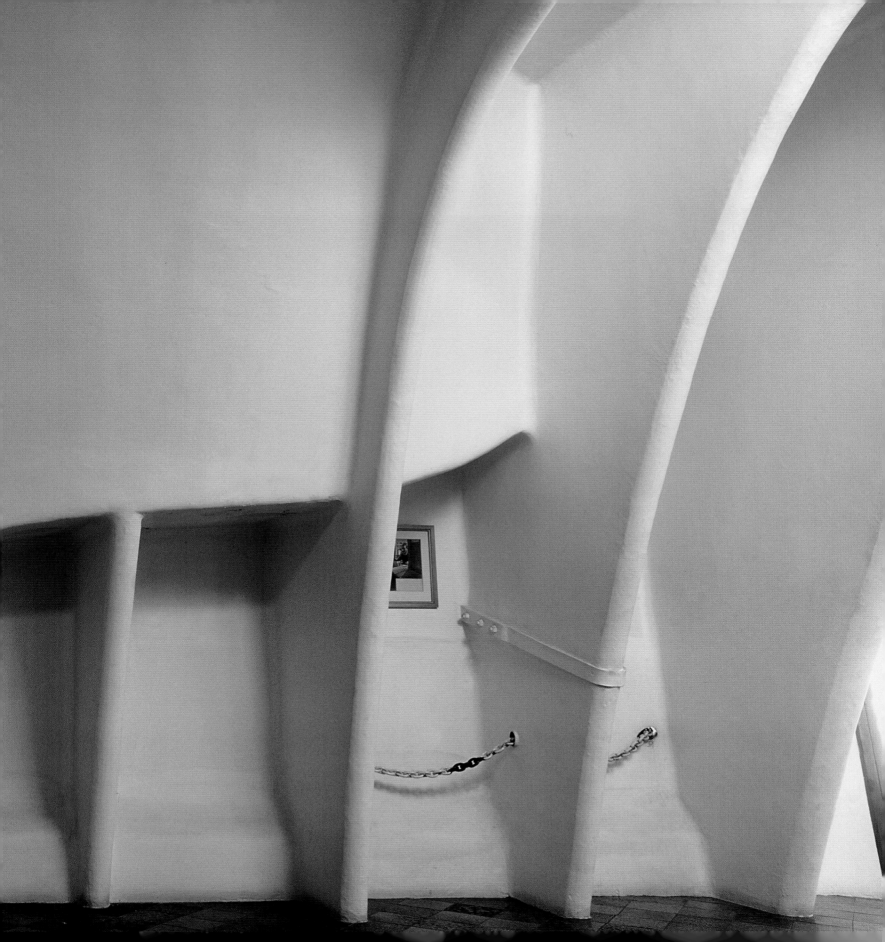

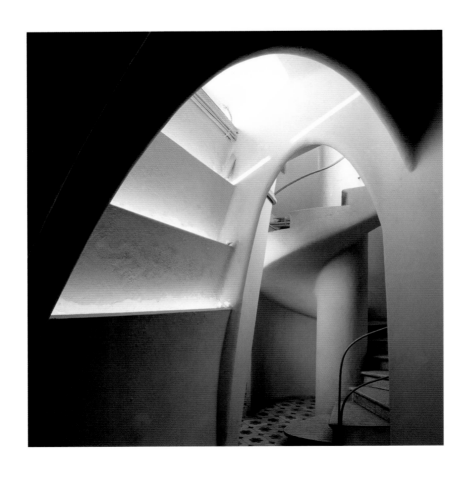

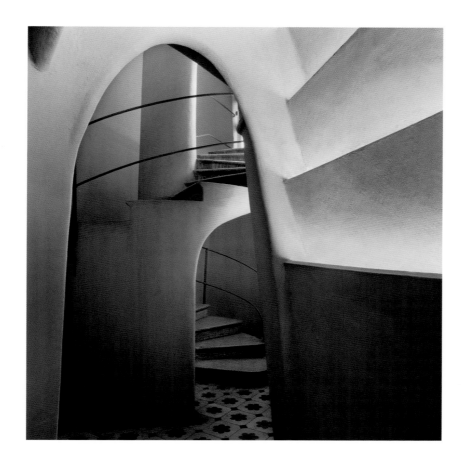

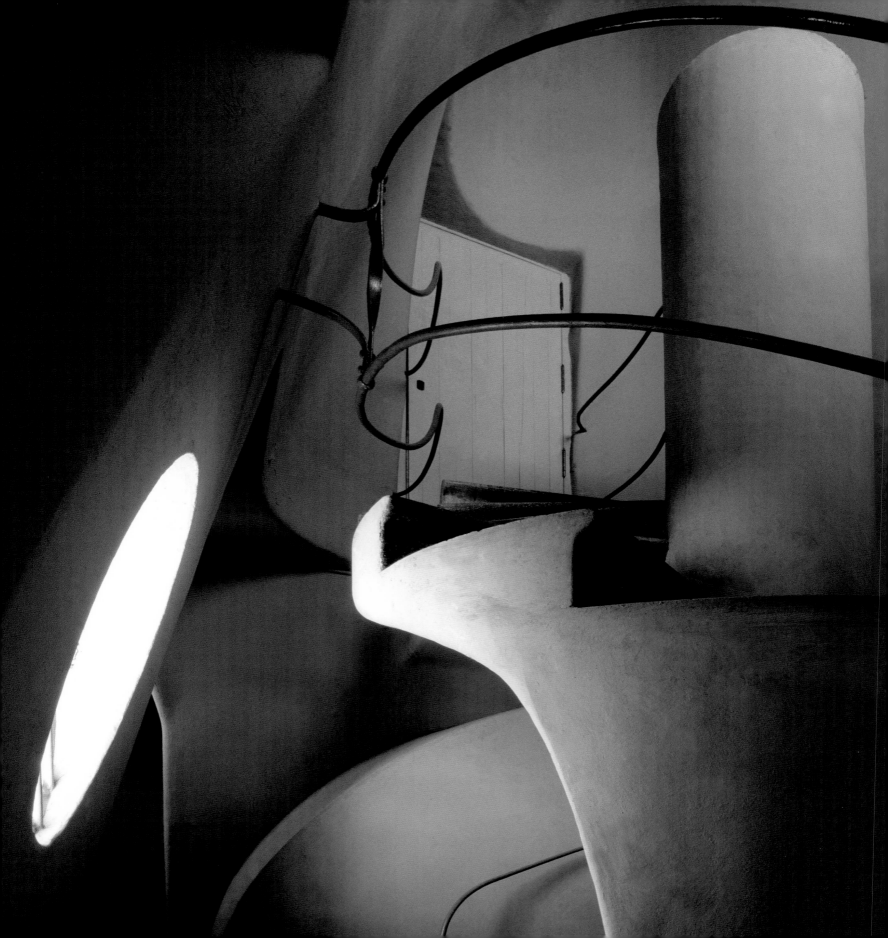

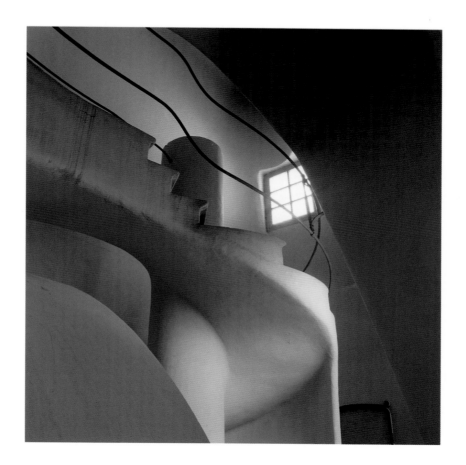

The illumination and ventilation of the corridors surrounding the courtyards is produced by means of some latticework that remind one of the fixed slats of giant blinds, allowing a filtered light to pass through which slides along the walls, ceilings and the rounded, edgeless partition walls.

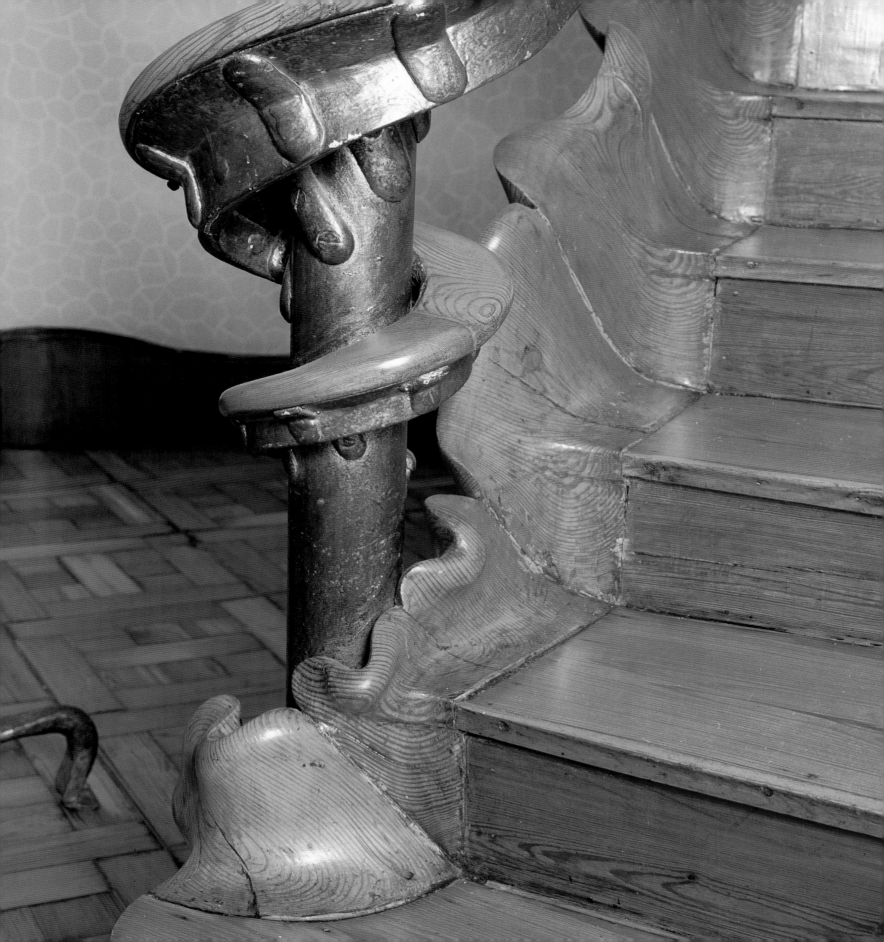

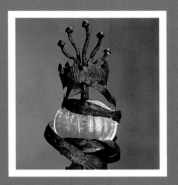

Casa Batlló

Private stairway

The private lobby contains the stairway leading
directly to the Batlló family's home on the first floor.
The oak stairway takes up practically all the space
and the carved pieces at the top of the steps follow
each other like vertebrae following the typical undu-
lation of some prehistoric monster's backbone, a
gigantic fossil inside a cave. The banister revolves
around a metallic central column enveloped by
two strips, also made of metal, which roll around it
in contrasting spirals. These hold a glass ball aloft,
crowned by tentacles, evoking the solidified splash of
a drop or the crown culminating a sceptre.

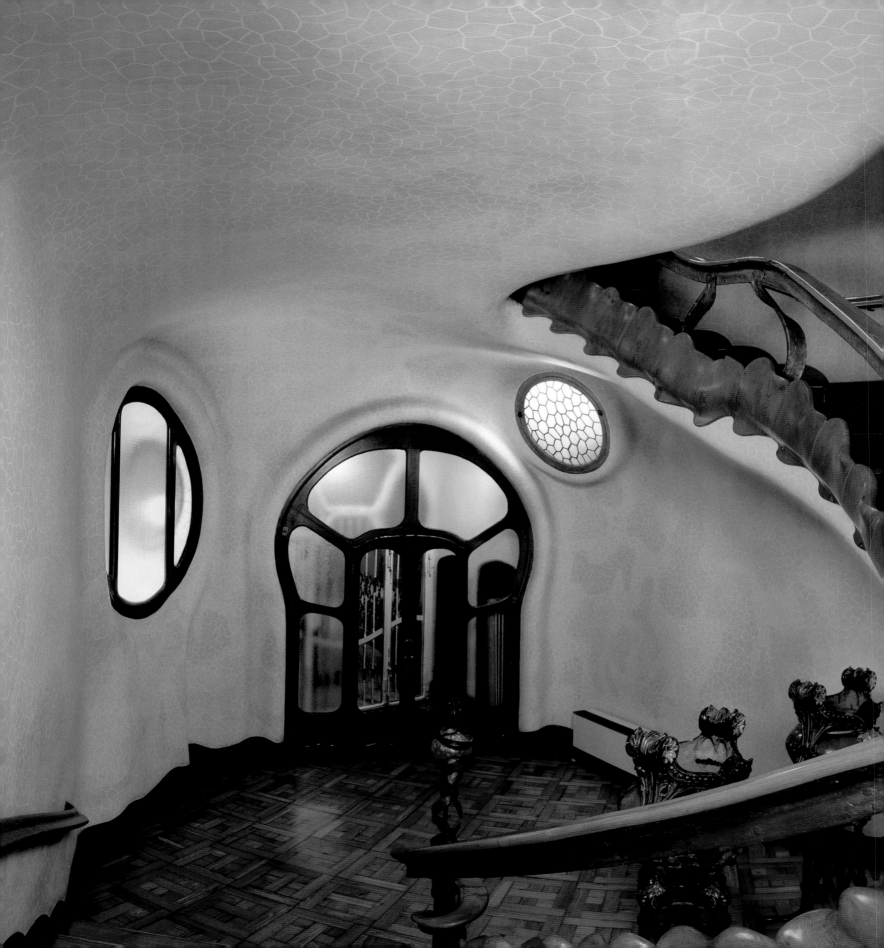

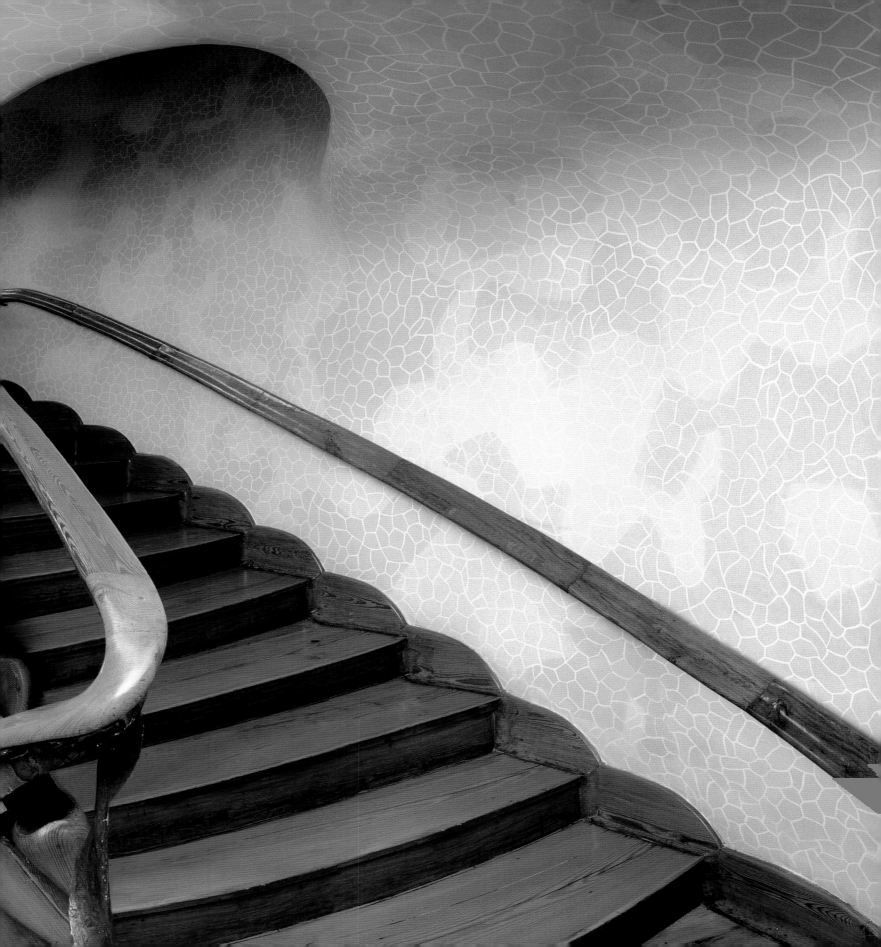

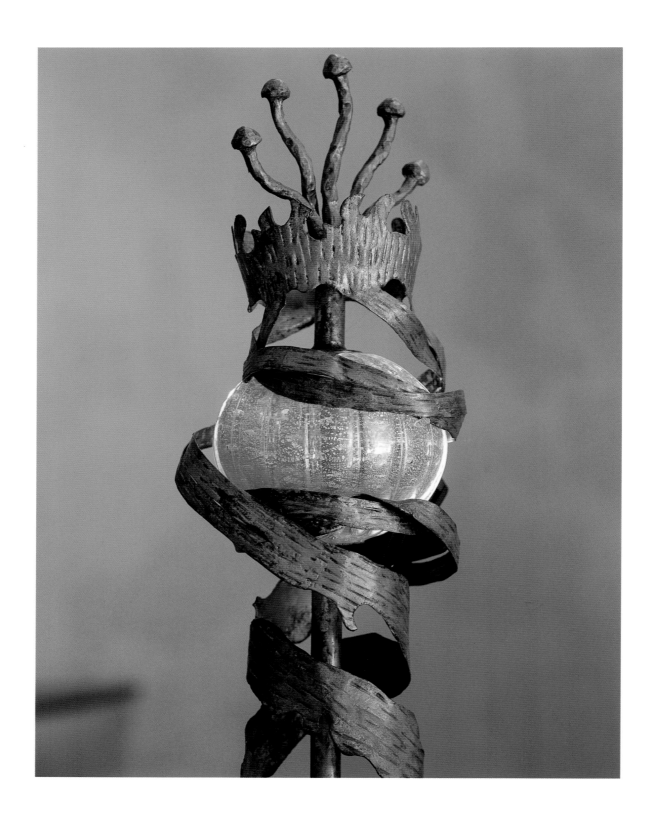

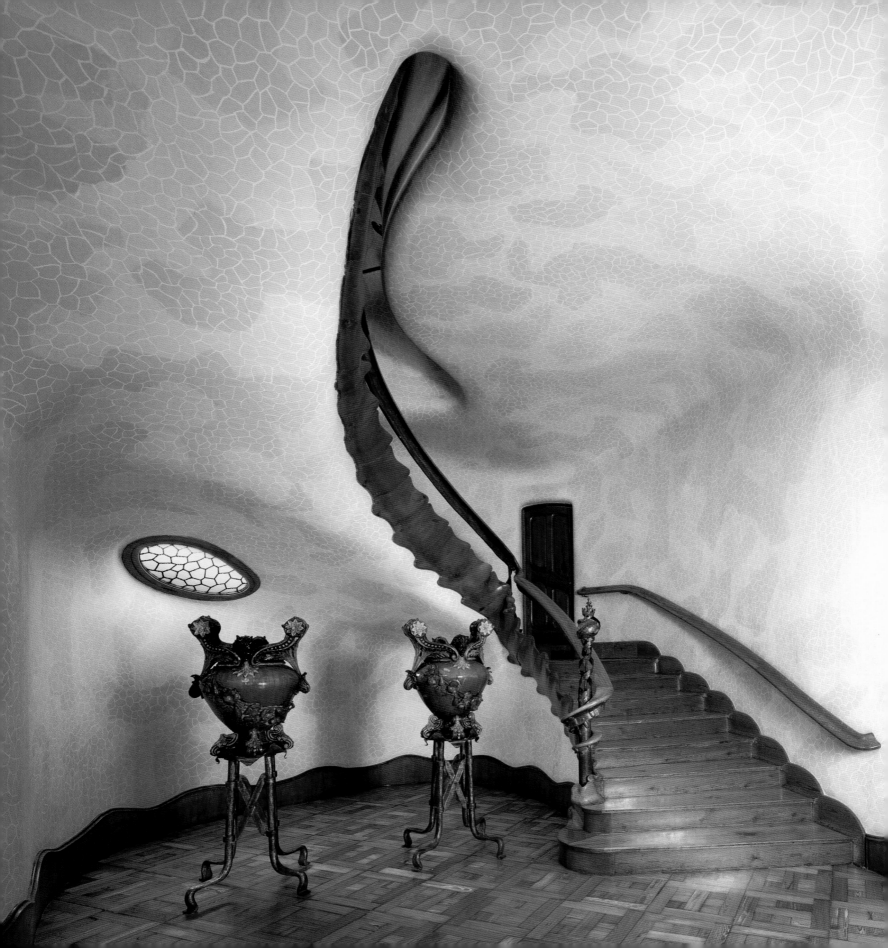

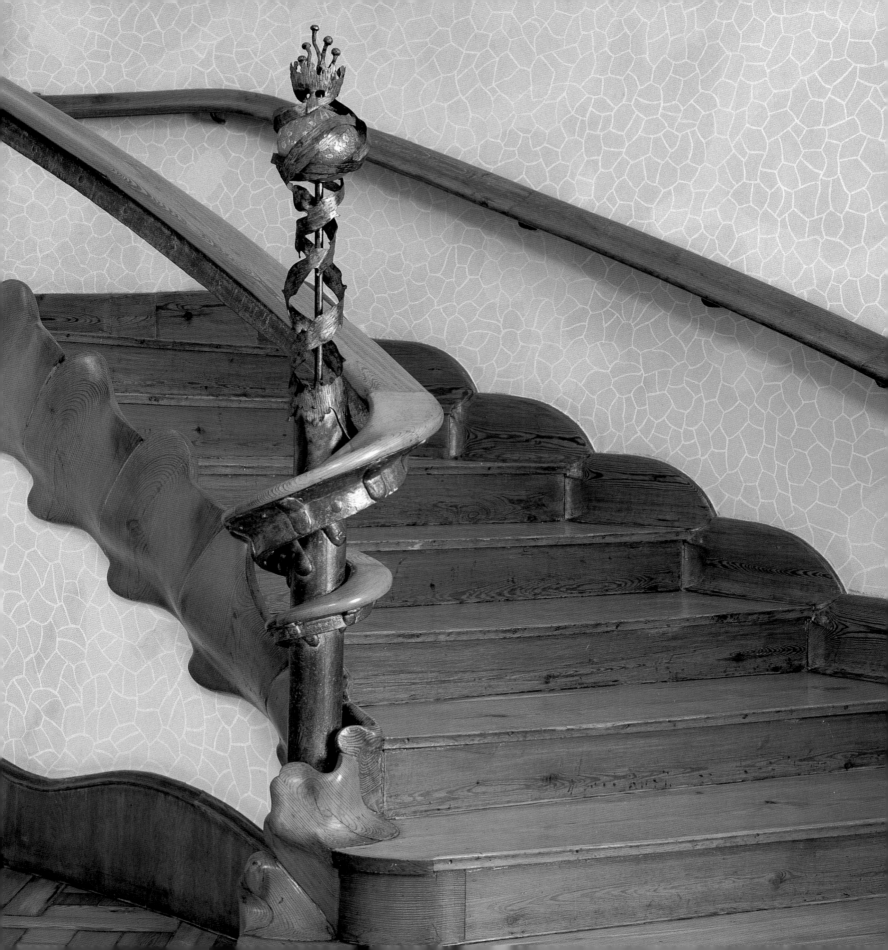

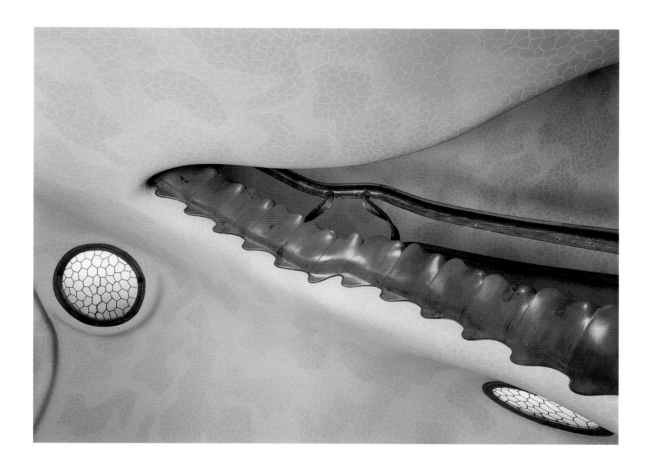

The continuity of the walls and ceiling, along with absence of corners is even more evident in this private lobby than in the main lobby. The smallness of the space seems to have been entirely occupied by the fossilised backbone of the stairway. On reaching the top, the skylights of circular glass manage to evoke the sensation of an underwater grotto even more, like those built in the aquariums for the universal exhibitions of the time.

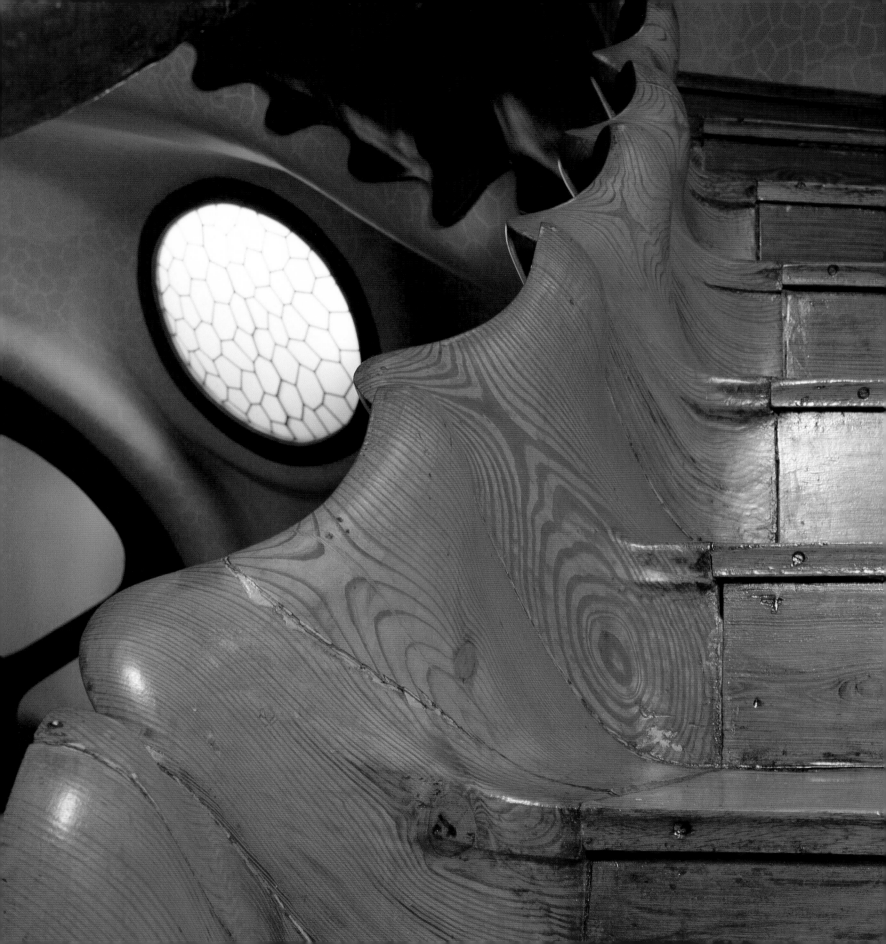

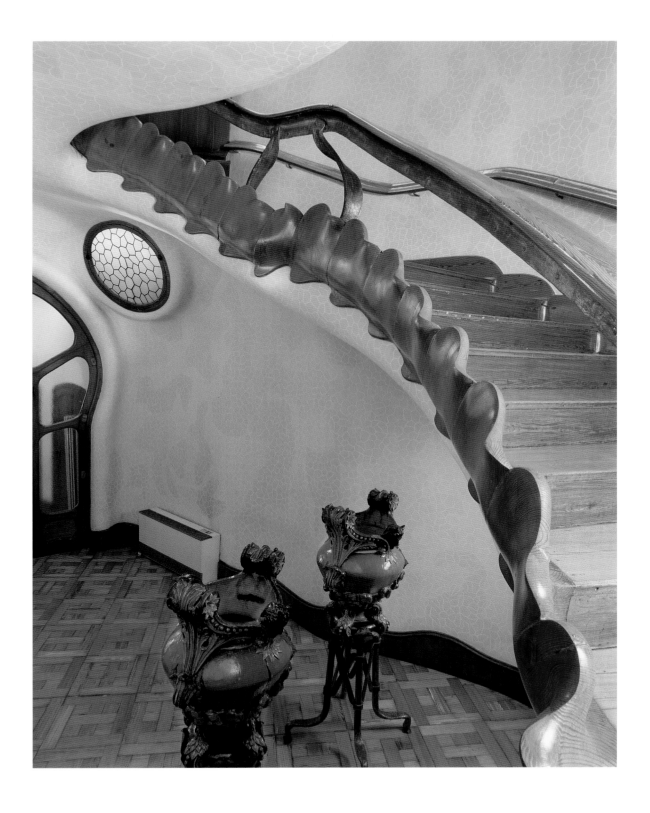

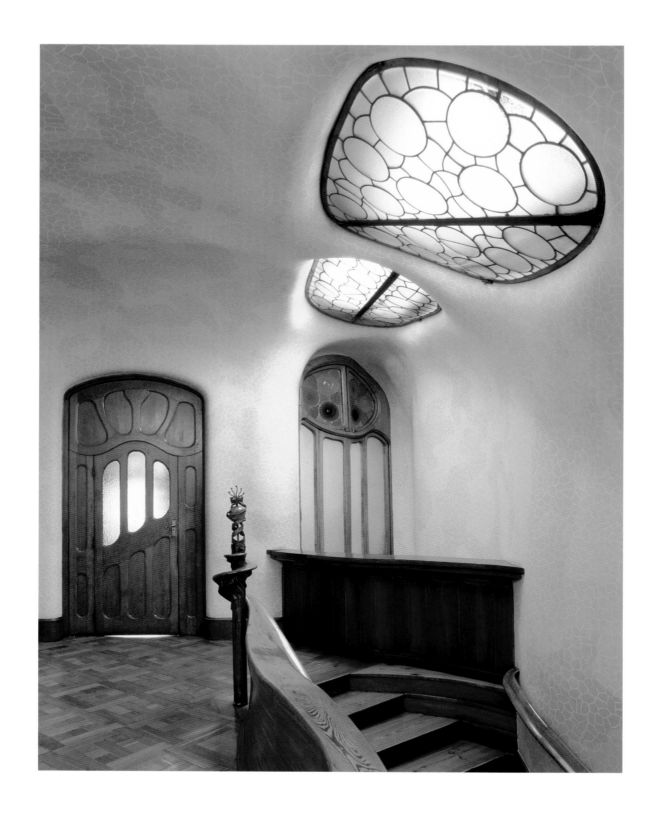

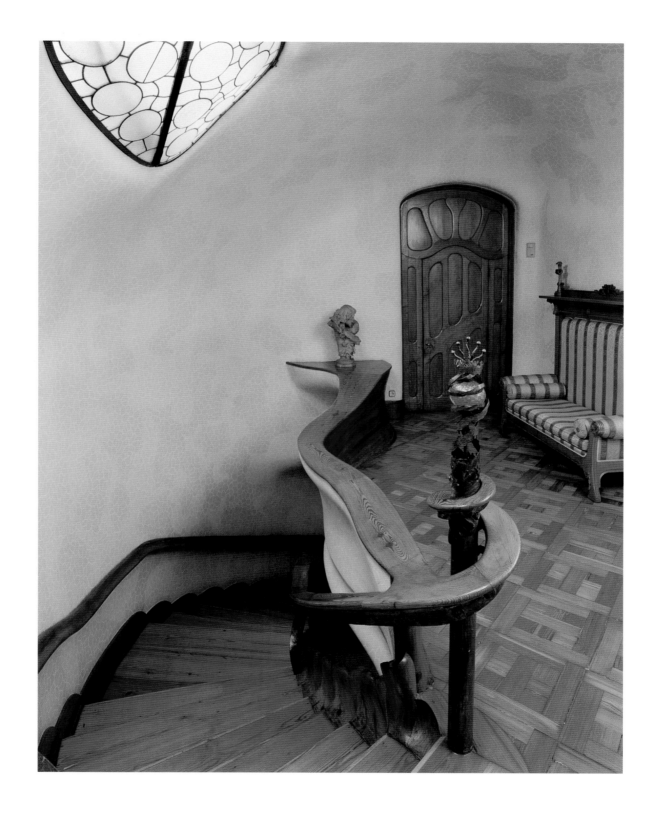

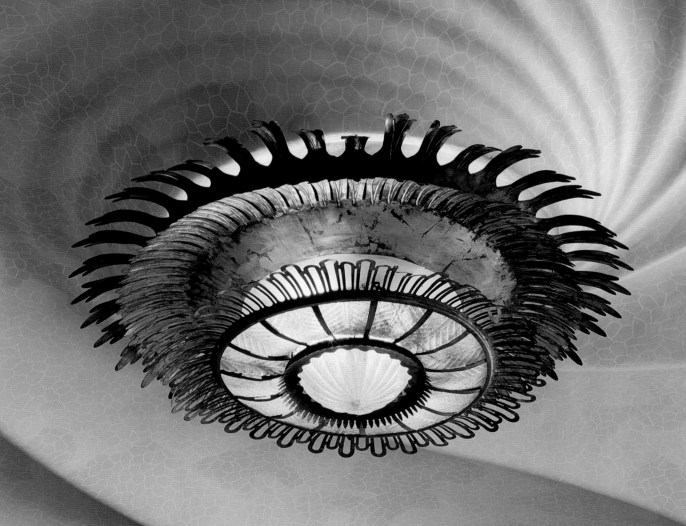

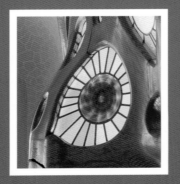

Main floor

The first floor was the residence of the Batlló family. It was essentially distributed into two parts. On one side were the rooms forming the facade that looked out over Passeig de Gràcia, behind the stone gallery. This was where the more public parts of the house were found and different artists and craftsmen, under the guidance of Gaudí, worked together on the decoration. In the central salon, for example, was the chapel, today disassembled, which contained a Holy Family by Josep Llimona with a frame by Gaudí himself, a crucifix by Carles Mani, some candelabras and sacred objects by Josep Maria Jujol, and a tabernacle by Joan Rubió i Bellver. On the other side, at the opposite end of the house, facing the block courtyard, were the more private rooms and the dining room, for which Gaudí designed the furnishings.

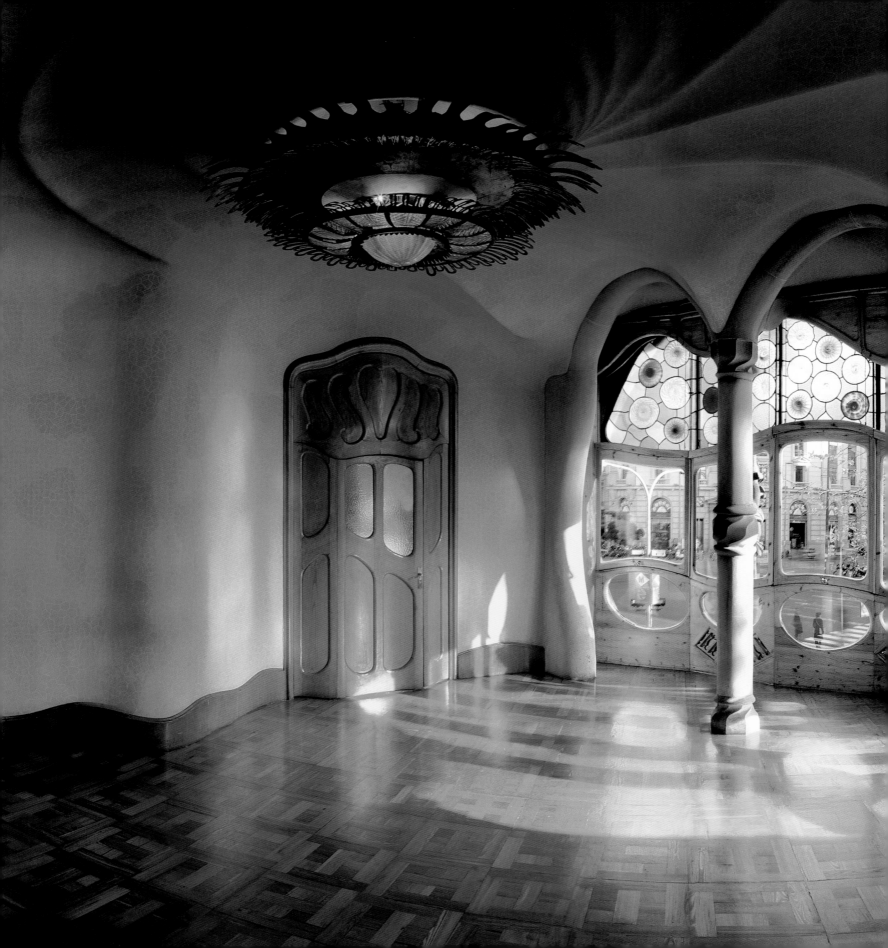

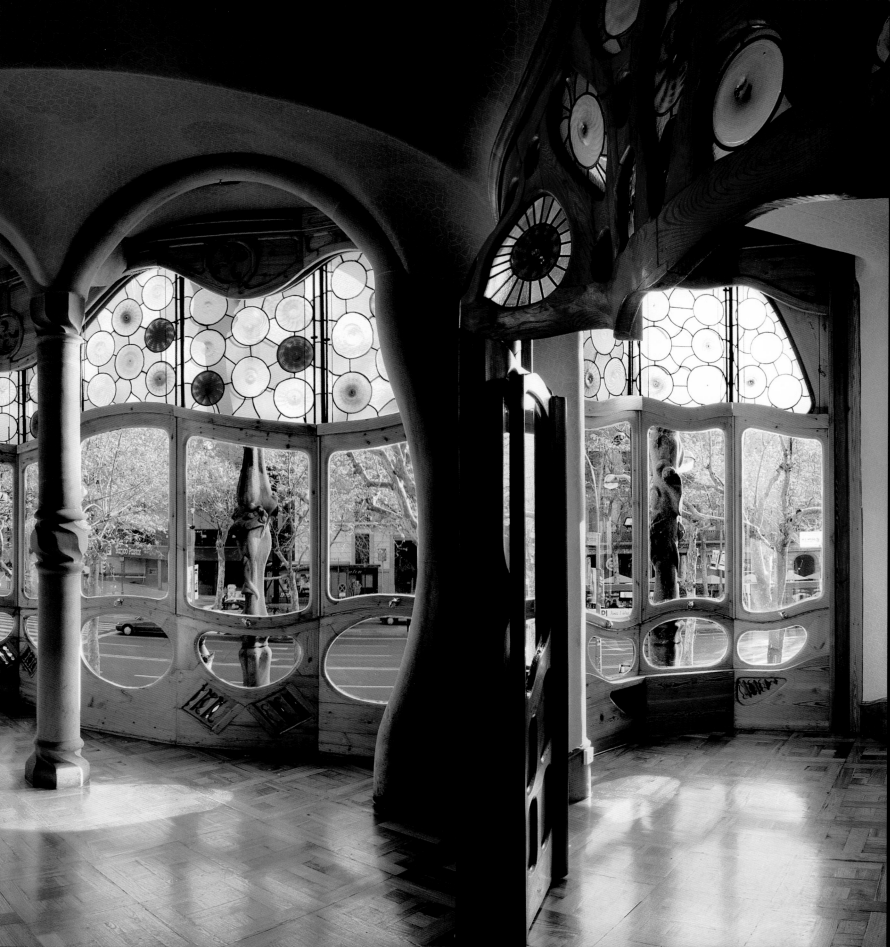

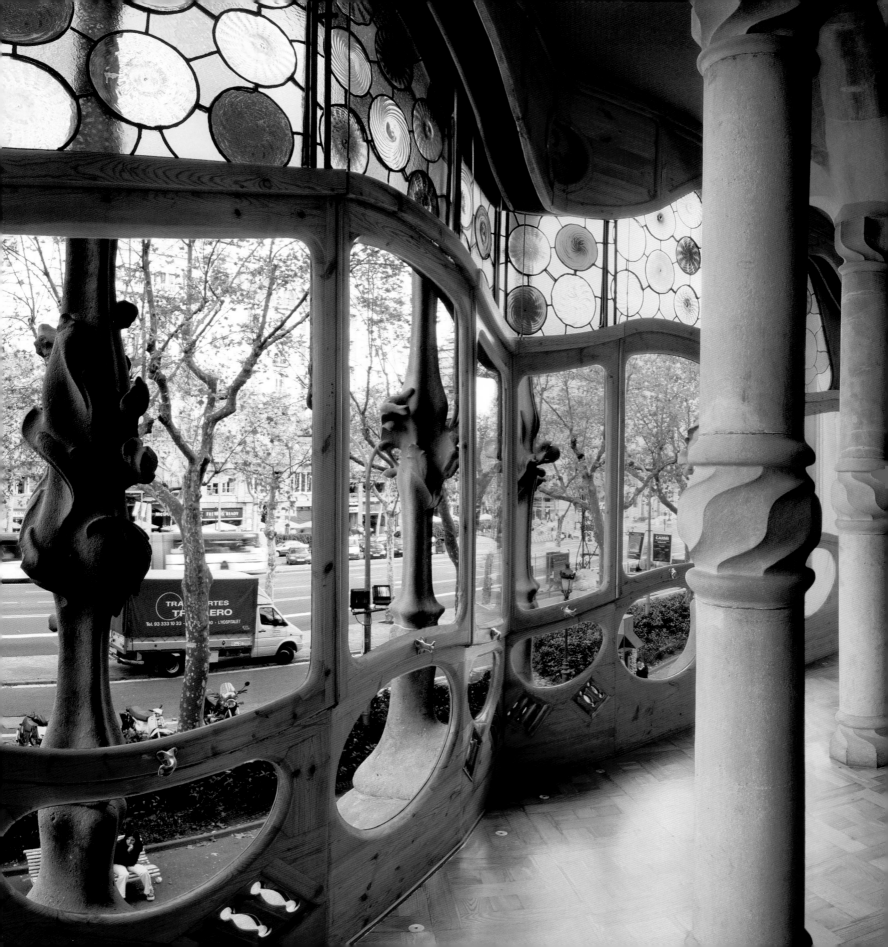

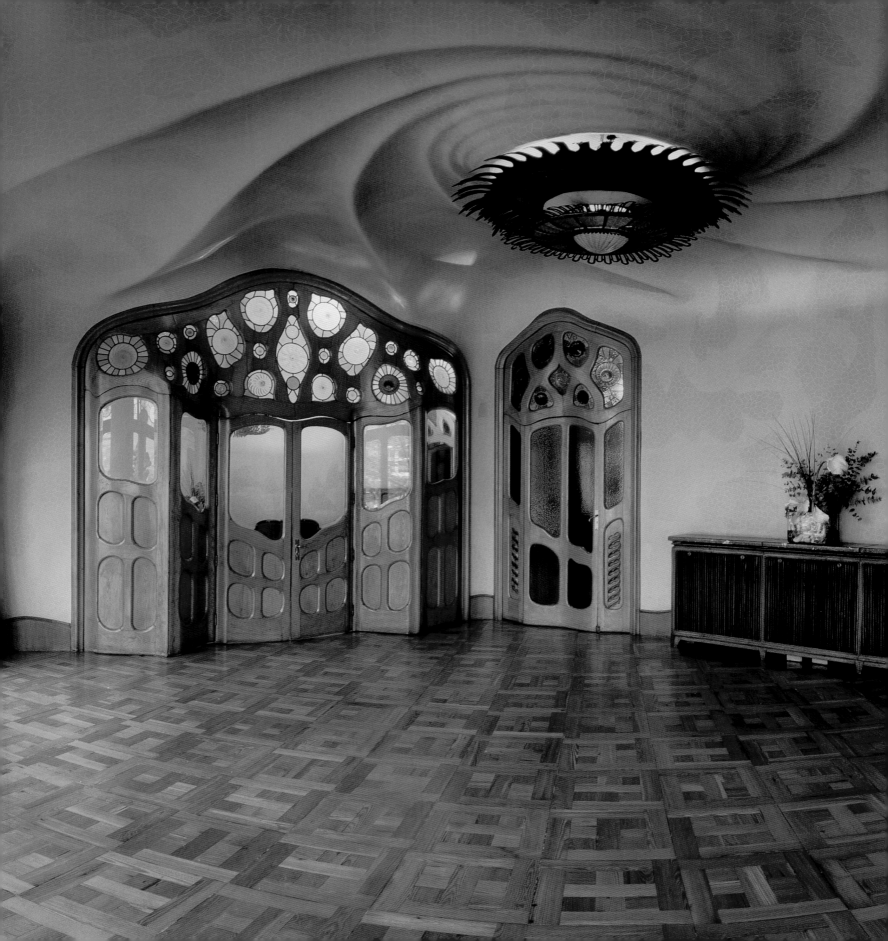

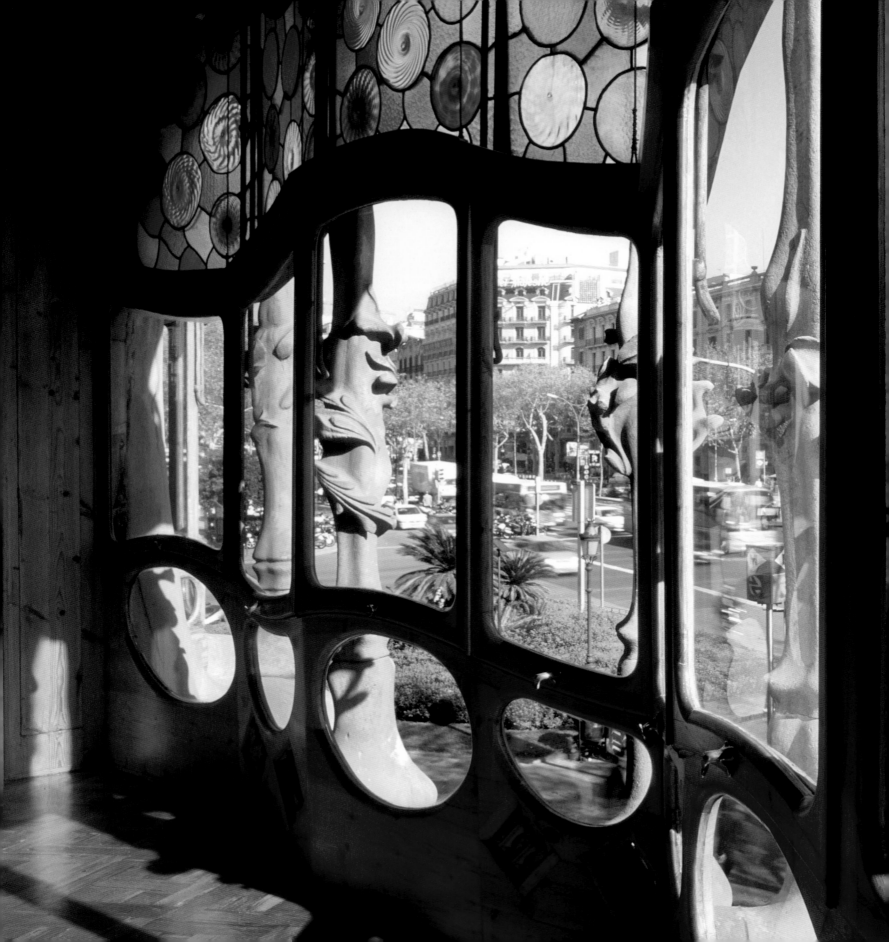

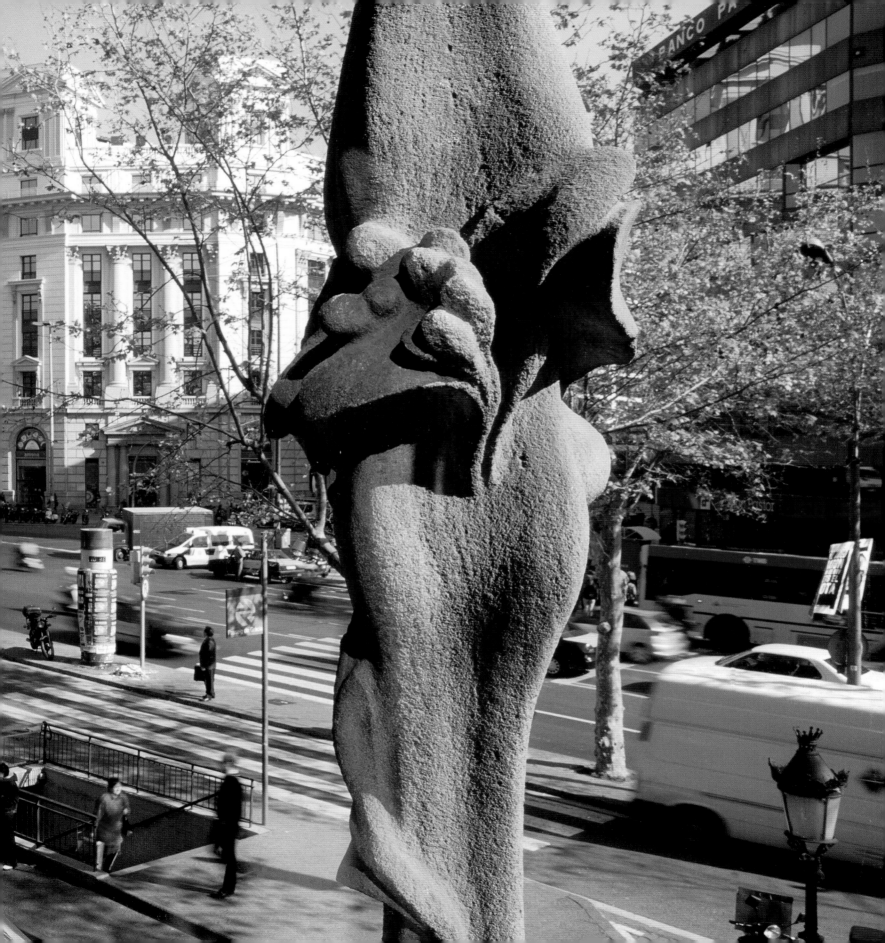

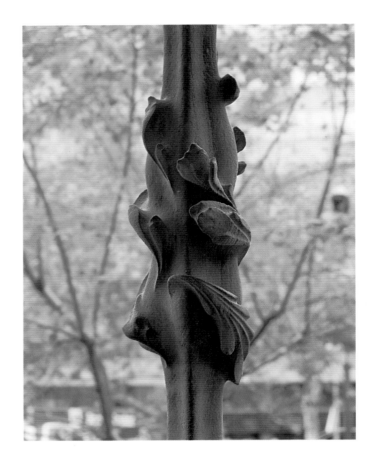

The main rooms open up to the street through the stained glass windows, the bluish coloured ceramic glass discs of the grand gallery, and connect through undulating oak doors, also with coloured discs, whose panels, developed in three dimensions, can be fully opened, turning it into one single open space. The ceiling of the central salon is smooth plaster that forms a whirlpool which, as well as forming a new marine reference, refers to, as so often in Gaudí's work, the idea of nature being generated.

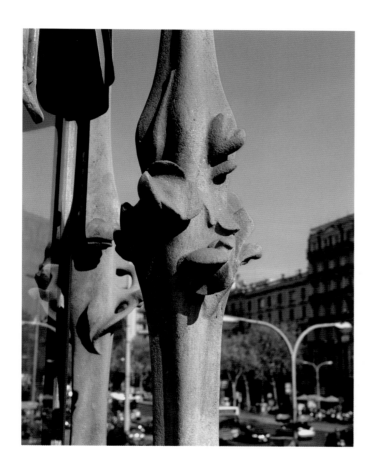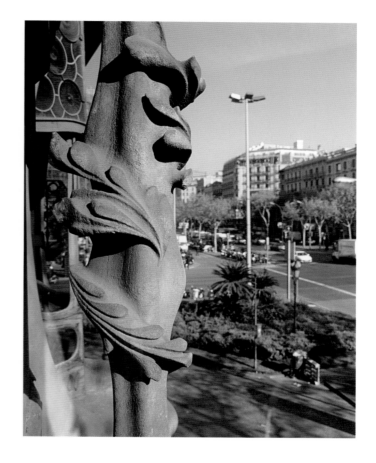

The wooden windows of the gallery are sash windows and operate by means of counterweights hidden in the ends, but there are no jambs or transoms between them, so that when they are all open at the same time there is an unimpeded view out to the street. Alternatively, on the thin columns of the gallery you can see how, among the joints of the bones, some fleshy leaves are sprouting, with which Gaudí once again, as in the case of the whirlpool on the ceiling, refers to the constant regeneration of all creation.

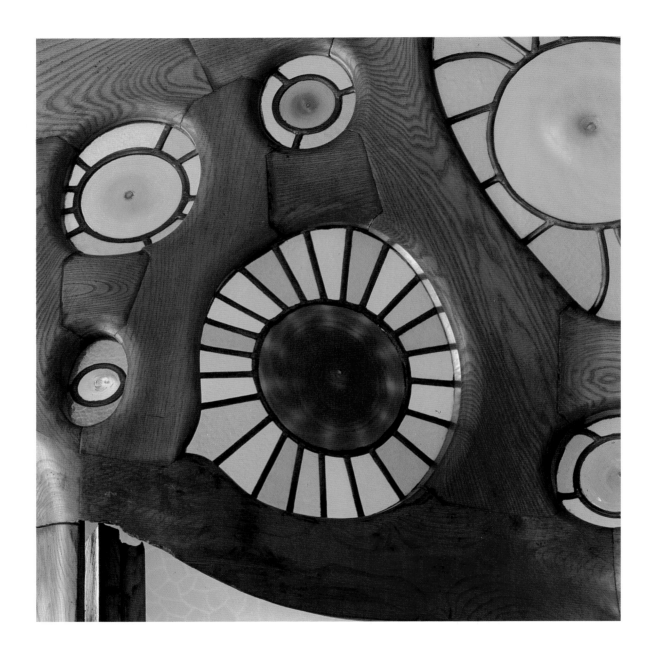

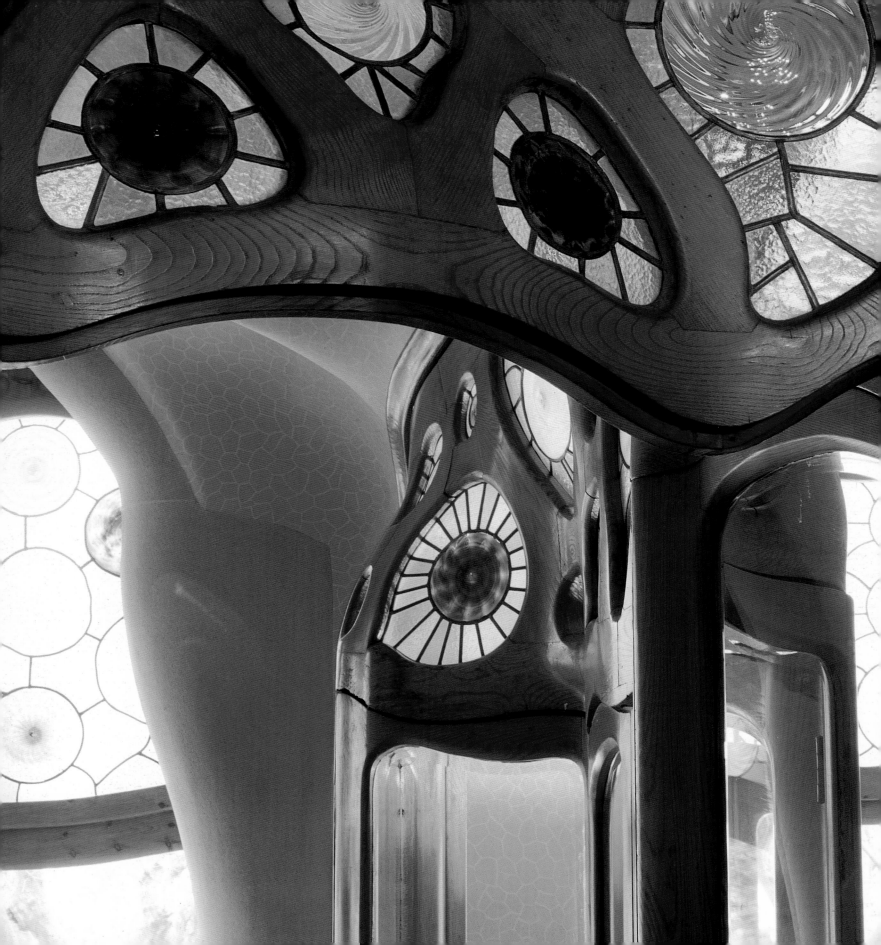

The closures of the Casa Batlló, always in oak, have a wide range of shapes, and their curved frames are adapted to the softness of the hollow spaces. Furthermore, Gaudí devised a particularly complex system of joinery. In some of the windows, doors and skylights, as well as the usual glazed panels, some small wooden grilles can be independently opened, thus enabling air currents to pass through and thus obtaining controlled ventilation in all the areas of the house.

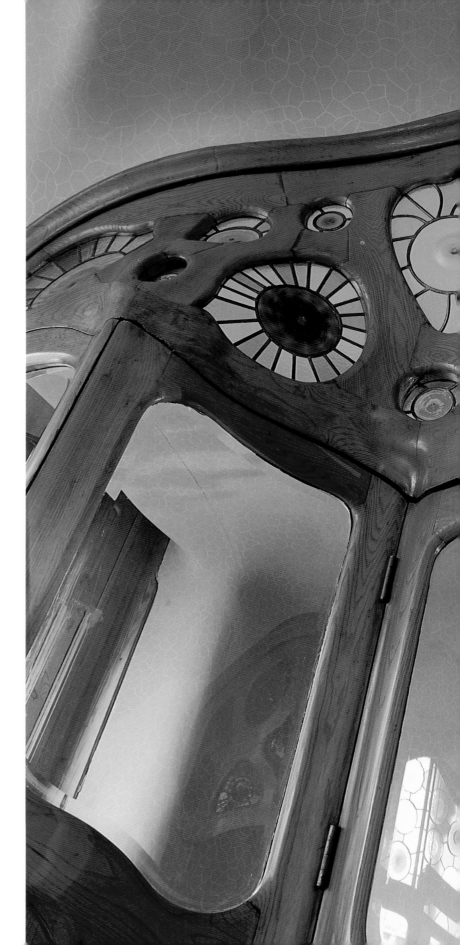

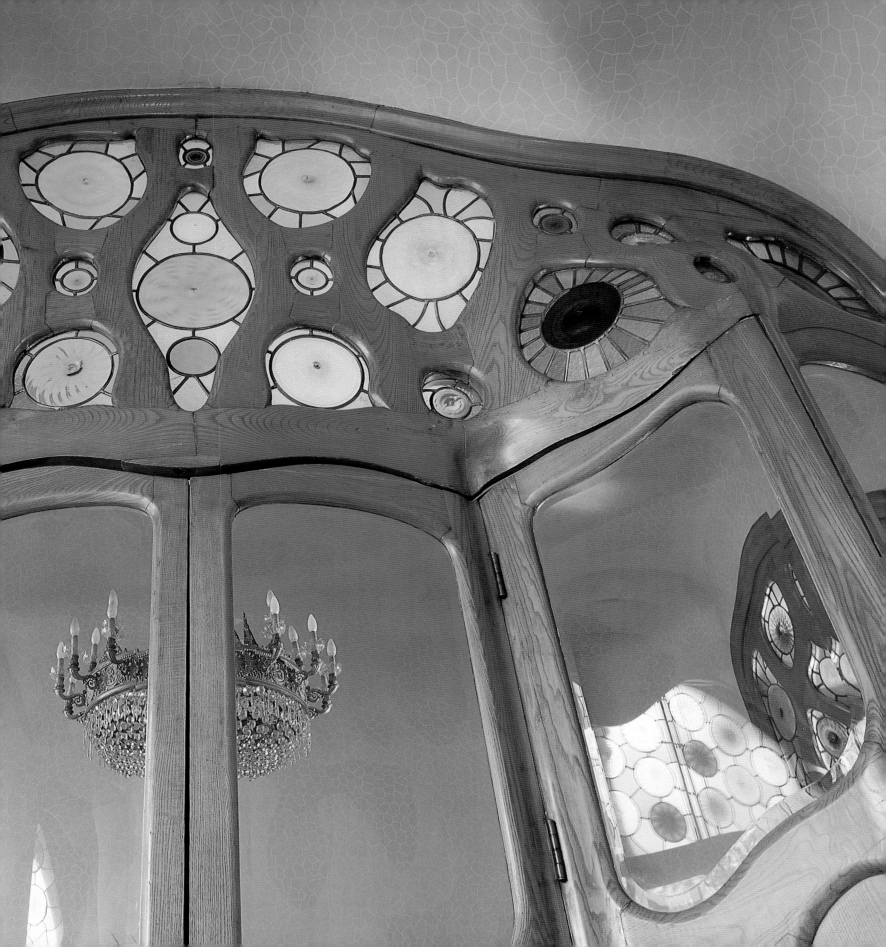

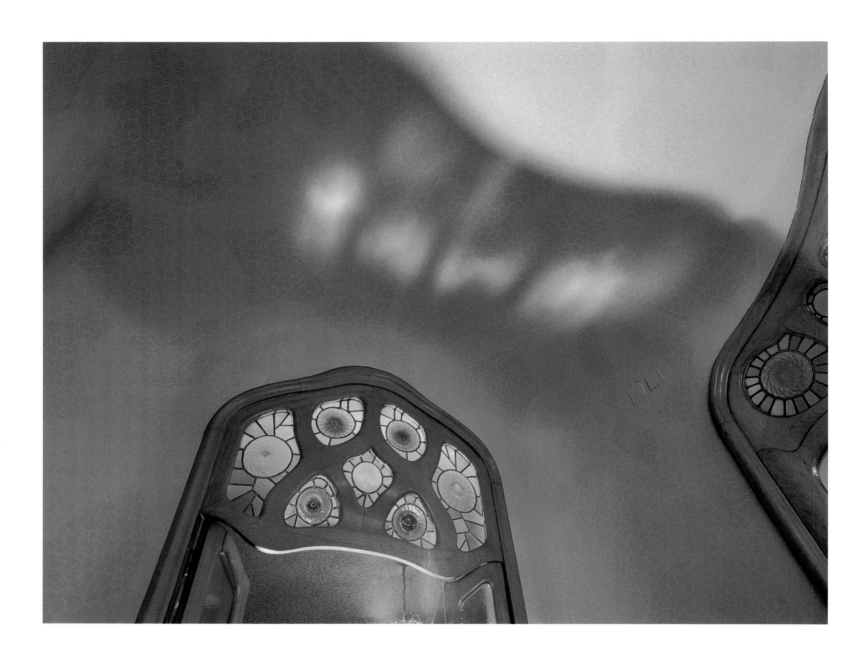

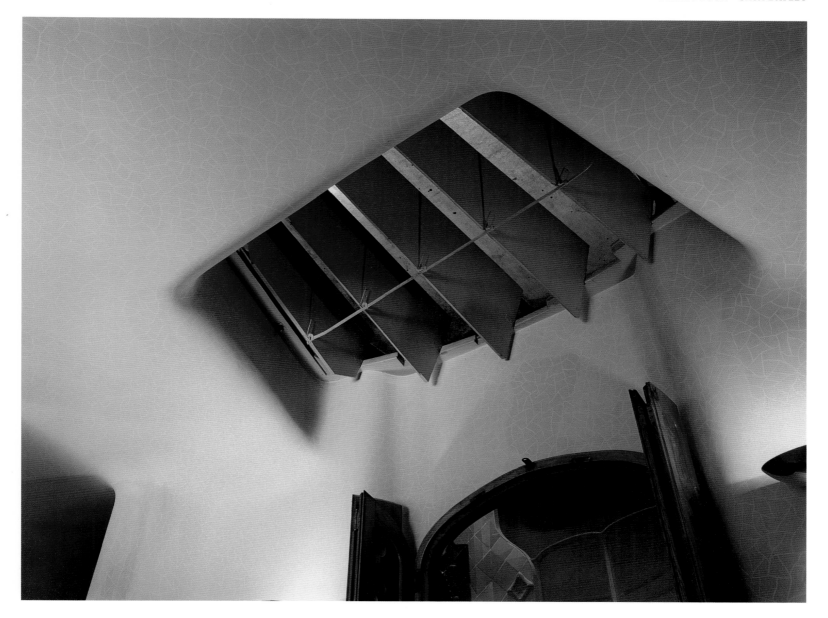

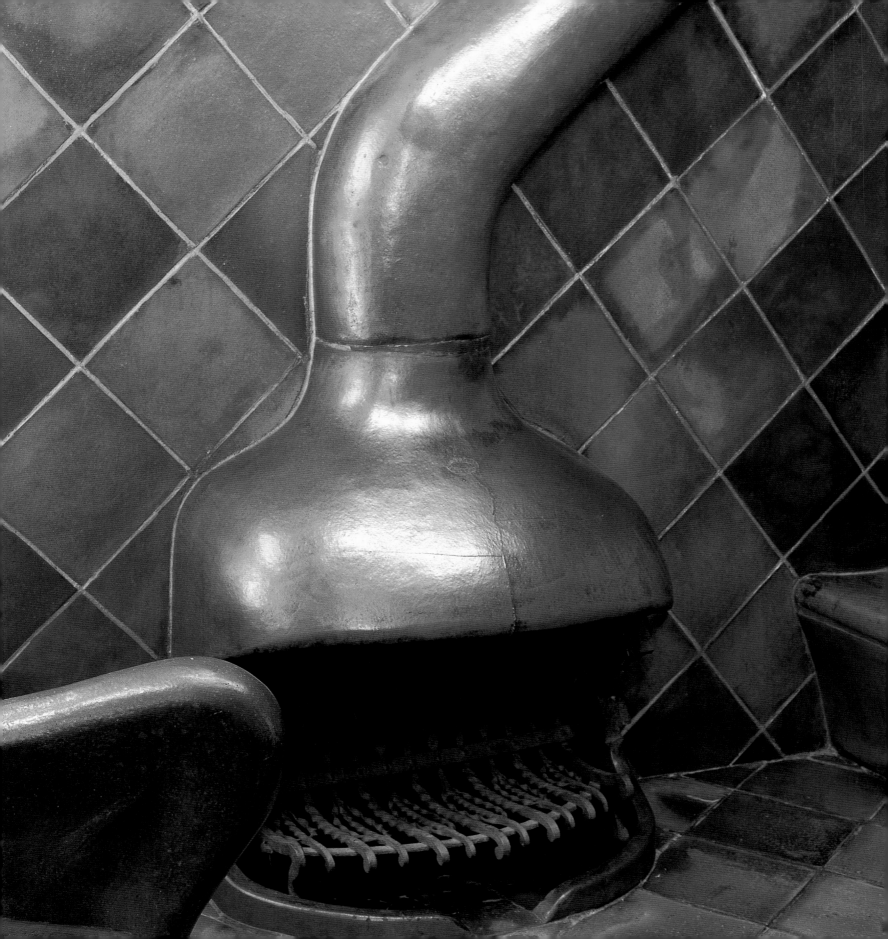

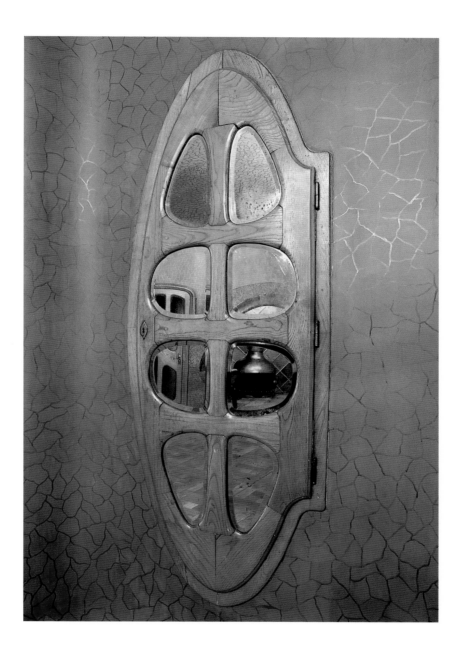

Between the stairway and the main salon is a small area of rounded forms that contains a fireplace. Like the benches in the hearth of traditional homes, a symbol of family unity, this has been fitted into a small niche in the wall, which also contains some benches. The finish is in heatproof ceramic tiling.

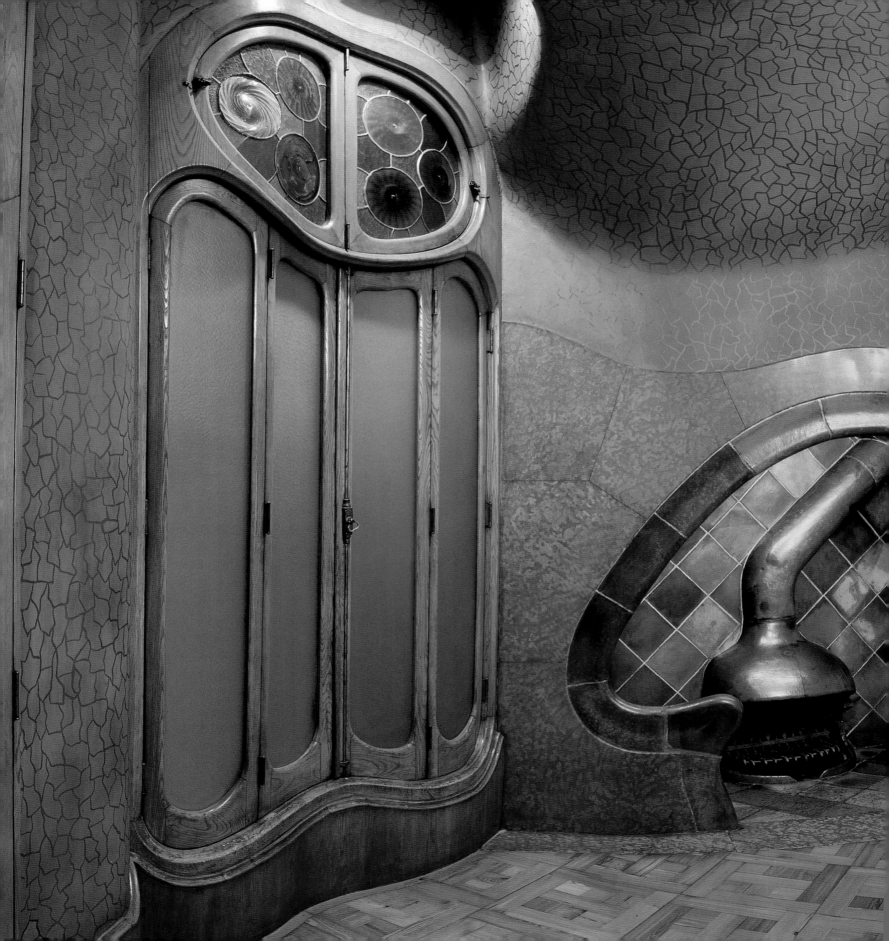

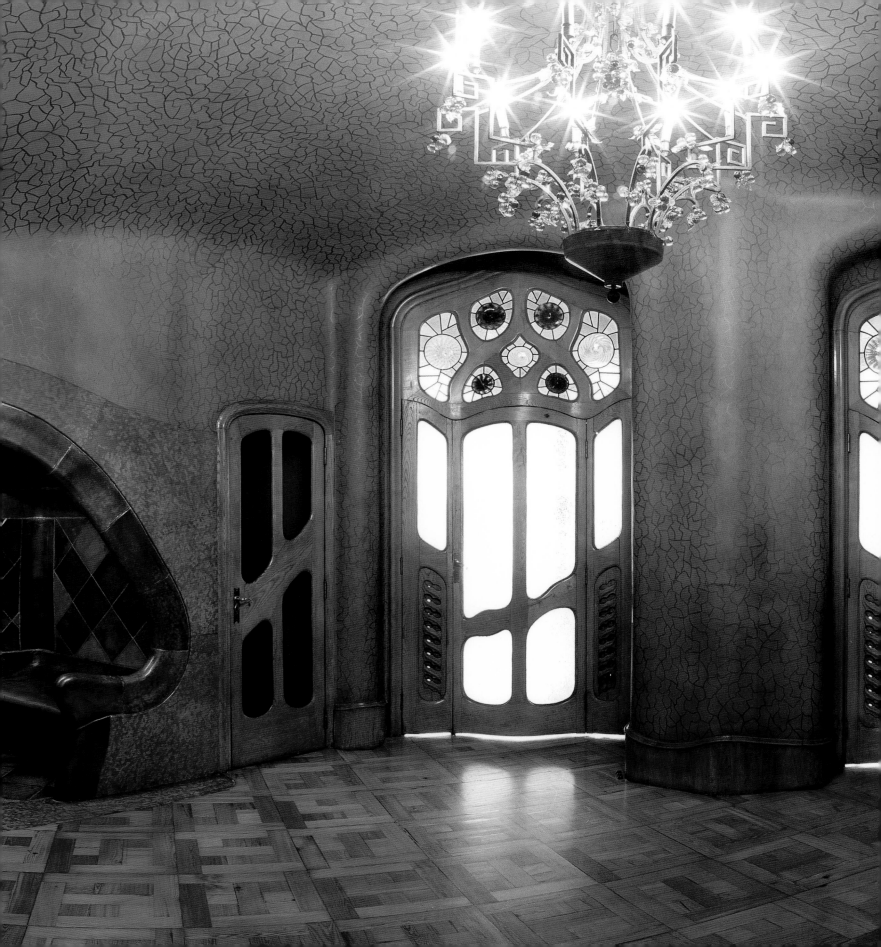

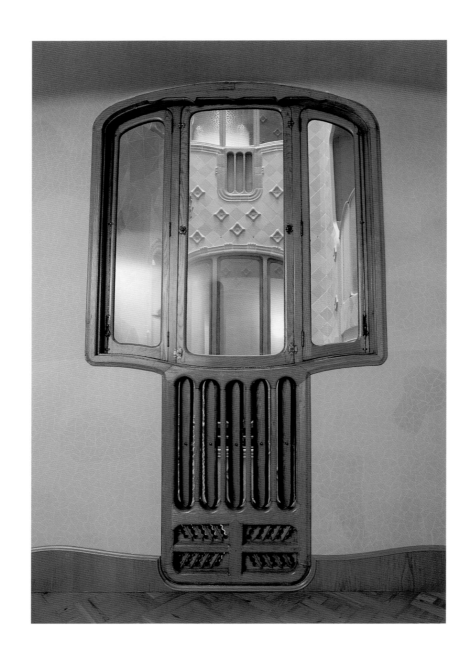

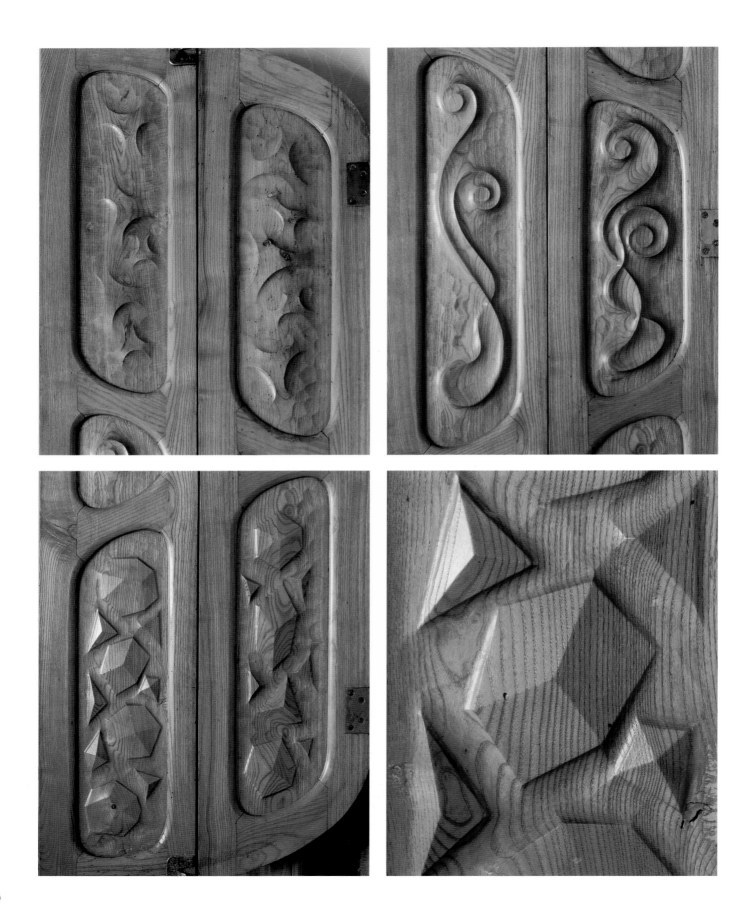

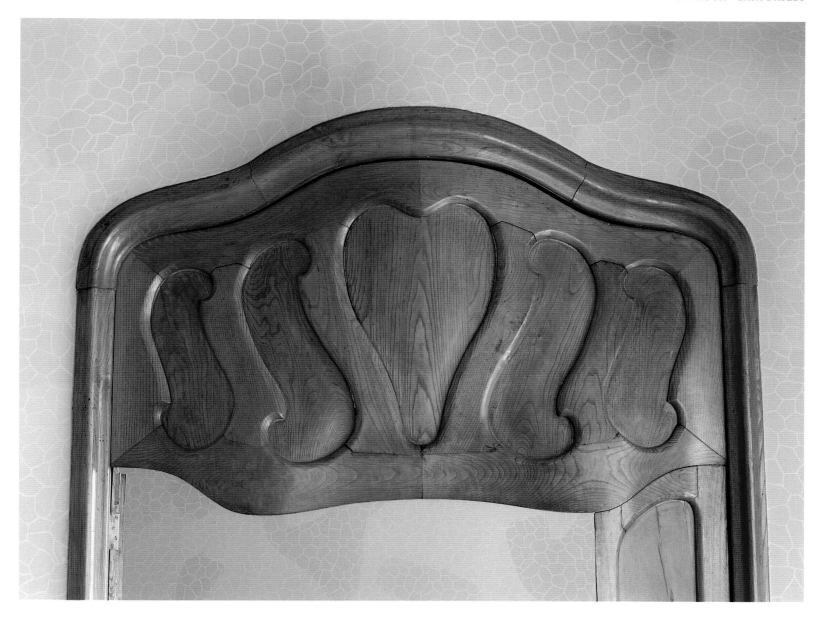

Apparently contradictory shapes have been carved on the oak wood joinery. Some are based on the curve and the idea of continuity expressed by it while others are of a geometric cut in a crystalline way of abstract forms. Gaudí thus refers to the complementary aspect of the worlds of nature – animal, mineral and vegetable – and in the connection established by creation in its continuous generation between the organic and the geometric.

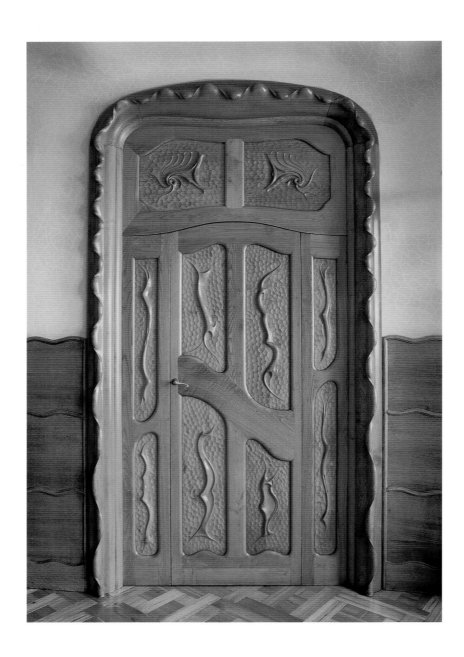

The spiral is the shape of the nebulous, the shape that takes the generation of all the created world, the splendid image of the *perpetuum mobile* of matter. Apart from the great whirlpool in the main salon, there are other smaller ones that can be found all over the place. It is also worth remembering that Gaudí had designed a hydraulic mosaic flooring for the Casa Batlló with sea creatures which, when combined, form spirals, and which was finally used in the Casa Milà.

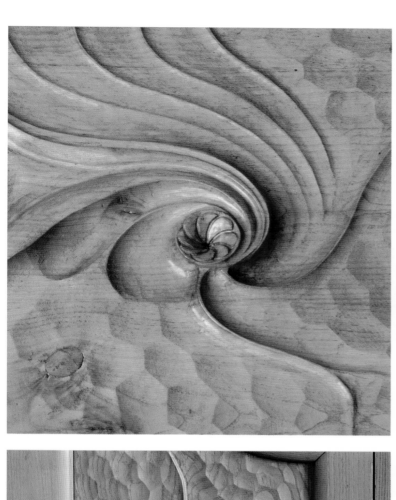

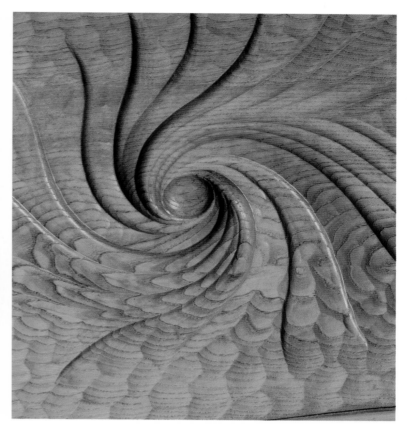

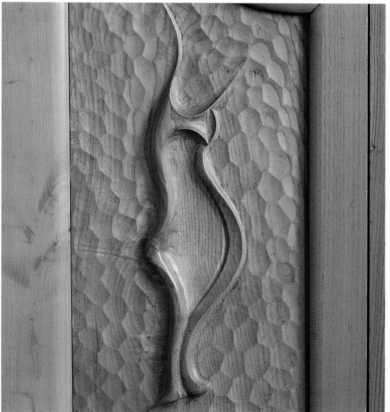

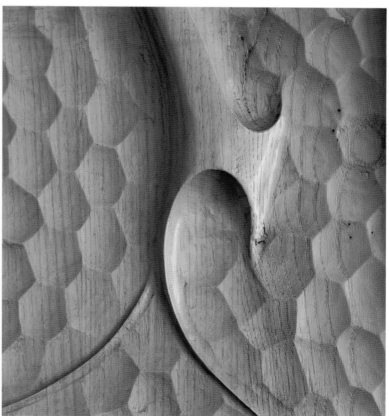

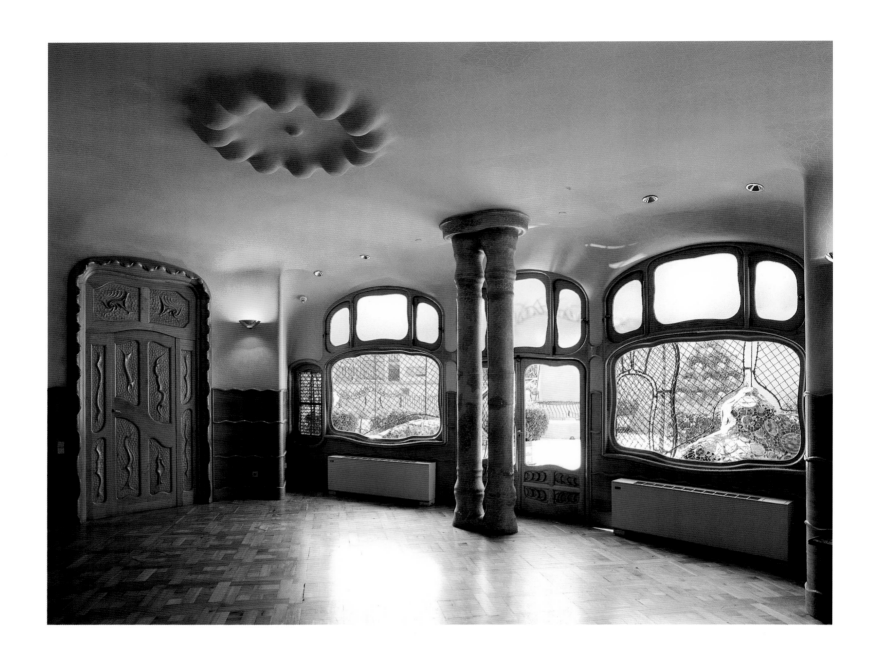

In the rear part of the house is the private dining room of the Batlló family. For this spot, Gaudí designed all the furnishing in varnished oak, consisting of a table, some chairs, a pair of two-seater benches and another of five places, a corner cupboard and some other secondary pieces. This space is today very changed, although the majority of the furnishings can be seen in the Gaudí Museum in Park Güell.

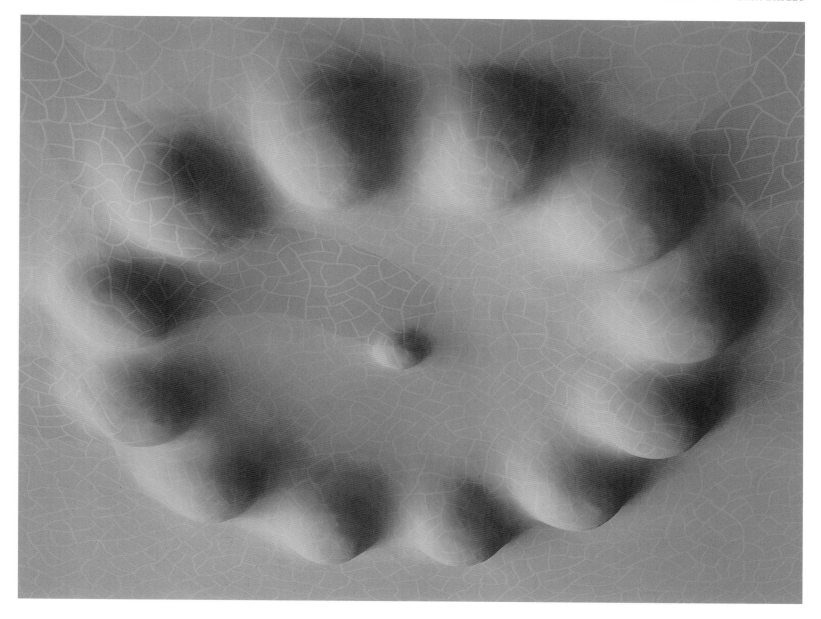

In the centre of the dining room, the smooth ceiling takes on the form of a splash, the drop from which the imaginary waves of creation originate. Some dressers separate this space from the inner courtyard. In the centre of the hollow two thin columns, inspired, as so often occurs in Gaudí's work, by the Lion's Courtyard in the Alhambra, show us some morbid capitals and bases, softened and worn down by a long period of erosion.

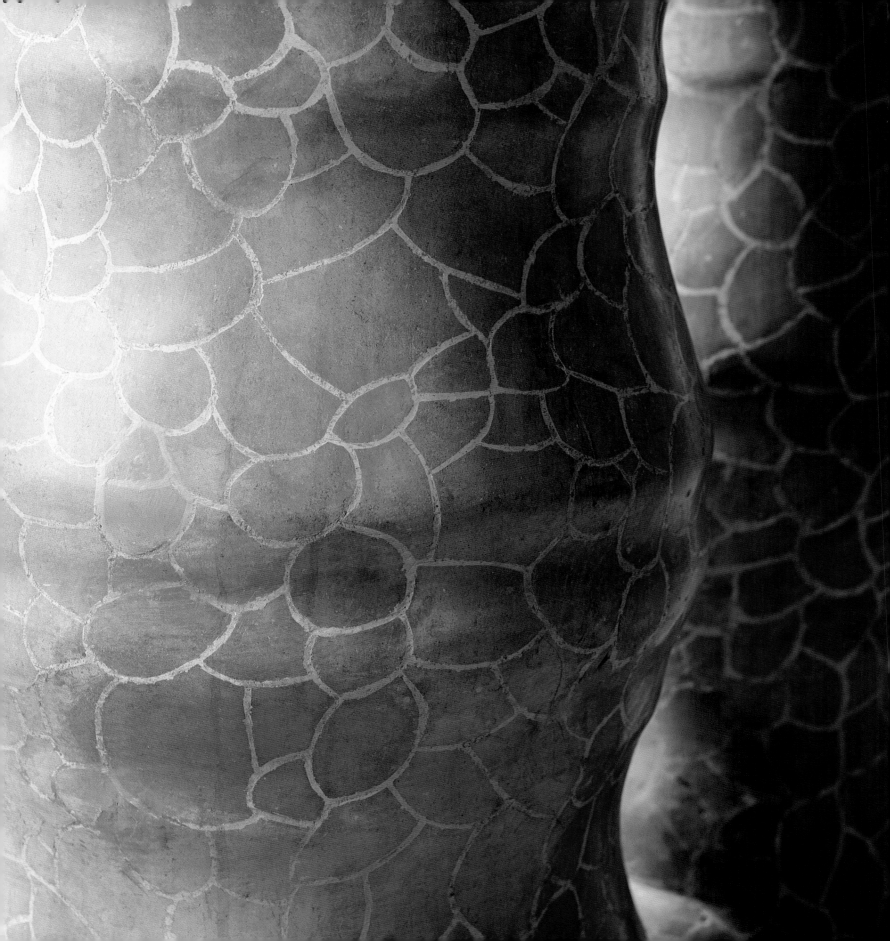

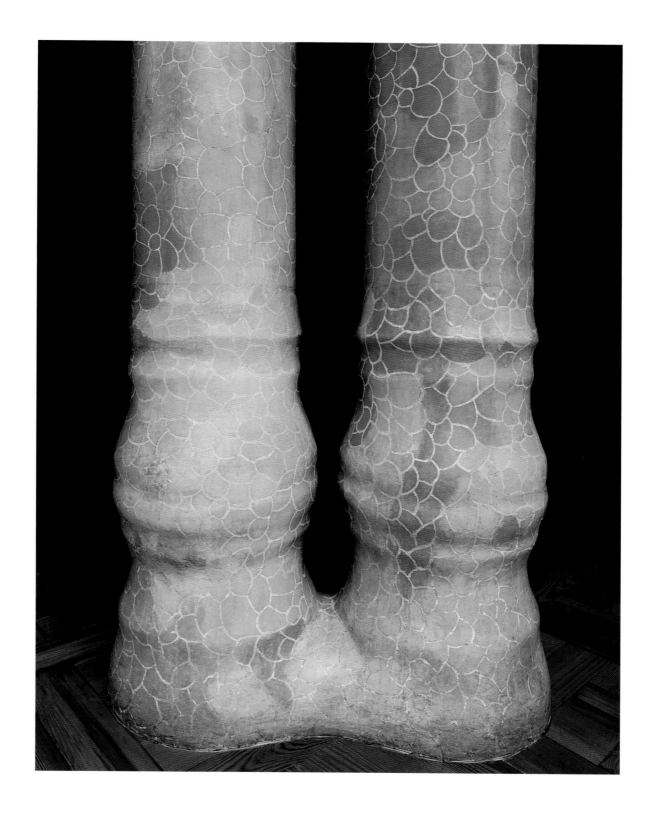

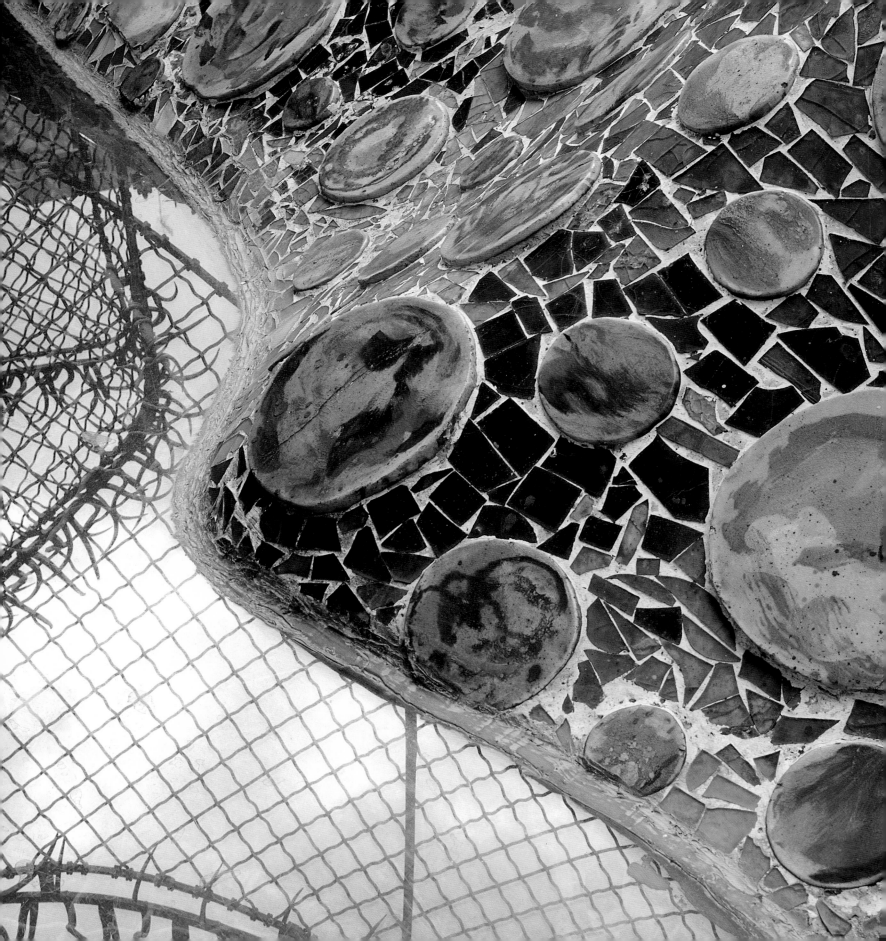

CASA BATLLÓ

COURTYARD AND REAR FACADE

The rear facade of the building is organised through the superimposition of continuous balconies which open into the large dressers of the different flats. The rail of these balconies and part of the floor are made up of very transparent iron grilles, giving a sensation of extreme lightness. The upper finish, however, is a solid parapet with some rounded, three-lobed gaps and decorated by ceramic discs and the *trencadís* of colours, whose pieces form different radial and spiral designs.

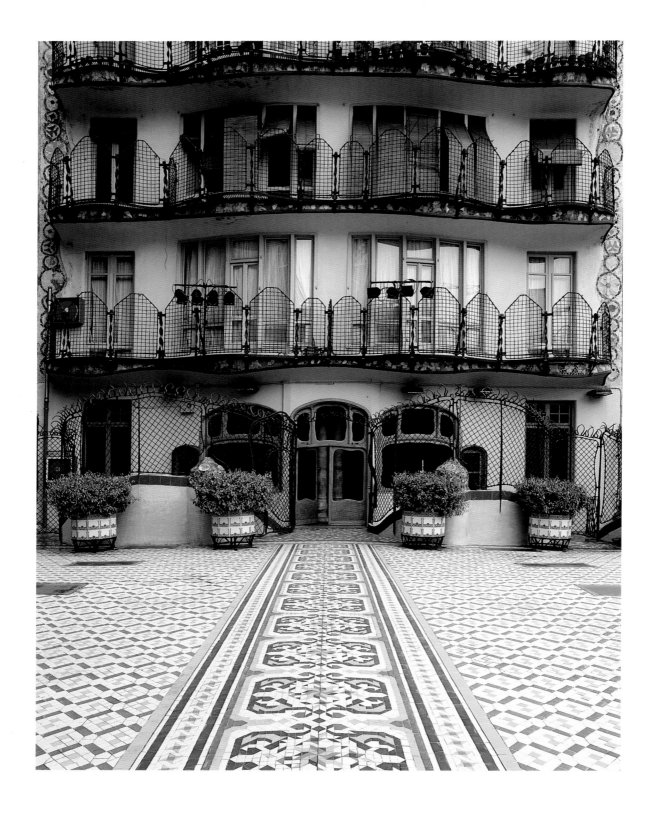

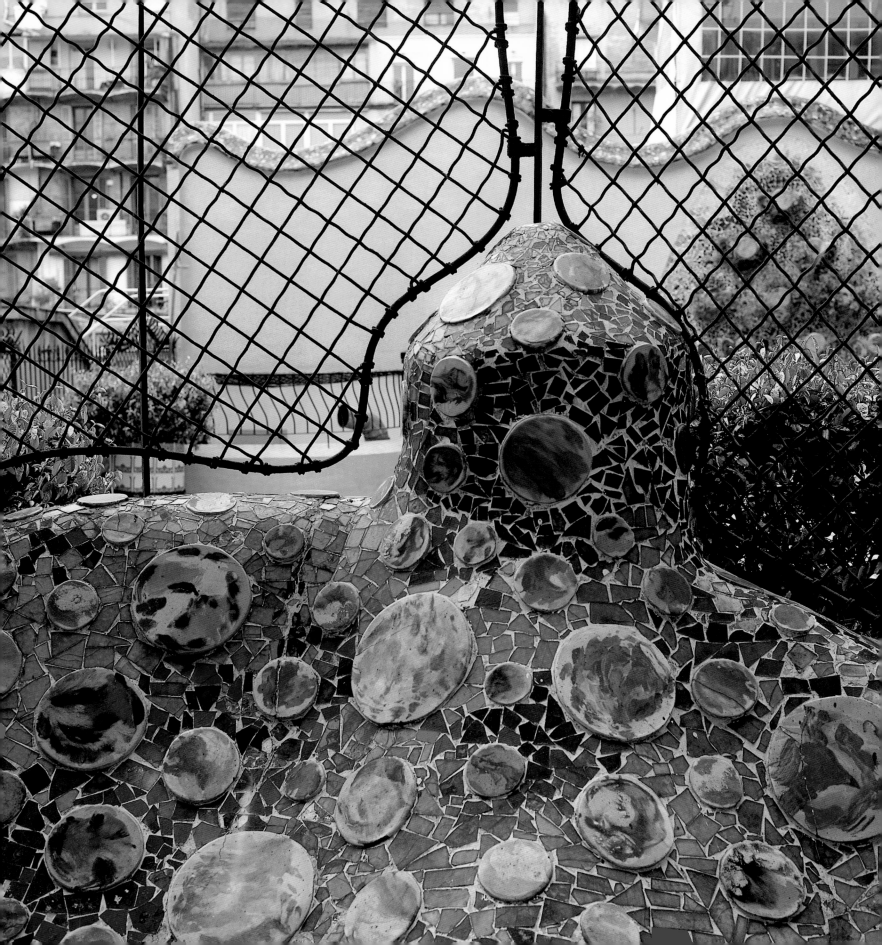

The dining room on the main floor leads to the terrace of the inner courtyard, which was for the exclusive use of the Batlló family. A small bridge should be crossed over the ventilation courtyard of the ground floor and passes through an undulating grille crowned by pointed metal and built, like the balcony rails, with a very transparent iron grille, of industrial origin.

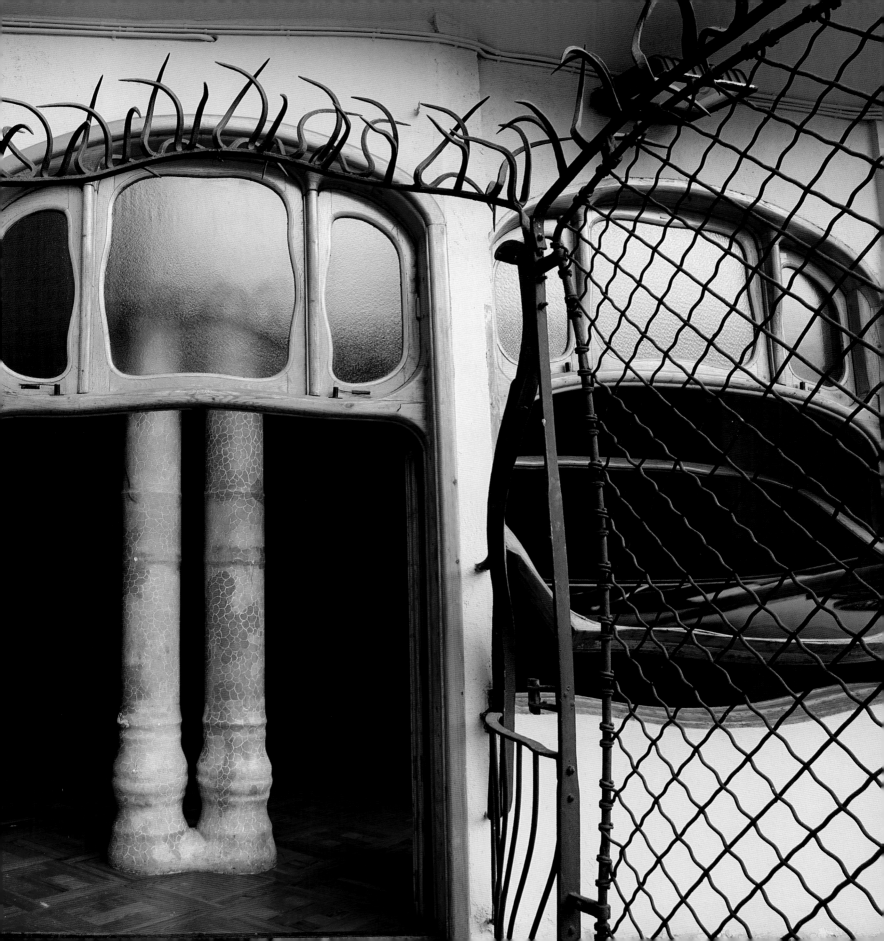

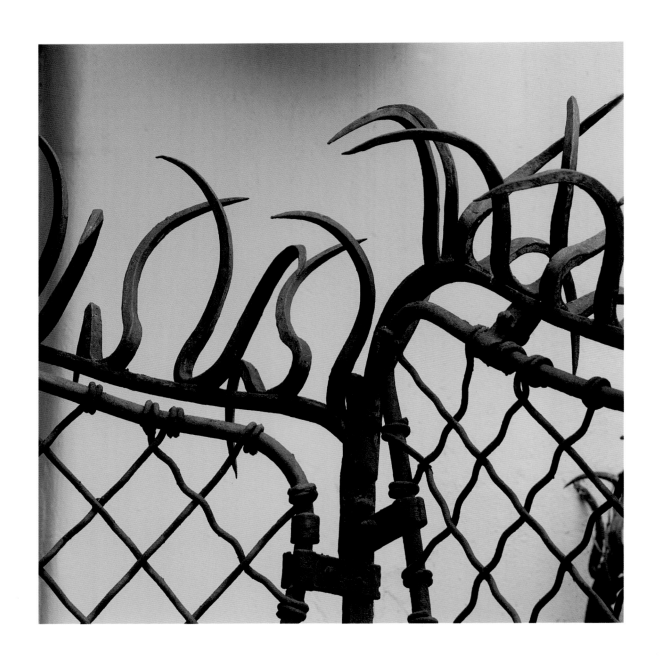

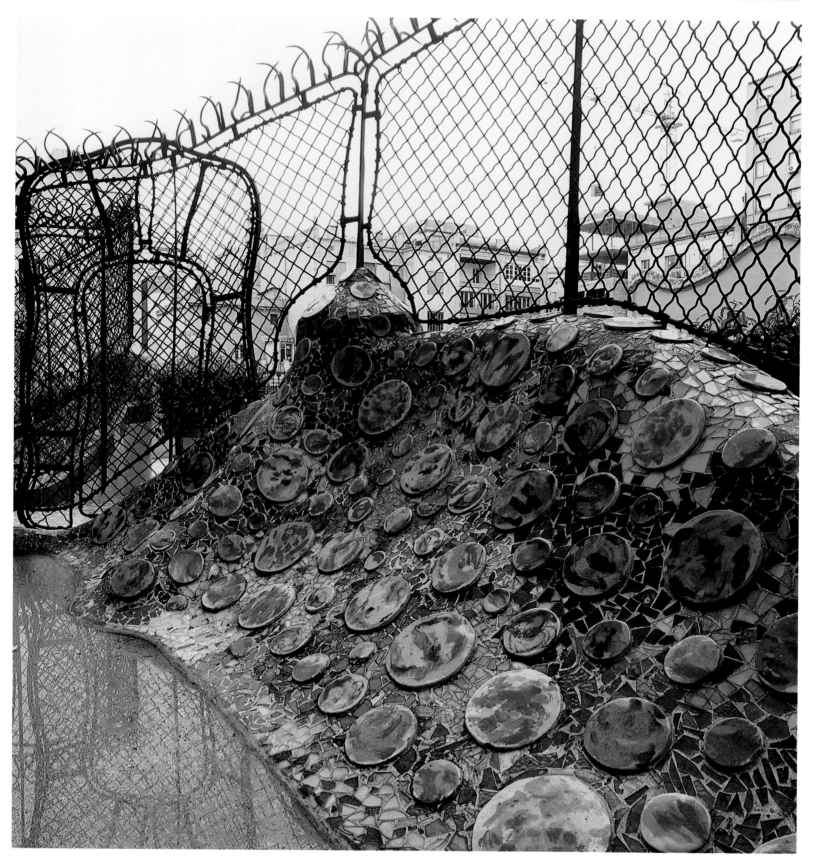

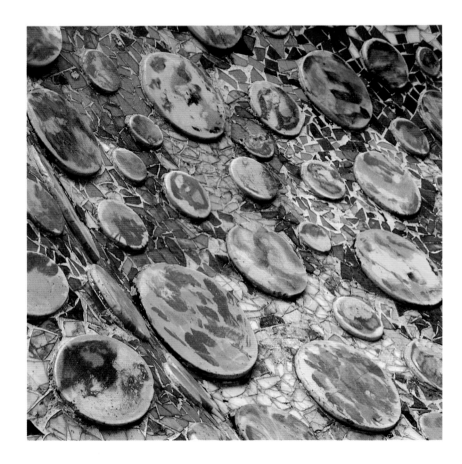

The courtyard is decorated with rocaille and flower boxes covered with ceramic discs and *trencadís* glass and ceramic pieces of different colours, although with a predominance of dark green hues, reminding on of the moss that forms in the shadiest and most secluded corners of gardens.

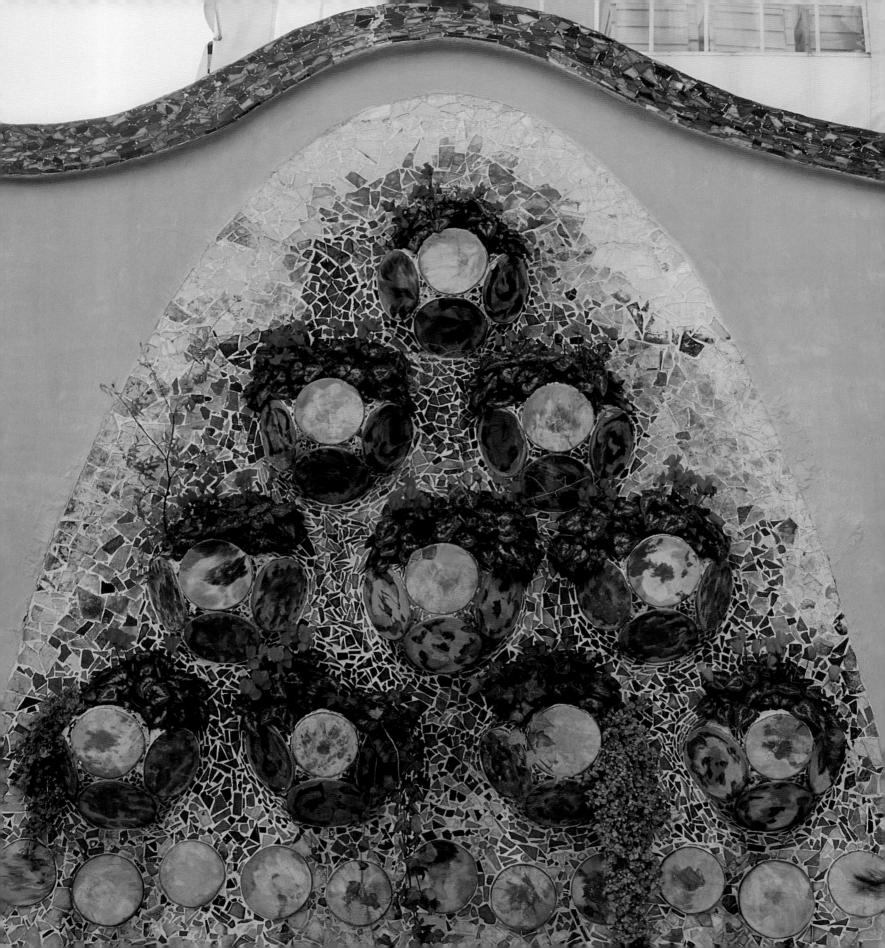

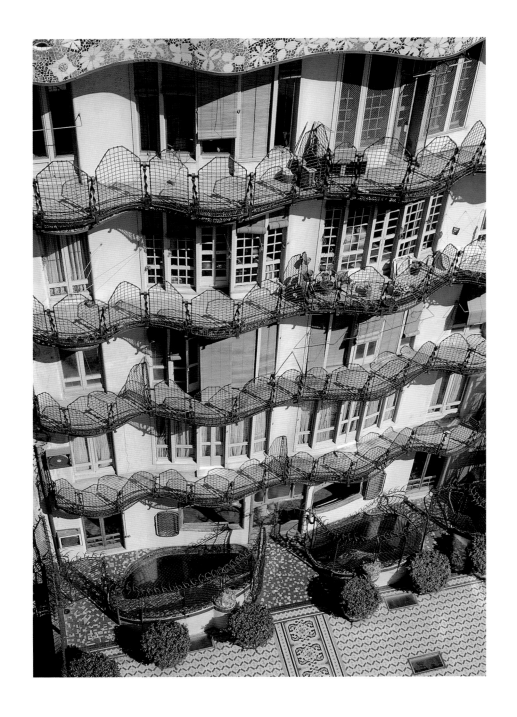

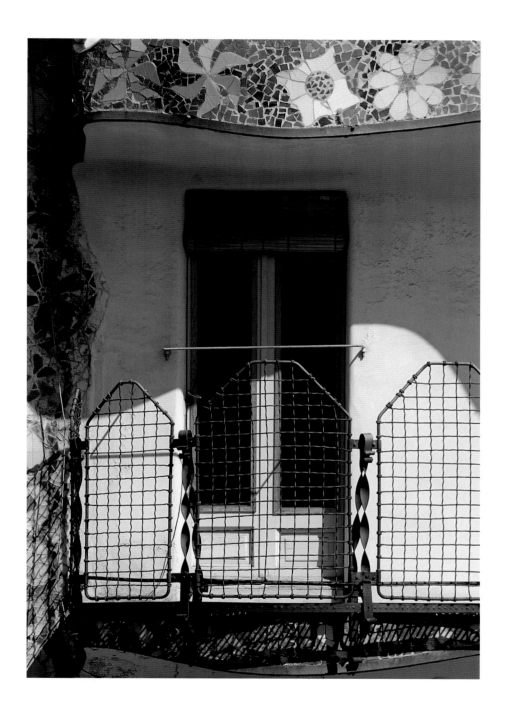

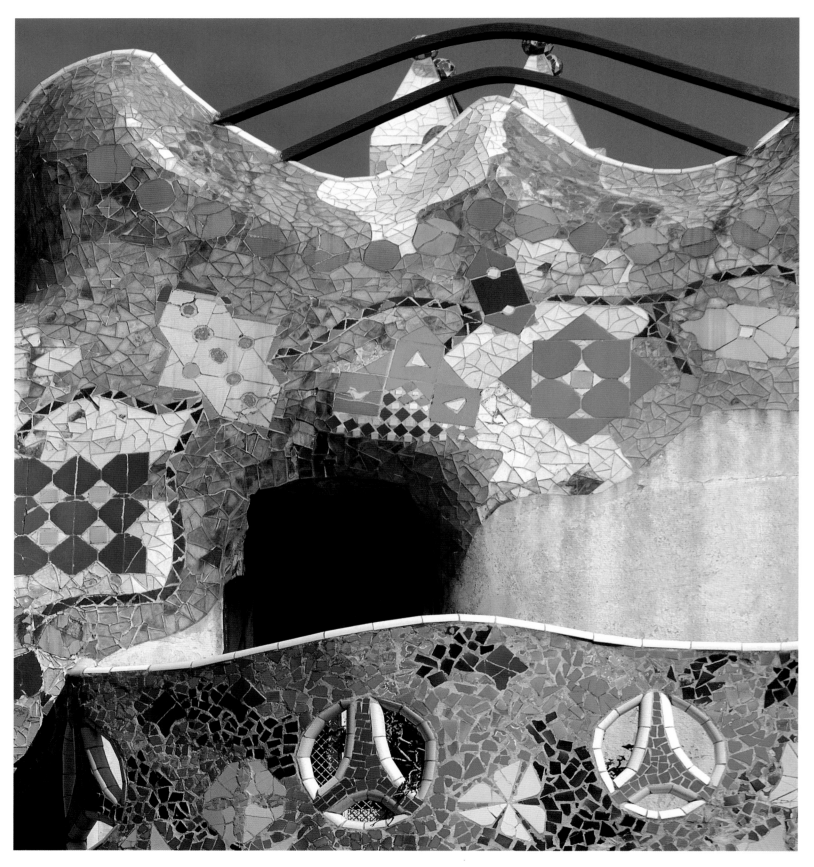

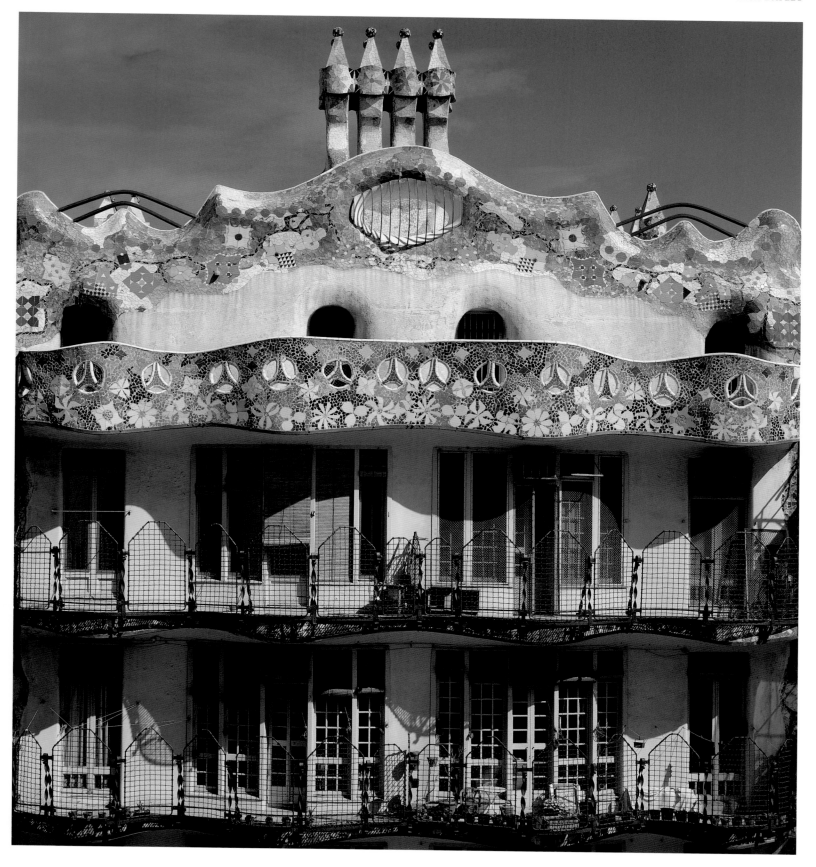

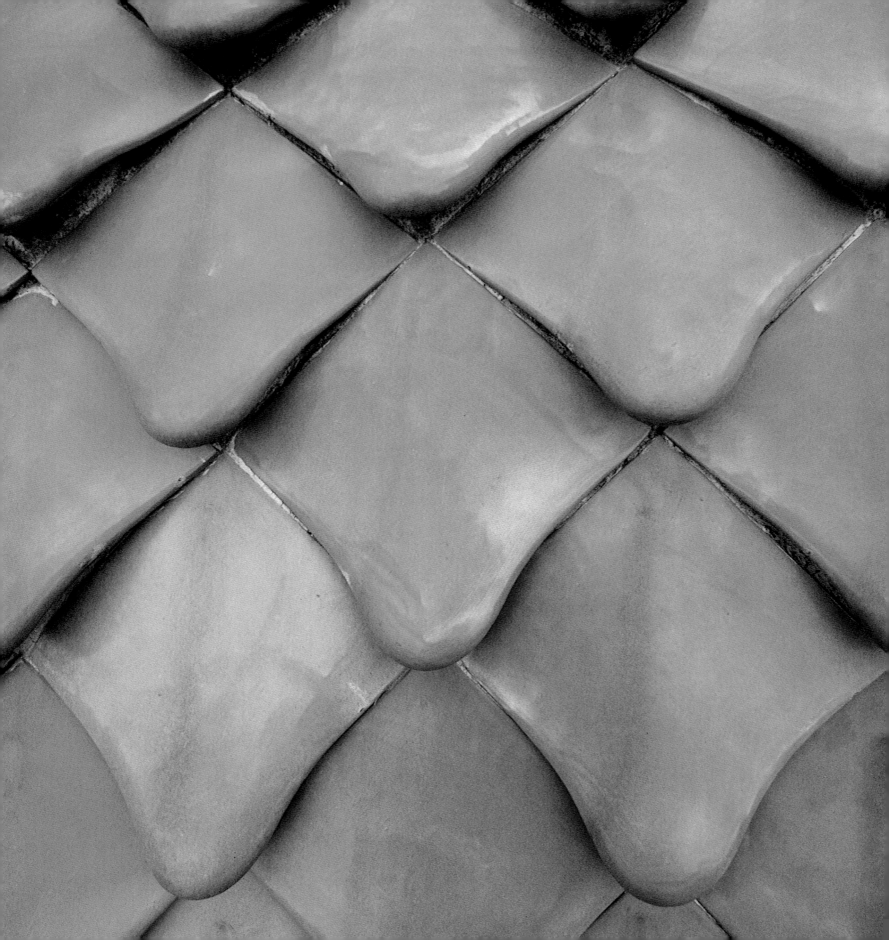

FLAT ROOF

On the flat roof, as is common in Gaudí's work, from that in the Palau Güell to that of La Pedrera, the chimneys create a landscape of incredibly varied shapes and colours. This is the spot, closest to heaven, in which the greatest offerings of Gaudí's imagination are produced.

The dragon's back crowning the facade is covered with large ceramic scales in electric blue shades on the outside and by ceramic and glass *trencadís* on the inside, whose colour gradually changes from white to yellow and from an orange hue through to green. The backbone is formed of a succession of roughly spherical ceramic pieces in blues and greens, which appear be set with other reddish and orange-hued cylindrical pieces. The bulbous shape and the four-armed cross that crown the tower is made from ceramics from Manacor and was brought expressly from Majorca.

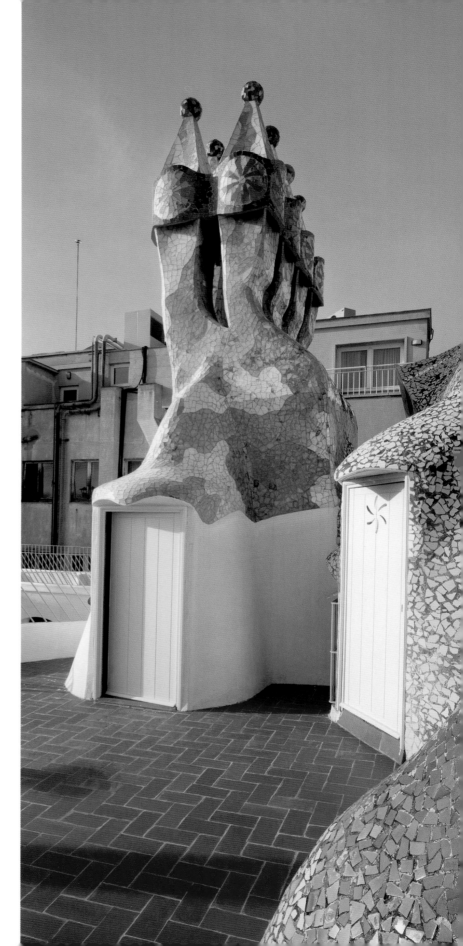

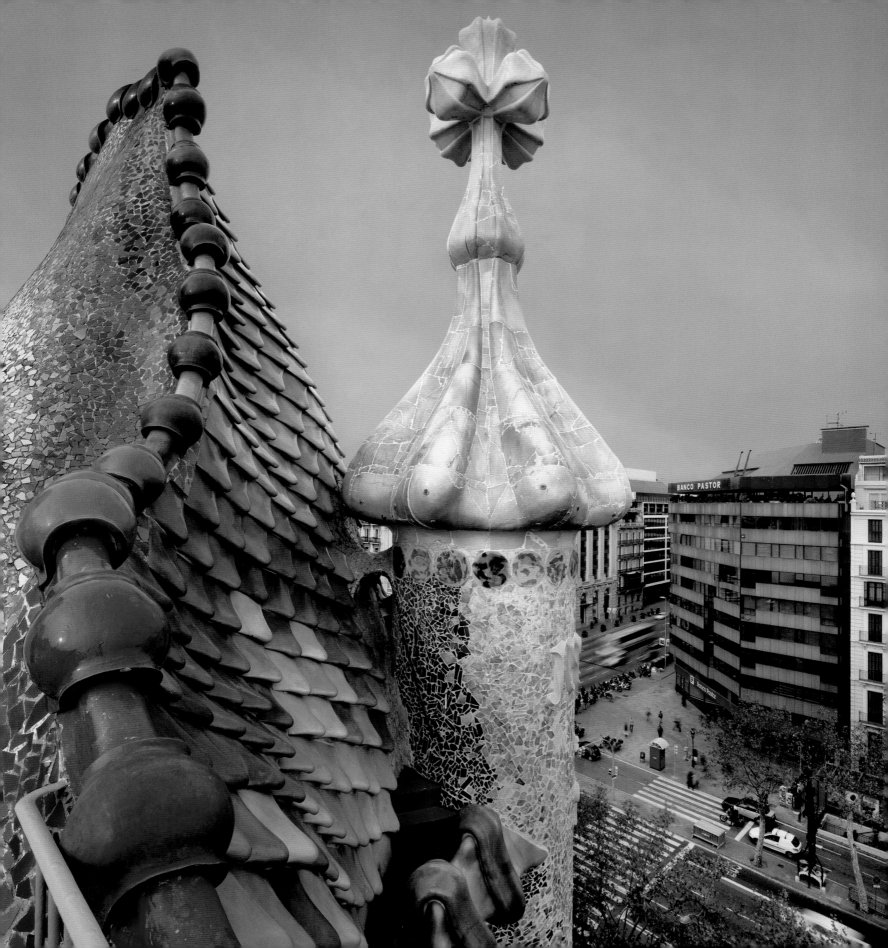

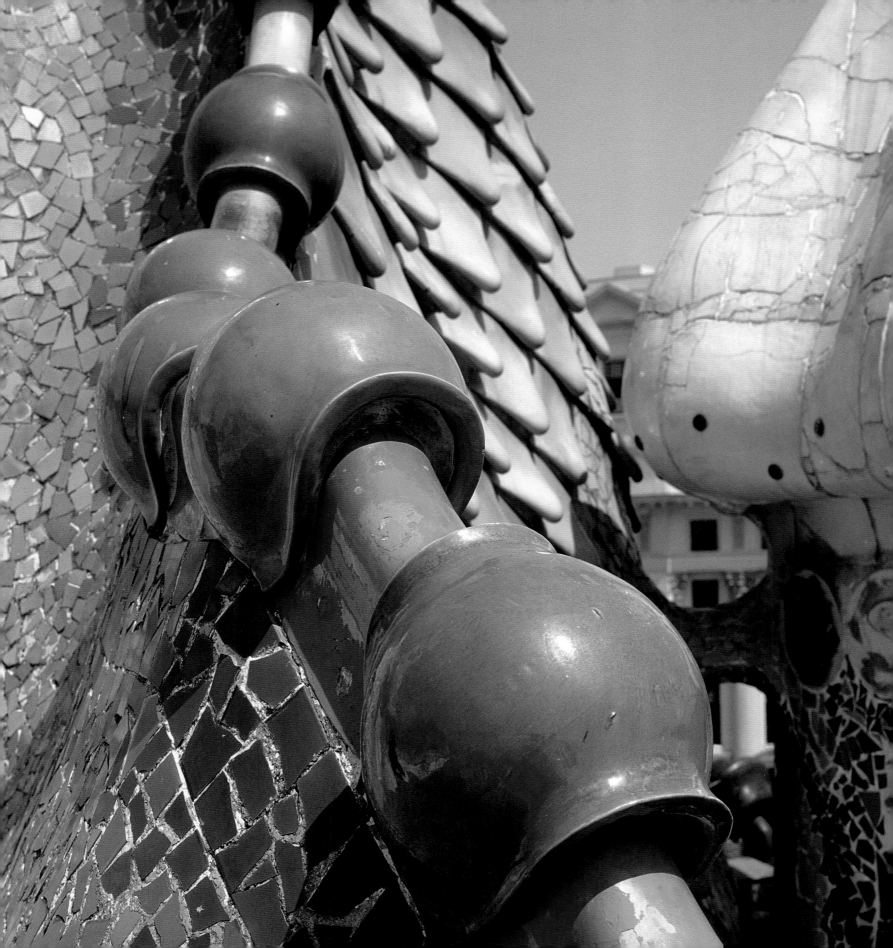

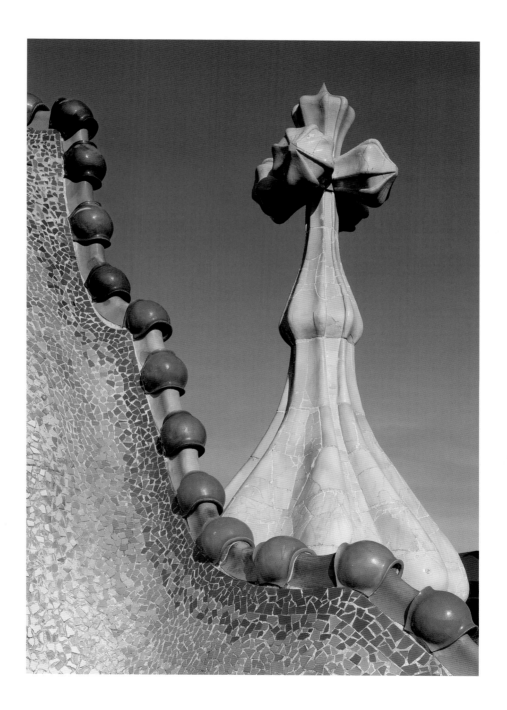

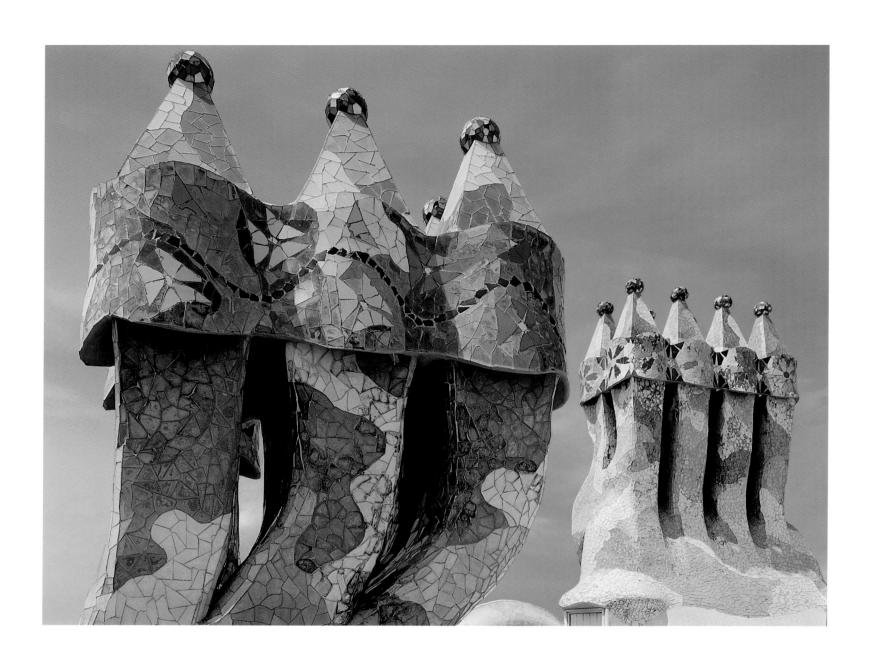

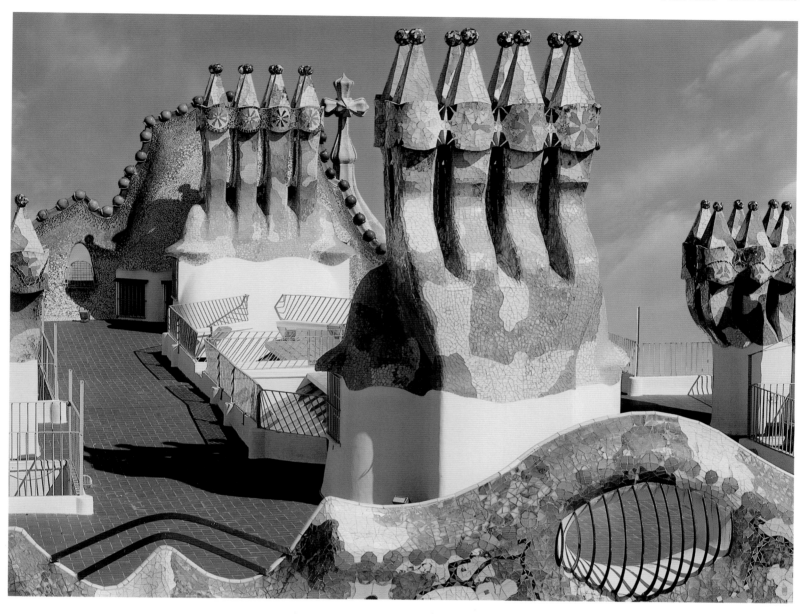

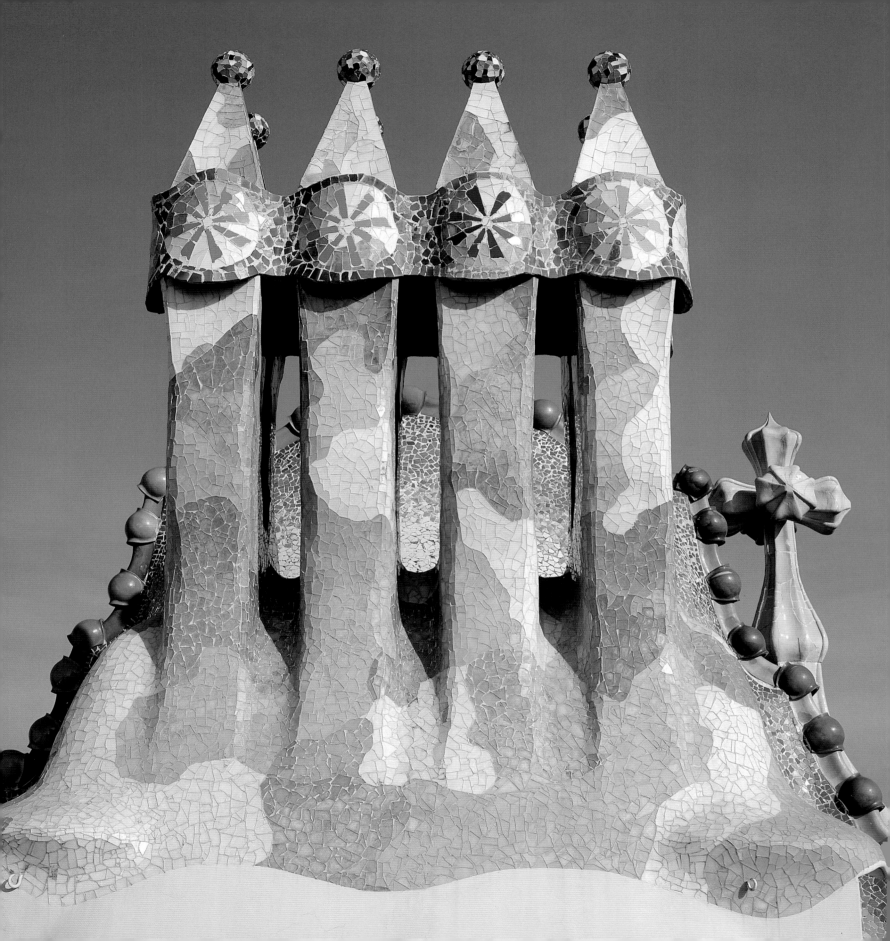

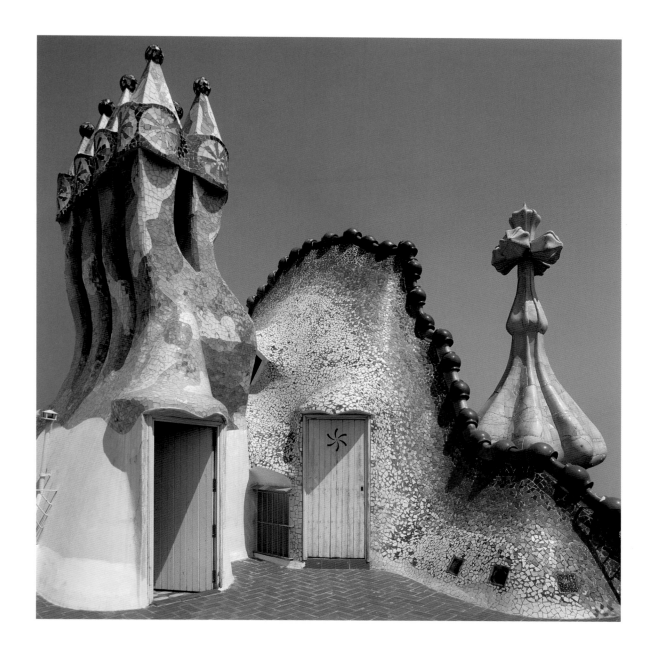

The chimneys rise up in dense groups from their compact bases, each stretching out their helicoid trunk covered in *trencadís* of glass and colours and showing off their pointed conical cap, hoods with ceramic borders topped by balls which were originally made of glass and filled with different coloured sand. The floor was also originally coloured, made up of randomly scattered mosaic pieces from Reus.

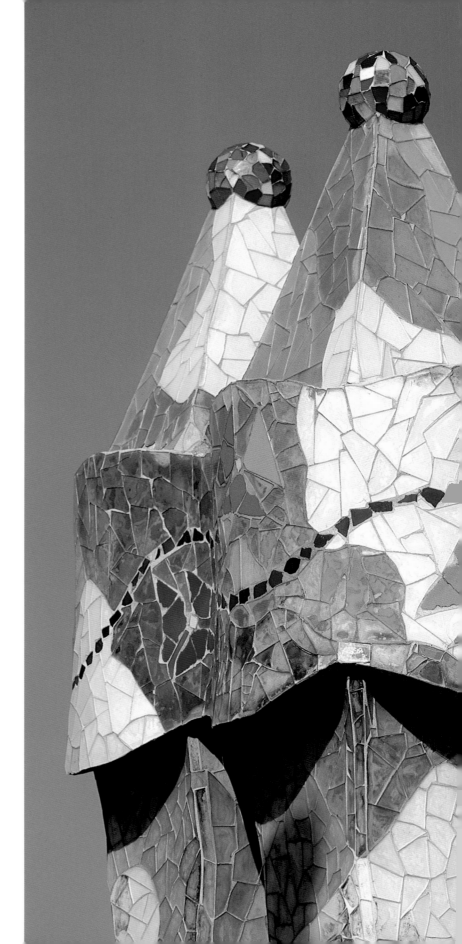

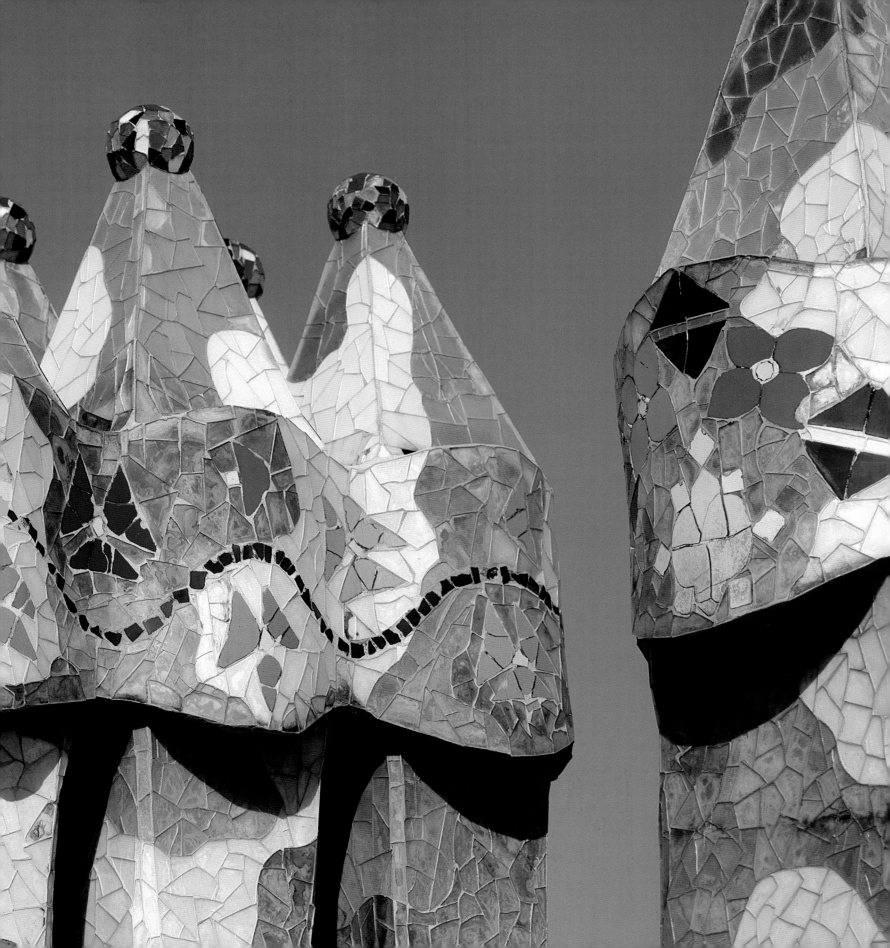

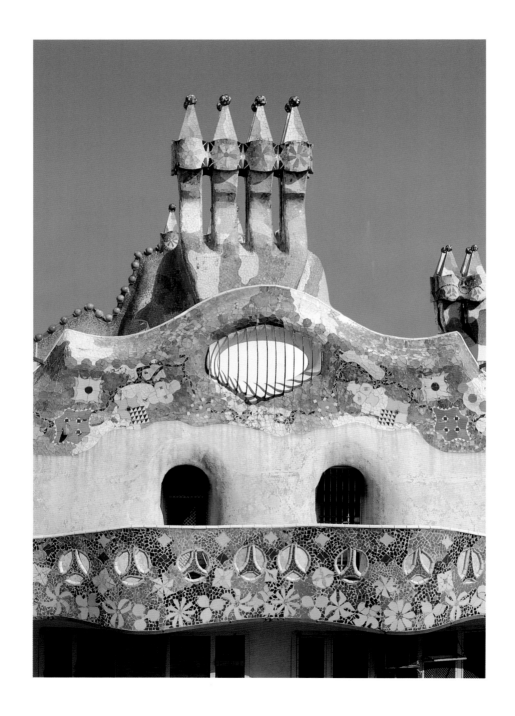

194

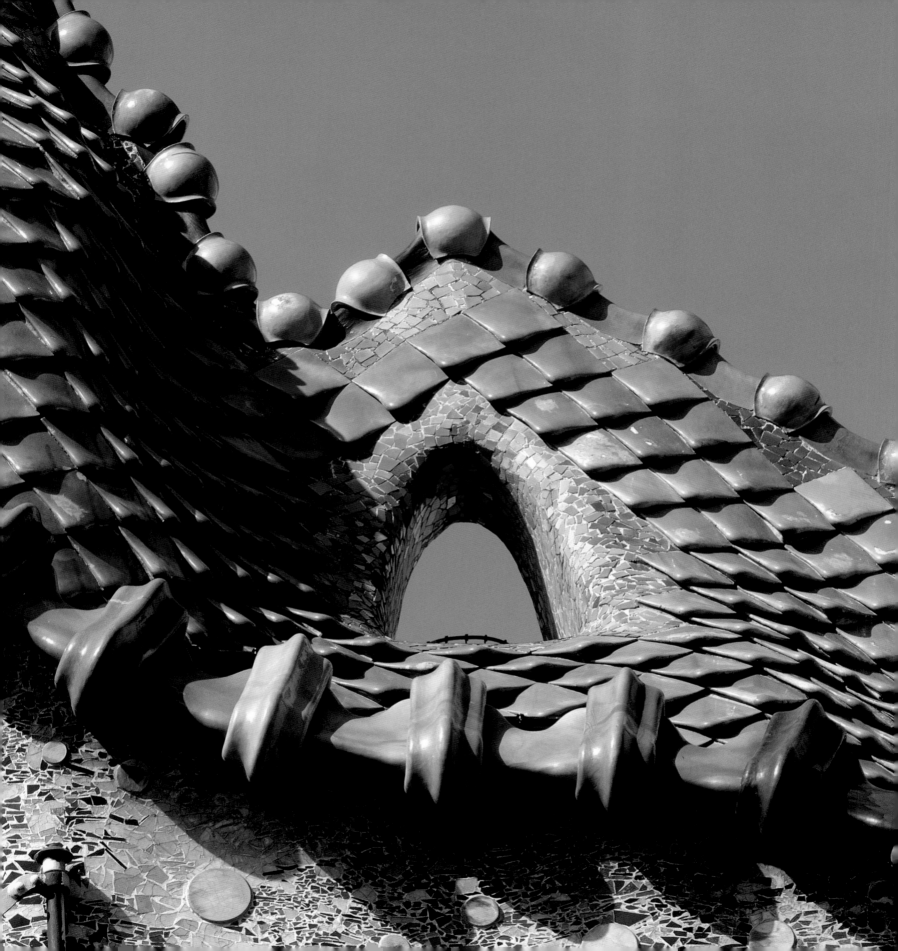

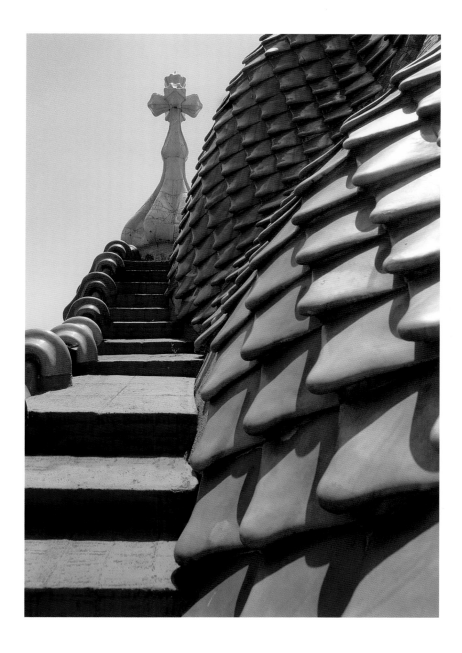

An extremely narrow and short walkway runs around the top of the facade, above the cornice and at the base of the scales. This is also one of Gaudí's common solutions, and we can see it in works such as the Bellesguard Tower or, later on, in La Pedrera, but in neither case is the effect produced as dizzily as in this one.

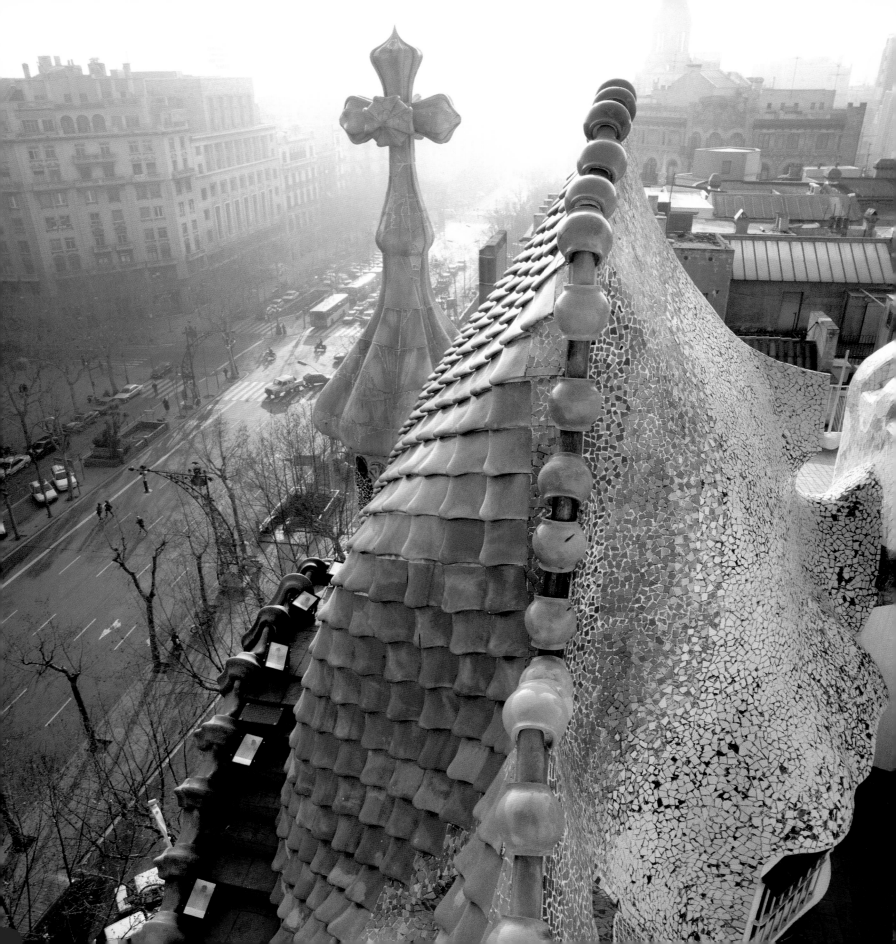

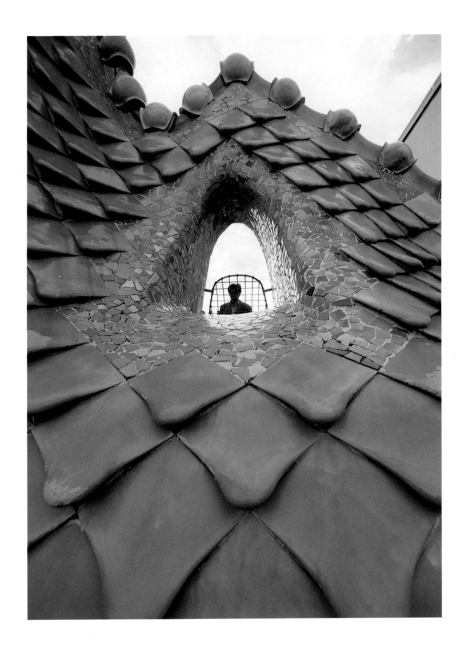

THE SKETCH OF THE FACADE

Besides the plans presented to Barcelona City Council for the approval of the project, the only surviving original document from the Casa Batlló is this sketch. It is in fact priceless since, with the exception of his student projects and the odd sketch for the church in the Güell Industrial Village produced on photographs, this is the only surviving drawing on paper that shows us how Gaudí and his assistants worked. It was presented to an exhibition of architects' drawings organised by the Architects' School of Barcelona and since Gaudí never got it back, there it stayed. It was thus saved from destruction, something that all his drawings suffered when the Sagrada Familia workshop was burnt down at the beginning of the Spanish Civil War in 1936. It was discovered by Joan Bassegoda in the school's archives.

As well as some small details, we see a section and elevation of the building. In the latter, over the rigid section of neo-classical balconies of the original construction, Gaudí's pencil has gently flowed, giving the initial form, but in a very detailed way, to the essential elements of his project. The crown of the building, the gallery and the ground floor, the latter being shown half in elevation and half in plan, and one of the balconies already show a great deal of detail. What is interesting here, however, is that what we are able to see is an intermediate stage of the project's evolution. Thus, although many things suggest the finished building to us, there are other aspects that are closer to a previous work, the Casa Calvet, which provided the final solution to the Casa Batlló. The crown of the building, for example, is still without the lateral tower, which seems to want to find a more central positioning, contrary to the location finally decided. The undulating forms also remind one more of mountain peaks – Montserrat, for example – than the back of a dragon to which the attic we see today refers. Alternatively, the pillars on the ground floor have been drawn with chained ashlar stones and with very clearly marked joints, similar to those of the Casa

Sketch by Gaudí showing
a study of the facade and some
details of the Casa Batlló.

Calvet. The forms of the balconies also have a certain Baroque or rococo air about them, something also inherited from the Casa Calvet. In short, in this drawing we see Gaudí freeing himself of the last stylistic remains of his previous work which lay buried beneath the organic, continuous and soft forms of the constructed work: a process that this remarkable sketch clearly shows.

SECTIONS AND MAIN FLOOR

In the longitudinal and transversal sections of the building and, particularly, in the ground plan of the owner's flat, we observe the curious structuring of the interior of the Casa Batlló. The sinuosity of the facade continues in the interior of the main floor which is partitioned by walls which, in the main, are of curvaceous forms. These plans were drawn in 1958 by Ramon Berenguer under the supervision of the architect Lluís Bonet Garí.

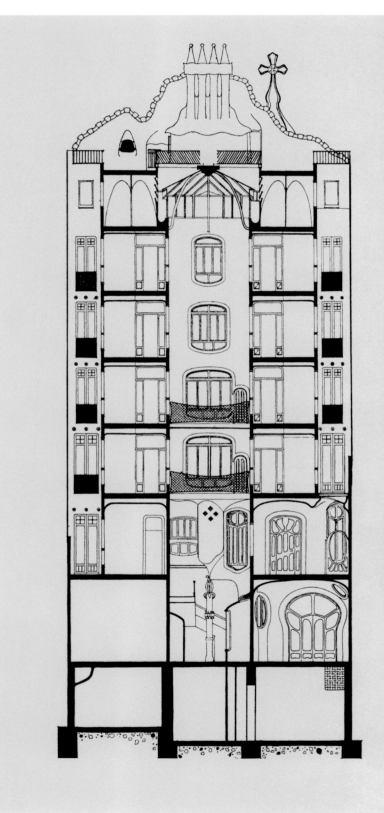

Main floor
and transversal
and longitudinal sections.

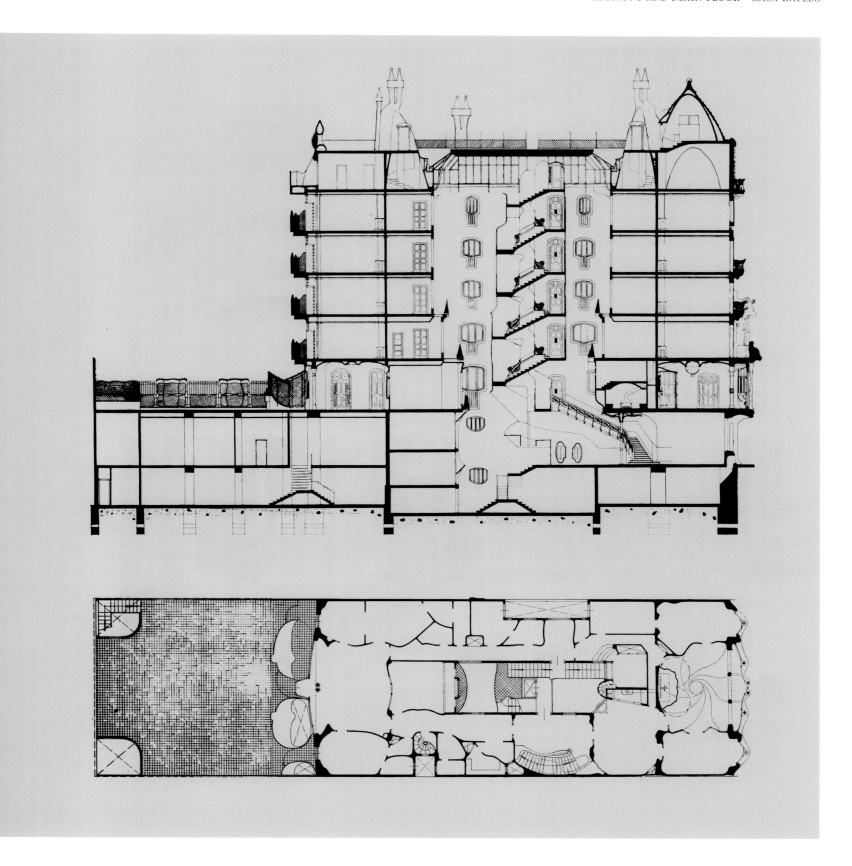

GAUDIAN MORPHOLOGY

For Gaudí, form came from nature, understood as God's creation. The origins of this thought are very old and can also be found, in different ways, in some 19th century theoreticians such as Ruskin or Viollet-le-Duc. Gaudí, however, and above all in the work undertaken after 1900 – Park Güell, Casa Batlló and Casa Milà – seems to want to go much further. For him it was not just about imitation, as some of the classicists exclaimed, but to understand the selfsame processes of creation, of creating in the same way that nature herself creates.

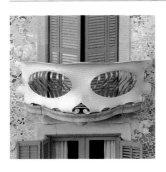

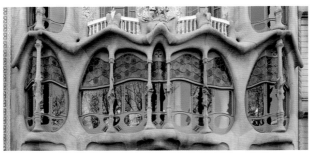

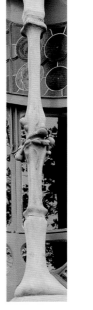

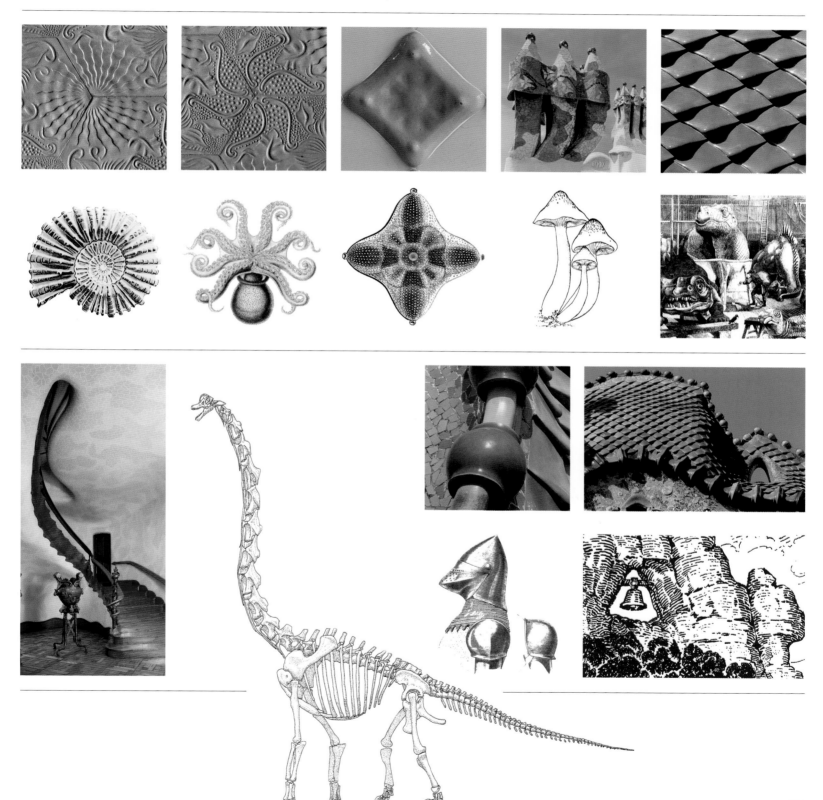

THE RHYTHM OF ESSENTIAL FORMS

Gaudí was convinced that in the *perpetuum mobile* of nature, all forms are contained but that, at the same time, all these forms are based on some essential movements, forming symbols of genesis and life. Some allusions, such as the ever-present bones, refer to the end of life and its most essential and severe aspects. Others, however, such as the circles and spirals, the whirlpool or the nebula, refer to the fact that everything has its beginning.

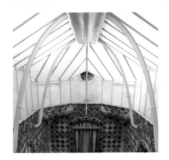 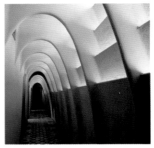

 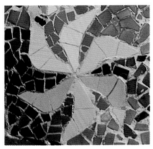

 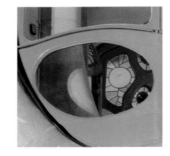 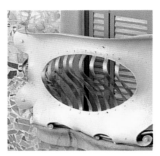

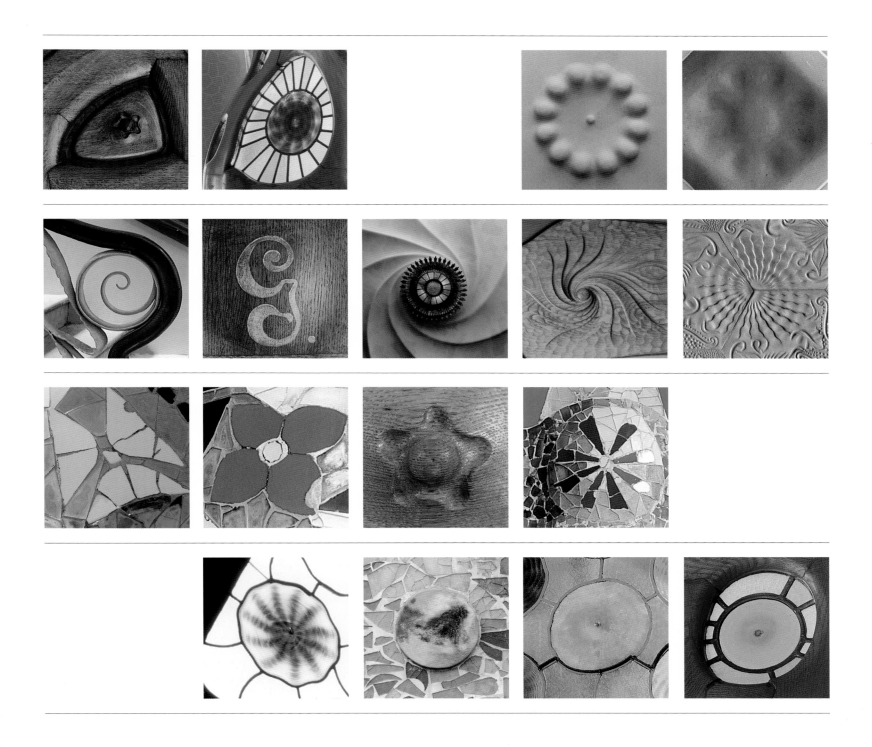

© 2001, TRIANGLE POSTALS S.L.

© PHOTOGRAPHY
Pere Vivas, Ricard Pla

© TEXT
Juan José Lahuerta

© ARCHIVE PHOTOGRAPHS
Cátedra Gaudí, p. 202, 203
Arxiu Mas, p. 29, 30, 32, 33, 36
Museu de la Sagrada Família, p. 200
Arxiu Administratiu Municipal, p. 36

INTERACTIVE CD-ROM
Juanjo Puente | Music interpreted by Xavier Algans

COORDINATION
Paz Marrodán, Imma Planes

DESIGN
Joan Colomer

LAYOUT
Mercè Camerino, Antonio M.G. Funes and Salvador Benet

DIGITAL RETOUCHING
Pere Vivas, Ricard Pla, Álvaro López B.H.

TRANSLATION
Steve Cedar

ACKNOWLEDGEMENTS
Banco Pastor, Servicio Estación and Casa Batlló.

COLOUR SEPARATIONS
Tecnoart

PRINTED BY
Grup 3 S.L. Barcelona
DEPÓSITO LEGAL
B-37845-2001

ISBN
84-8478-027-9

Third edition, June 2002

Triangle Postals S.L.
Tel. +34 971 15 04 51, +34 93 218 77 37
Fax. +34 971 15 18 36
www.trianglepostals.com
E-mail: paz@teleline.es

gaudí 2oo2
Any Internacional Gaudí
Año Internacional Gaudí
Gaudí International Year